COMIC ART NOW

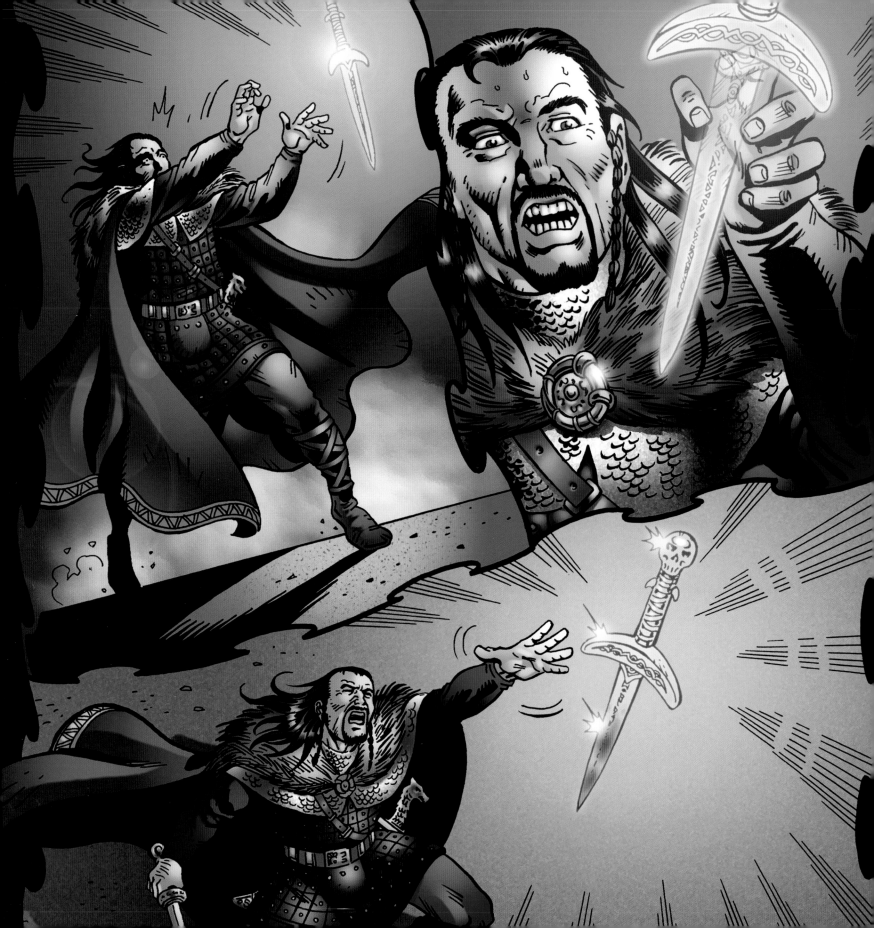

The very best in contemporary comic art and illustration

COMIC ART NOW

Author **DEZ SKINN**
Foreword by **MARK MILLAR**

COLLINS|DESIGN
An Imprint of HarperCollinsPublishers

HarperCollins books may be purchased for educational,
business, or sales promotional use. For information,
please write: Special Markets Department, HarperCollins
Publishers, 10 East 53rd Street, New York, NY 10022.

First published in North America in 2008 by:
Collins Design
An Imprint of HarperCollins*Publishers*
10 East 53rd Street
New York, NY 10022
Tel: (212) 207-7000
Fax: (212) 207-7654
collinsdesign@harpercollins.com
www.harpercollins.com

Distributed throughout North America by:
HarperCollins*Publishers*
10 East 53rd Street
New York, NY 10022
Fax: (212) 207-7654

Library of Congress Control Number: 2007938191
ISBN: 978-0-06-144739-6

For more information on Comic Art Now, go to:
www.web-linked.com/comius

Printed in China
First Printing, 2008

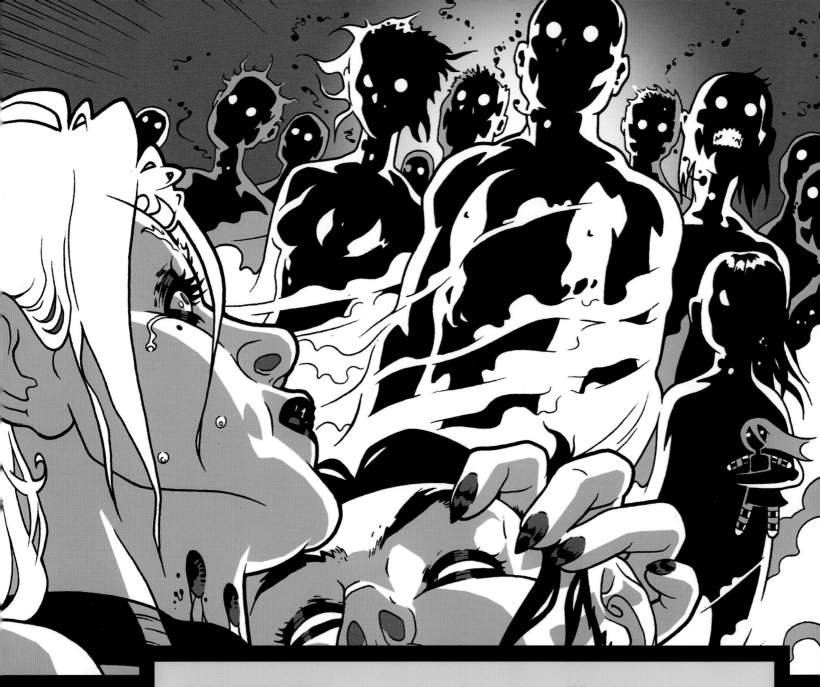

CONTENTS

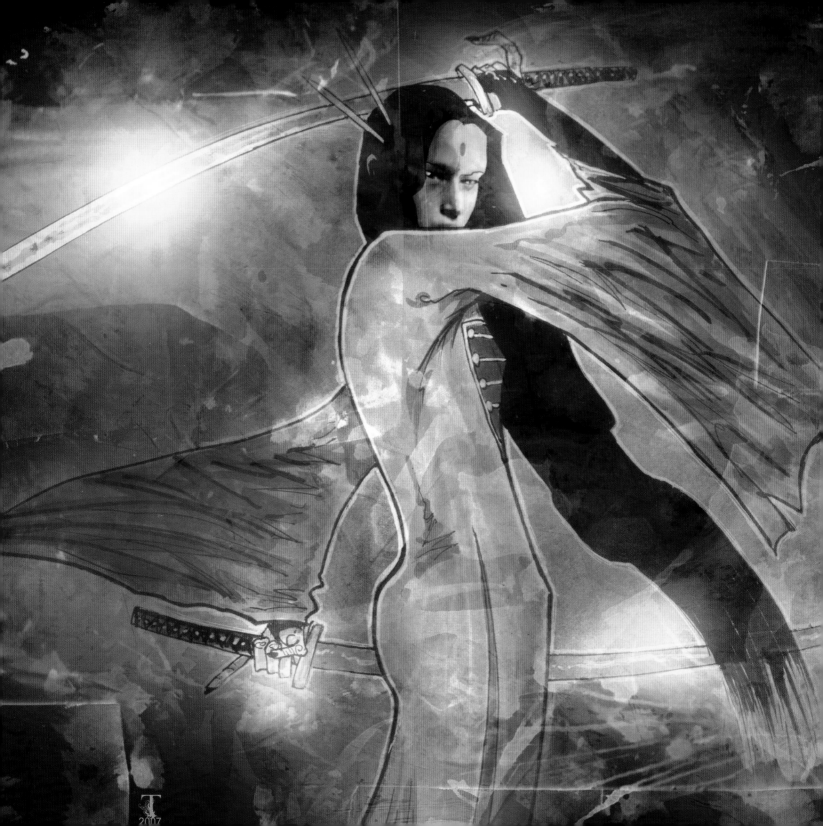

Foreword

It's all about the art and always has been. Anyone who thinks otherwise is only kidding themselves.

Now you have to understand. As a writer, that was perhaps the most painful sentence my fingers have ever typed, but it's absolutely true. So much so, in fact, that people out there in the real world are always surprised to learn that comic book writers even exist in any shape or form. Whenever I meet strangers at a cocktail party (or, more realistically, lying drunk in a public park and slurring to my fellow winos), it's widely assumed that I'm an artist. When I explain that I'm a comic book WRITER their noses kind of wrinkle. They assume I merely fill in the balloons and look vaguely disappointed, glancing over my shoulder in the hope that someone more interesting has just walked into the room. Like a comic book ARTIST, for example.

But I'm not bitter. I've been obsessing over this stuff since I was four years old, and as any child will tell you it's the art that draws them into the story. My first experience of Marvel Comics wasn't Stan Lee, but Jack Kirby and Steve Ditko reprints. My first experience of Superman wasn't Cary Bates or Elliot Maggin, but the gorgeous Norman Rockwell qualities of Kurt Swan and Bob Oksner. A bad artist can slit the throat of even the sturdiest story, but a great artist can resuscitate a corpse. It's no surprise that all my own most notable works were handled by the likes of Bryan Hitch, Frank Quitely or John Romita Jr. The honest truth is that the artists do all the hard work.

We live in an era when high production values verge on science fiction. Flipping through back issues, we're immediately reminded that comic books were a trashy, despised medium and usually printed on what looked like toilet paper. It was generally underpaid, forcing talented men to work twice as fast to make a living and the artistry was seldom celebrated. Even credits were a rarity until a generation or two ago. How great work was ever achieved under these conditions is quite remarkable and yet stars shone from the murky print like Kirby, Ditko, Gil Kane, Hal Foster, Alex Toth, Carmine Infantino and John Buscema. But it's easy to be nostalgic for the past when we handpick a few greats from a very long time ago and fail to recognize that right now we probably have the greatest assemblage of artists ever working in the industry at any one time. The styles are more varied and personal, the recognition is international, and the paper enhances every subtle detail. It's rare to call something a Golden Age while we're still in the middle of it, but some of the best comic books ever created are happening right now and this book celebrates the cream of that talent.

So stop reading immediately and go look at the pretty pictures. This is the boring bit. These are only words and words all look the same.

—*Mark Millar*

Mark Millar is an award-winning comic book author and one of the most high-profile writers of his generation. His creator-owned book *Wanted* has been made into a movie starring Angelina Jolie and Morgan Freeman, and his next book, *Chosen*, is now in development as a motion picture.

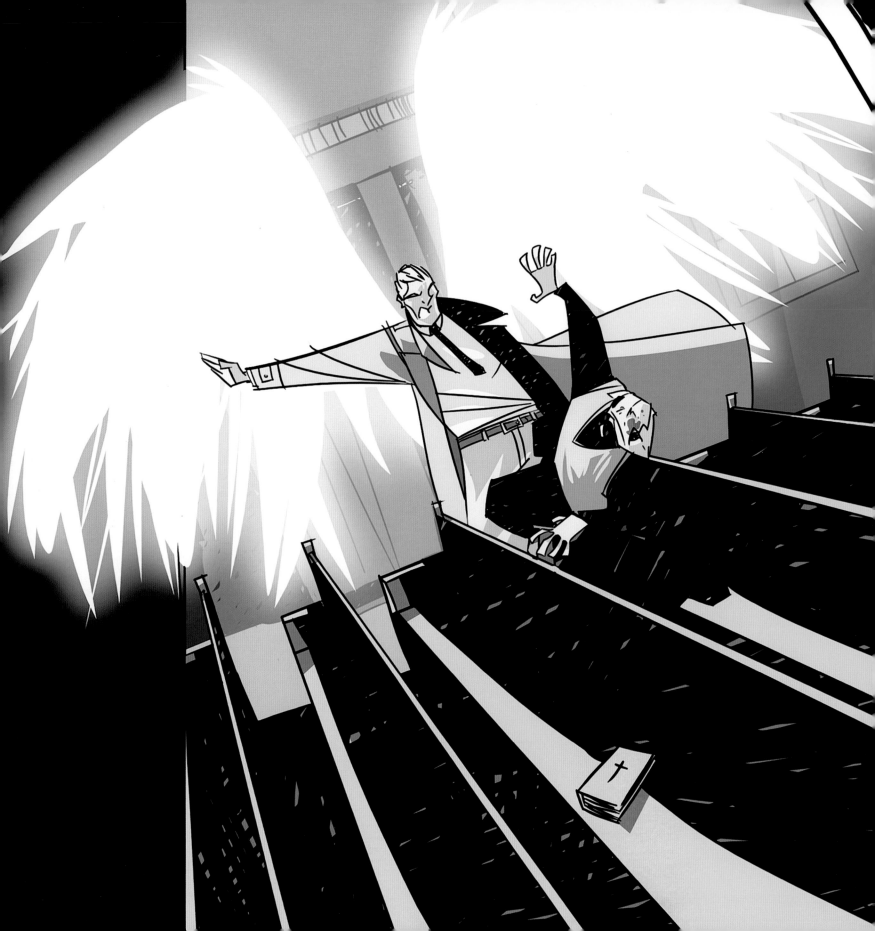

Introduction

From Carole Bayer Sager and Peter Allen, to Barenaked Ladies and Hugh Jackman, we've been told for over 30 years that "Everything old is new again." Now, after decades of primarily kiddie fare, it applies once more to comics as they join movies, music, and mainstream print as a true entertainment medium.

No longer the fanboy niche they had steered themselves into, whether you call them comics, graphic novels, manga, fumetti or bande dessinees, comic art has blossomed and—as you are about to see—embraces all styles in its visual storytelling. Noir, expressionism, abstraction, retro, postimpressionism, even primitivism and cubism are eagerly embraced.

Just as television found its rightful place as "radio with pictures" following early resistance from Luddite elitists, so comics have risen above the scornful notion that "stories don't need visuals" and, as a medium, embrace the full spectrum of entertainment. But comics have a distinct advantage that radio, TV and film could never lay claim to; they promote literacy by making reading fun.

In the early days, comics were anthology titles—printed "variety shows" if you will—where dozens of artists each drew short self-contained strips on a range of subjects covering western, war, sport, humor, adventure, science fiction—a genre list as wide as any popular medium. This enabled publishers to reflect ever-changing popular trends on their covers, while maintaining reader and retail confidence with continuing titles.

But somehow it all went badly wrong when one genre achieved dominance to such a point that it virtually squeezed out all others and created an illegitimate offspring of the anthology in the single story superhero comic. Pandering to a fan base gave publishers an immediate short-term gain at a time when newsstands were overflowing with more expensive (and more lucrative) magazines and had little space for such disposable ephemera as comicbooks. But fans, suddenly in the driving seat, could hardly be called visionaries. Their needs were for more of the same and artists found themselves becoming little more than cogs in a machine, producing derivative work—the only kind publishers would accept—for a factory-line of corporate owned properties.

By the early 1990s the situation got even worse, with the creators of the titles finding themselves less important than the gimmicks and formats which had suddenly taken over. Comics were being bought by fans for their packaging, and diecut covers and metallic embossing were suddenly more important than the actual content. Sales soared to multi-million printrun levels, bolstered by marketing manoeuvres such as relaunching titles to create new "collector's item"

first issues, and publicity-rewarding gimmick storylines where iconic characters would seemingly die or be transformed.

Naturally, the bubble soon burst, leaving many artists, writers and publishers floundering. They'd reached the end of a dead-end street they had so eagerly raced down.

Generally dismissed, following a false start a decade earlier, graphic novels had been an outreach program enabling comics and their creators to embrace more mature themes and genres beyond those of their 32-page parents. Less pretentiously known as "albums," they had been the major revenue strand of the European comics industry for over 50 years, some collecting popular serials, others being brand new stories by well-respected creators. But in the States, it was the independent visionaries that could not compete in the superhero comic book market who saw an alternative. Whether one-man writer/artists or specialist retailers-turned-publishers, creatives began publishing their own work, collecting serials into book format and reaping the rewards of publishing their own reprints.

Because it was aiming at casual readers instead of the fanboy market, it reflected film, TV, literature and even music in its content to attract non-comics readers. Influences from around the world got their US start through these brave experimentalists. Manga was absorbed, leading European and South American artists brought their unique styles to North America, and creators in Britain's comics industry

looked to the US when their native industry wilted, bringing with them a less deifying approach to comic books. At last, the comic book and its graphic novel sibling were part of a world market, both absorbing and reflecting a virtual panoply of ideas and approaches, touching on every subject matter available. No longer subject to the censorship imposed on comics during the 1950s McCarthy witchhunts, or corporate concerns over parental backlash, the medium had finally realized a potential it was born with.

Just as it had begun life with mainly adult readers, through its birth in newspapers, it once again had a format that would be both accessible and appealing to all tastes. With content drawn from a world pool of creativity, titles no longer have only national appeal, but are translated for a global audience. It had been a rocky road, with jarring bumps that almost stopped it in its tracks, but the unique format of words and pictures—with no budgetary restrictions on the creative imagination—has finally come of age.

This book reflects that world market, through its range of styles, content, and the countries its contributors work from. A truly international medium, we proudly present…
COMIC ART NOW!

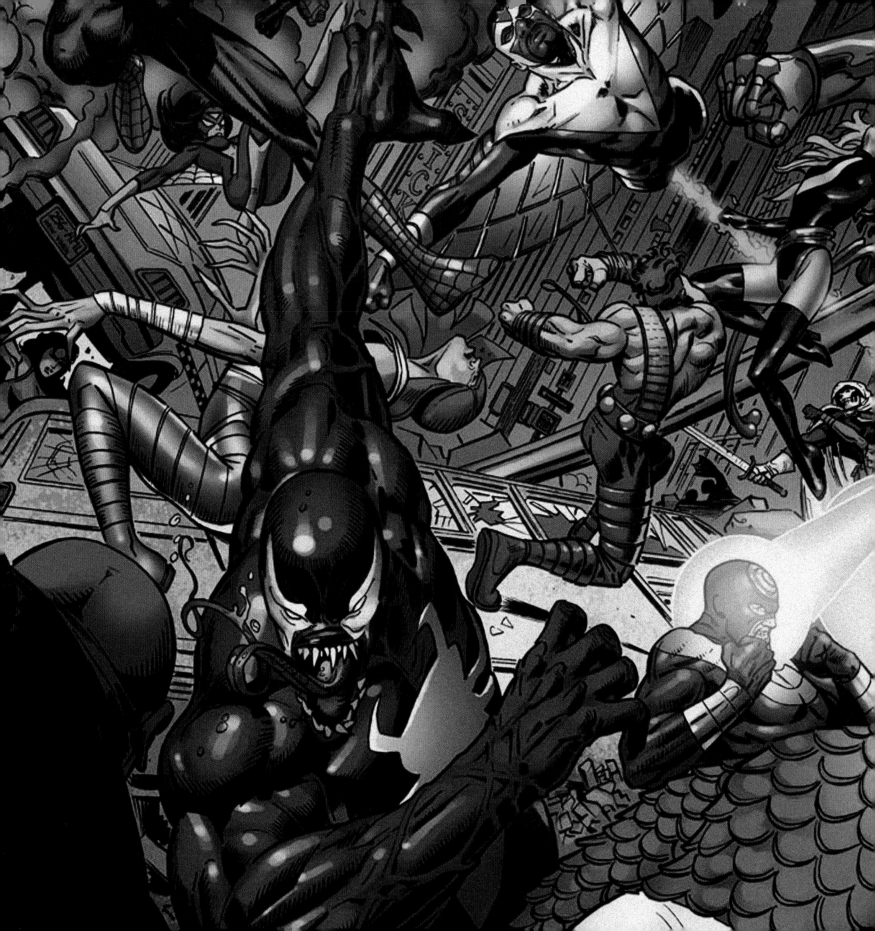

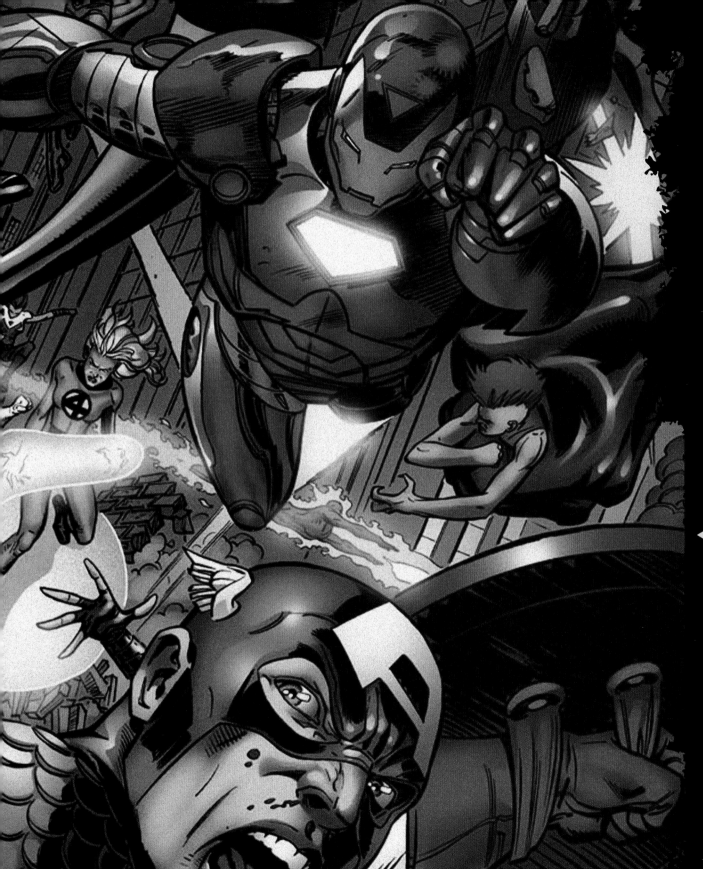

CHAPTER 1
HEROES AND VILLAINS

◄ **Amazing Spider-Man:
The War At Home**
Ron Garney
Marvel Comics
Brush and india ink, colored in
Adobe Photoshop by Matt Milla
yenrag@aol.com

On *Amazing Spider-Man*,
US artist Ron Garney is
interpreting scripts by comics
author J Michael Straczynski.
Garney breaks down the scripts
into panel-by-panel layouts,
then works up the content to
tight finished pencil art. Bill
Reinhold inks Garney's pencils,
before the pages are given to the
colorist. "Bill really knows how
to interpret and complement
my pencils, rather than putting
a technique stamp over them
where it wouldn't necessarily
be the best marriage."

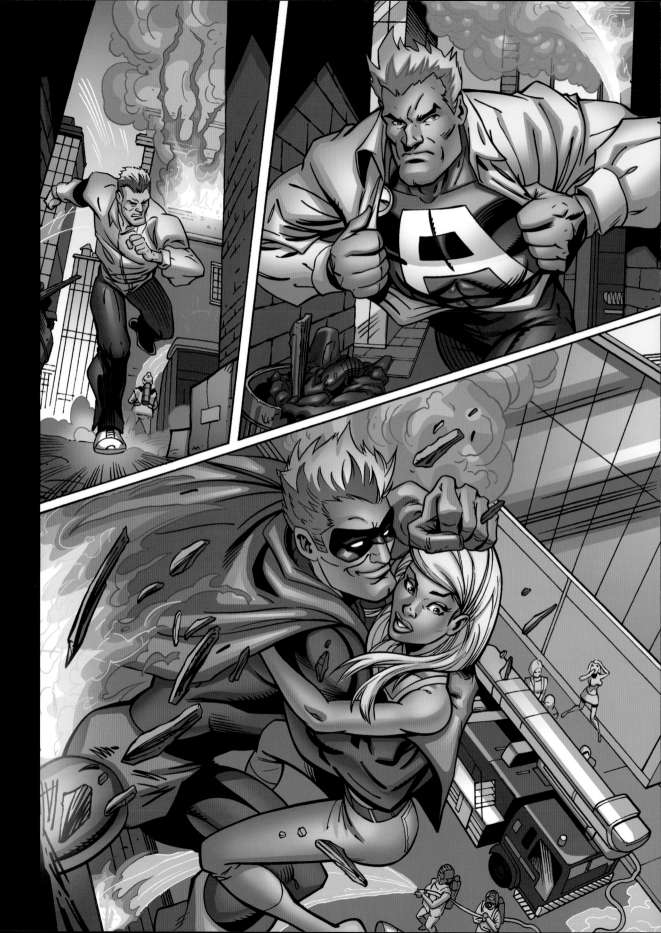

Super Aussiebum
John Royle
Advertising for "Aussiebum"
Pen and ink, colored
in Adobe Photoshop
www.johnroyleart.com
johnroyle007@hotmail.com

*Comic book art is a popular
tool for product promotion,
as artist John Royle found
when he was approached
by Australian fashion label
Aussiebum to create a
superhero to promote its new
range of "Supers" underwear.
Royle worked in pencil and
ink, with color added by James
Offredi — "A great colorist I
work with on the UK Spider-
Man comic." The end product
included ad posters for buses
and this three panel strip
for use on billboards.*

▶ **Incredible Hulk**
Carlo Pagulayan
Marvel Comics
Pen and ink, colored
in Adobe Photoshop
www.glasshousegraphics.com
antoniop@pldtdsl.net

*This powerful gladiatorial
scene sets the Incredible Hulk
in a scenario he could have
been born for, with beautifully
muted colors subduing the
complex background crowds
and making the action almost
three-dimensional. Despite a
career that only started at the
end of 2001, self-taught Filipino
artist Carlo Antonio Pagulayan
("I just copied a lot of stuff") has
already made his mark on the
US comics industry, drawing
a veritable "who's who" of the
Marvel universe.*

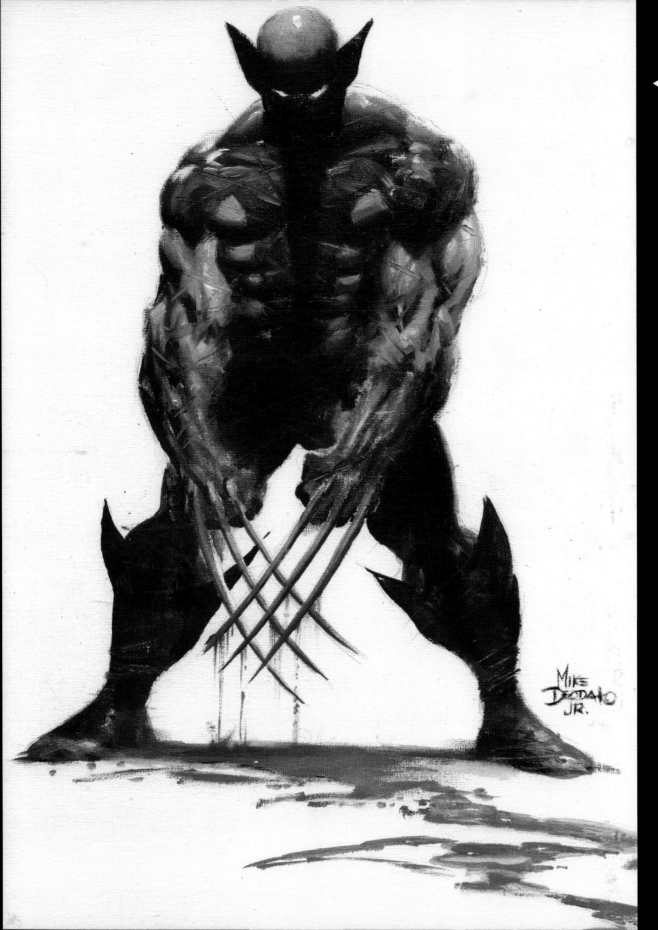

Wolverine
Mike Deodato Jr.
Marvel Comics
Oil on canvas
www.glasshousegraphics.com
mdeodato@terra.com.br

*Brazil's Mike Deodato Jr describes his comics career best, by saying "It took me a decade to become an overnight success." Having worked on almost every major US comics character and changing his style a number of times, he feels his current output blends his popular 80s style with touches of his more realistic 90s approach for "an effective, gritty look." Deodato Jr. admits a love of the X-Men's feral Canadian team member, saying "I'd love to draw the regular **Wolverine** title. I'm still in line, waiting for my shot."*

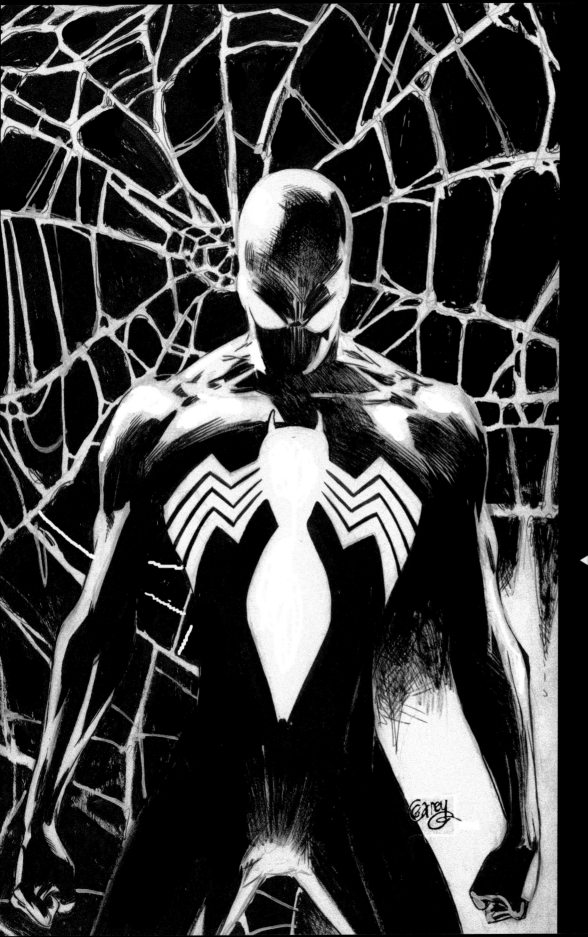

◄ **Spider-Man**
Ron Garney
Marvel Comics
Pen and ink on Bristol board
yenrag@aol.com

Unhindered by color or third-party inkers, this is a wonderful example of the sheer strength of Ron Garney's line work. A fully-rendered character shot of the new-look Spider-Man, with a highly stylized chest emblem emblazoned across his all-black costume, the superhero's coiled power is subtly portrayed through the somewhat threatening dipped head and his tightly clenched fists. The drama is enhanced further by the double lighting, employed to emphasize the musculature and push the figure from the webbed background.

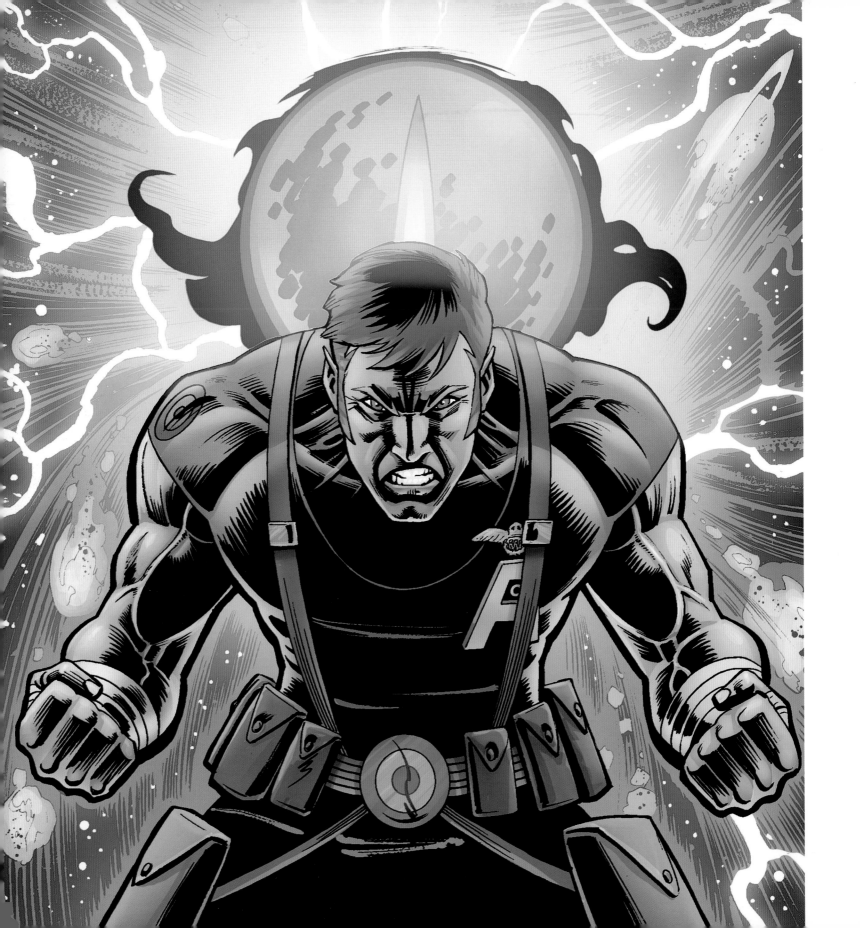

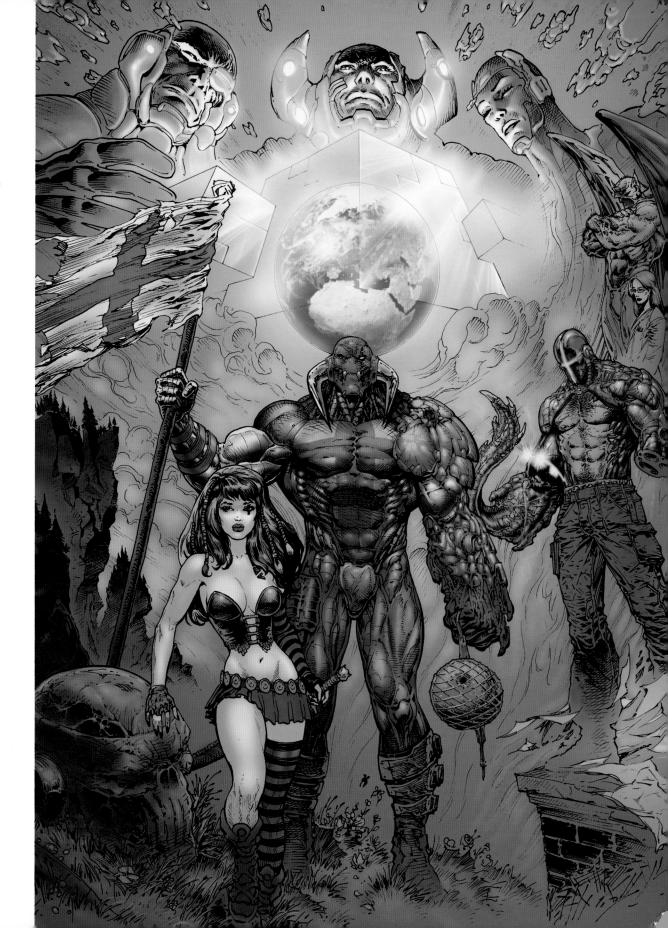

◀ **The Danger's Dozen:**
First Salvo
Norm Breyfogle
Pen and ink on Bristol board
www.normbreyfogle.com
nbreyfogle@chartermi.net

The Danger's Dozen is Breyfogle's latest project. "The cover and interior pages were first drawn at a small—but detailed—4.5 x 6.75" size, then enlarged on a photocopier to fit 11 x 17" plate finish Bristol boards. I then inked on a lightbox, using a variety of felt tip pens, dip pens, a #2 sable hair brush, and opaque white watercolor for corrections. When the original art was complete it was scanned in grayscale, altered in Photoshop, and sent for coloring by El-Taeb."

▶ **S.T.E.M. Cell**
Liam Sharp
Mam Tor
Pen and ink, colored
in Adobe Photoshop
www.mamtor.com
mamtor@mac.com

Previously unpublished, this new superhero task force is the first attempt at a mainstream title by Sharp, an artist who began his comics career with a year's apprenticeship with the legendary Don Lawrence and gained international recognition through work on WildStorm, Heavy Metal and Vertigo titles. "I have been moving steadily away from the mainstream for a decade now, and Mam Tor has given me the opportunity to explore my teenage love for the Metal Hurlant classics by Moebius, Dionnet, Druillet, Corben, and so forth. It's where my heart lies I think—with adult comics, prose and illustration."

▶ **What if..?**
Carlo Pagulayan
Marvel Comics
Adobe Photoshop
www.glasshousegraphics.com
antoniop@pldtdsl.net

*A Pagulayan cover painting
spotlighting the Hulk's warrior
bride,* **Caiera the Oldstrong***.
The artist digitally painted
this one to achieve the looming,
"ghost" image of the Hulk in the
background — thus making the
end product far more commercial
than if it solo-starred a relatively
unknown female support
character. While best known
as a layout and finished pencil
artist, he admits "Penciling is
now a full-time job, but on the
side I try to learn a few things
about Flash, 3D rendering,
coloring… anything I can
play with artistically."*

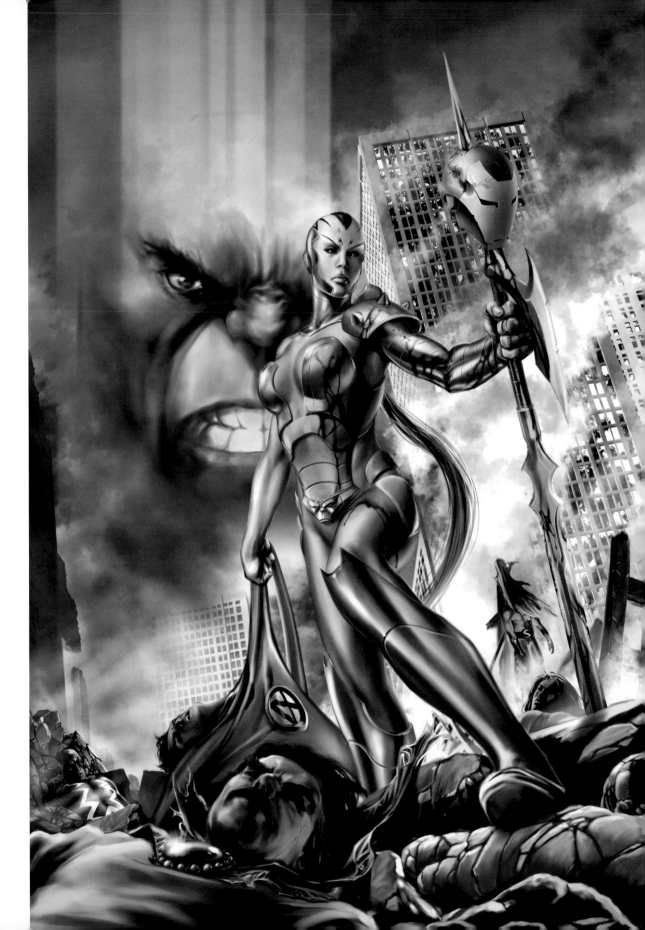

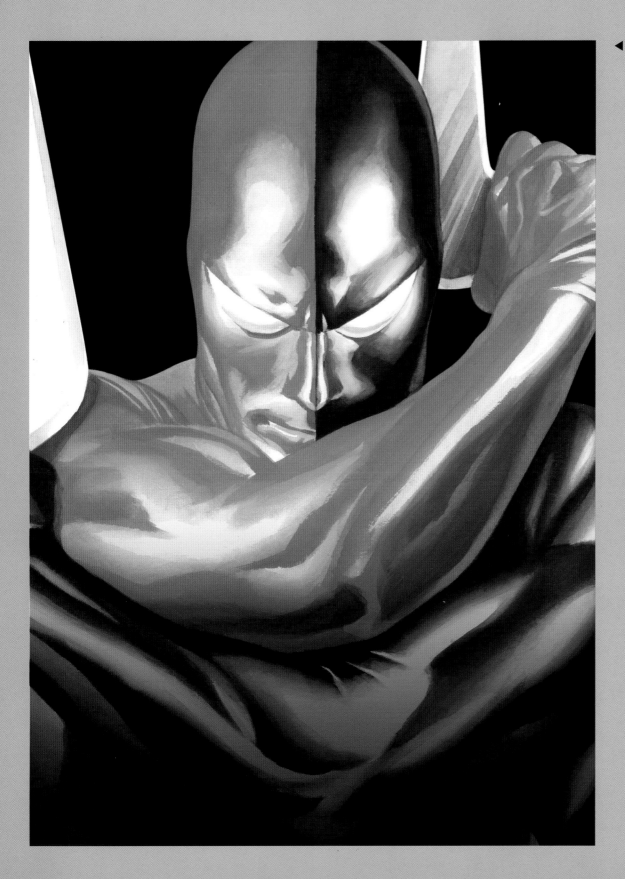

◀ **Superpowers: Devil**
Alex Ross
Dynamite Entertainment
Oils on canvas
www.alexrossart.com

With his regular comics partner,
Jim Krueger, Oregon-born artist
Alex Ross is co-scripting and
painting covers for a title set
to revive a plethora of obscure
1940s superhero characters.
Among these are the original
Daredevil—now renamed Devil
to avoid confusion with the
Marvel Comics hero. Renowned
for bringing photorealism
into comics, Ross comments
that "It just takes sitting down
with a blank piece of paper
and starting to tool out teaser
images, designs, redesigns—all
the time asking the question;
how do I illustrate these Golden
Age characters today?"

BEFORE THE DOCTOR

BEFORE BOND

GARTH

A TRUE BRITISH HERO

◀ **Garth**
Huw-J Davis
Hayena Studios
Pen and ink, colored
in Adobe Photoshop
huwj@japan.com

Garth — a time-traveling adventurer — was created by cartoonist / writer Steve Dowling and BBC producer Gordon Boshell for the national UK newspaper **The Daily Mirror** *in the early 1940s. The first three-panel strip appeared on Saturday 24th July 1943, and the series continued daily for 54 years, until March 22nd 1997. Japan/UK design group Hayena Studios has now acquired the rights to the character, to be relaunched in a series of graphic novels in Spring 2008 at the hands of co-founder Davis.*

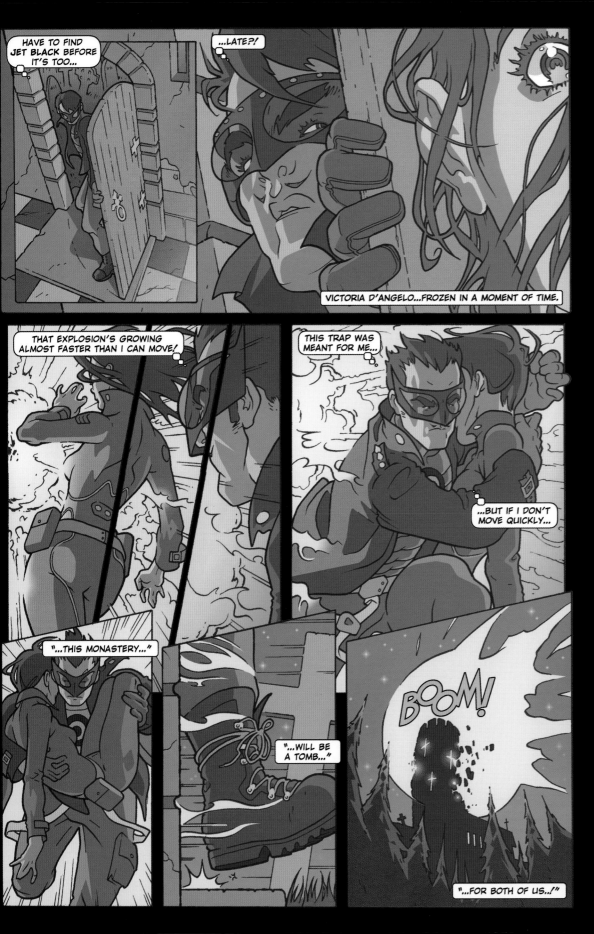

◀ **Jet Black**
Cosmo White
Pencil, felt tips, fine liners,
Adobe Photoshop
www.cosmowhite.com
cosmo.w@gmx.co.uk

As a consequence of the hero's
time-dilation abilities, the events
on this page take place during a
fraction of a second. White opted
for a large number of panels, each
showing a distinct progression
of movement/action. The text — a
single sentence streaming through
the panels — provides structure to
the sequence, and demonstrates
that, although the events take
place within a fraction of a second,
their duration is the time it takes
for the character to say the words.
"I went for some thumpingly
obvious time-saving techniques,
starting with an establishing shot,
then no backgrounds except a big
explosion, plus visual shorthand
to get the characters from inside
to outside!"

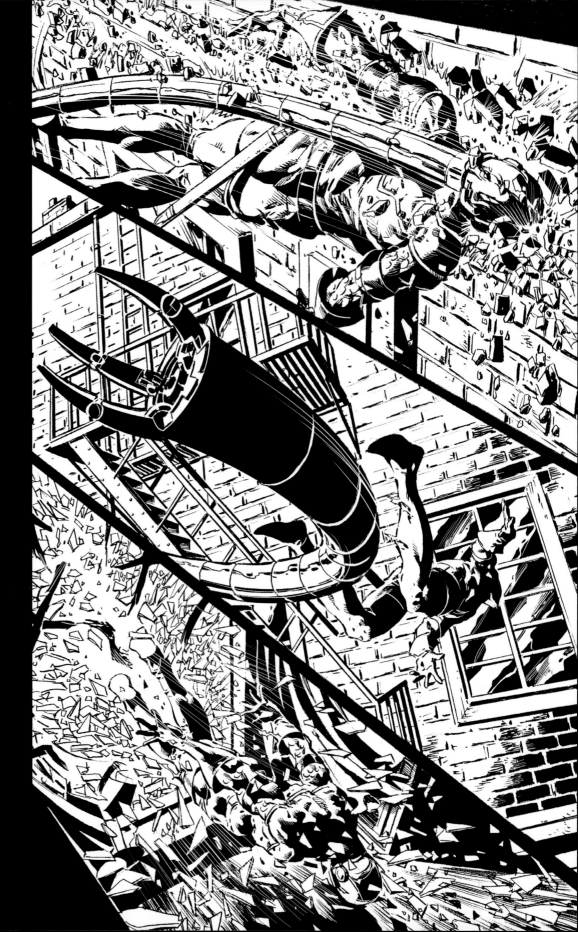

▶ **Thunderbolts**
Mike Deodato Jr.
Marvel Comics
Pen and ink on Bristol board
www.glasshousegraphics.com
mdeodato@terra.com.br

*Before working for the US
market, Brazil's Mike Deodato
Jr. was used to producing both
pencil layouts and finished
inking, creating artwork for
black-and-white titles that
did not rely on color to fill the
gaps. This page is a wonderful
example of his style, with a
strong chiaroscuro feel in its
harsh contrast and minimal
outlines. Being one man's unique
vision rather than a team effort,
the spontaneity of his inspired
layout and extreme action is
not lost through diverse hands
diluting the initial concept.*

▶▶ **The Silver Surfer Strikes**
Michael Golden
Marvel Comics
Pen and ink, colored
in Adobe Photoshop
www.evaink.com
evaink@aol.com

*Michael Golden is best known
for a unique art style that
is at times incredibly detailed,
but at others amazingly
streamlined — cutting away
the excess and maintaining
the true essentials of a piece.
For this seemingly simple
action shot, Golden has
combined classic superhero
poses and basic line work
for the main characters, with
contemporary Photoshop-
rendered backgrounds and
movement effects giving the
end product an almost three-
dimensional appearance.*

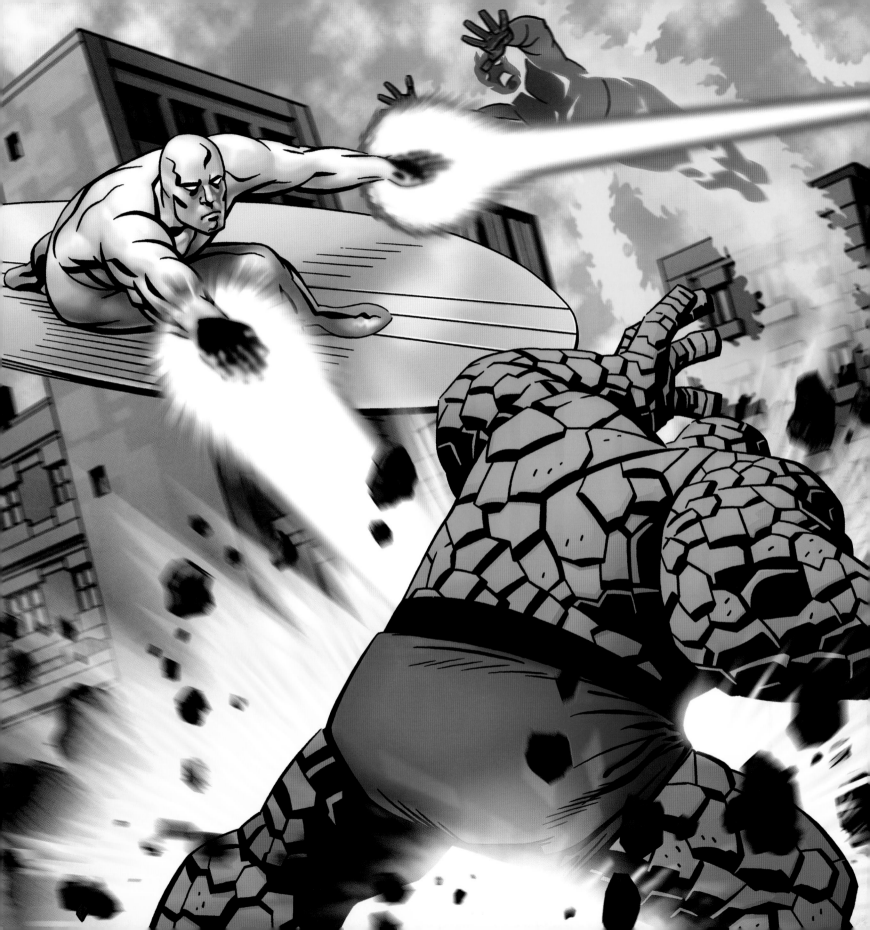

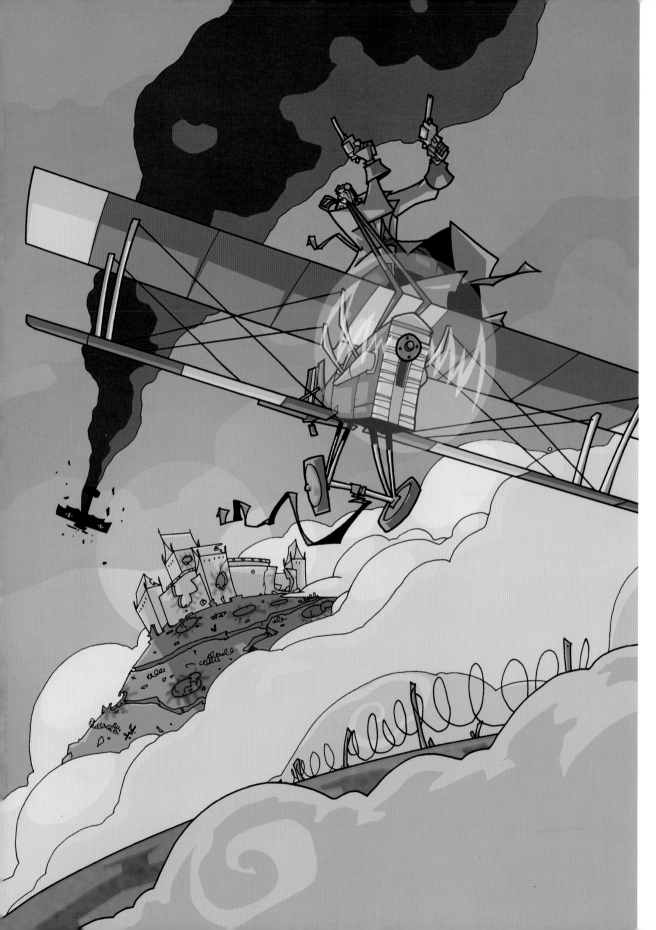

◄ **The Crimson Todger**
Dan Boultwood
Pen and ink, colored
in Adobe Photoshop
baronvonbloodshrimp@gmail.com

Dan Boultwood's unique
style — almost always colored in
pastel shades — has made his art
instantly recognizable in a sea of
uniformity. Invariably working
on indie titles, Boultwood and
writer Tony Lee's euphemistically-
named parody, **The Crimson
Todger**, is set to appear in their
equally eccentric **Dashing Tales
for Young Chaps Almanack**.
Here, The Crimson Todger will
join Doc Chronology and his
Time Travelling Armchair,
Digger Hole — the Australian
Archeologist, and Penny Pink —
She is a Girl and Therefore
Alien to Us.

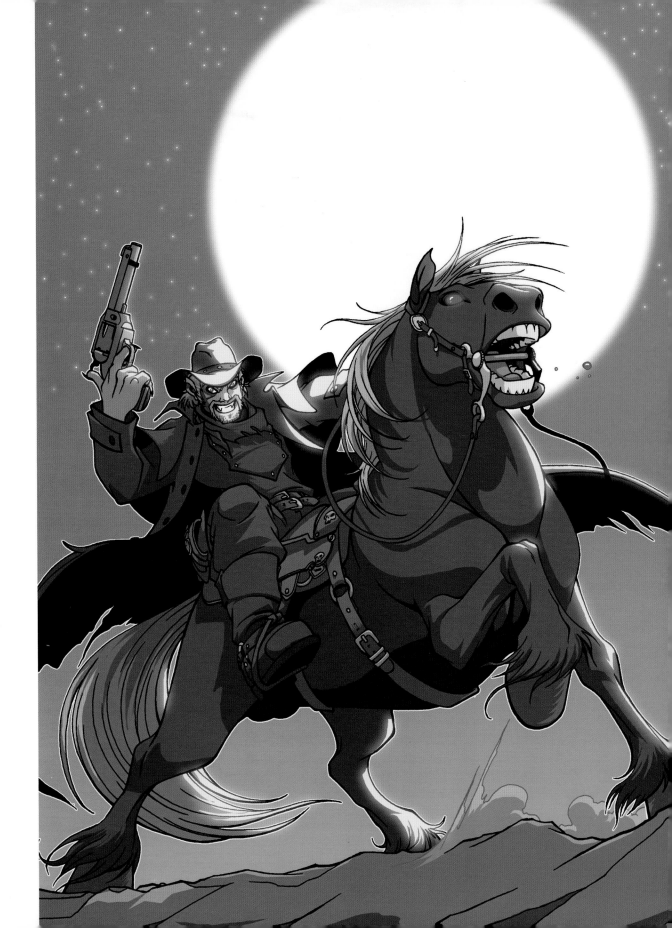

▶ **The Demon Outlaw**
Jack Lawrence
Pen and ink, colored
in Adobe Photoshop
www.jackademus.com
jack@jackademus.com

*Jack Lawrence is an animator
turned comics artist who burst
onto the scene in 2002 with his
UK manga style of art. On **The
Demon Outlaw** he comments,
"I've had it in my mind for a
while to do a western. I'm a
sucker for all genres; science
fiction, horror, fantasy, etc., but
I think the western has fallen by
the wayside. Obviously, there's
a little bit of the supernatural
about this concept, but all the
gunslinging and saloon stuff
would be in there." Lawrence
drew the horse using a
beautifully sculpted child's toy
as reference, but adds that
"getting the gun right was
the biggest problem. So I just
bought a replica Peacemaker
and drew straight from that."*

▶▶ **Thug**
Jack Lawrence
Portfolio piece
Pen and ink, colored
in Adobe Photoshop
www.jackademus.com
jack@jackademus.com

*Lawrence admits that this
"hard man with a heart of
gold" was really just a chill-out
piece, but tieing into the school
setting concept that he loves. He
touched on the idea in his first
professional work, **Darkham
Vale**, but would love to produce
a story revolving around a group
of school or college students.
"I've always thought there's
something really cool about
school uniforms. I loved being
at school, and I loved wearing
the uniform. Incidentally, this
guy's wearing my old school tie."*

▶ **The Gloom**
Dan Boultwood
Pen and ink, colored
in Adobe Photoshop
baronvonbloodshrimp@gmail.com

*The wraparound cover art
for the first collection of **The
Gloom** — an avenging angel
for 1940s Manhattan! When
millionaire playboy Carson Kane
is given two silver pistols by the
Angel of Vengeance, he takes
to the streets at night to fight
evil as The Gloom. Pulp noir
that shamelessly borrows every
adventure cliché from Golden
Age radio and print, dressed
up in an art style that's best
described as "Looney Tunes
meets The Shadow."*

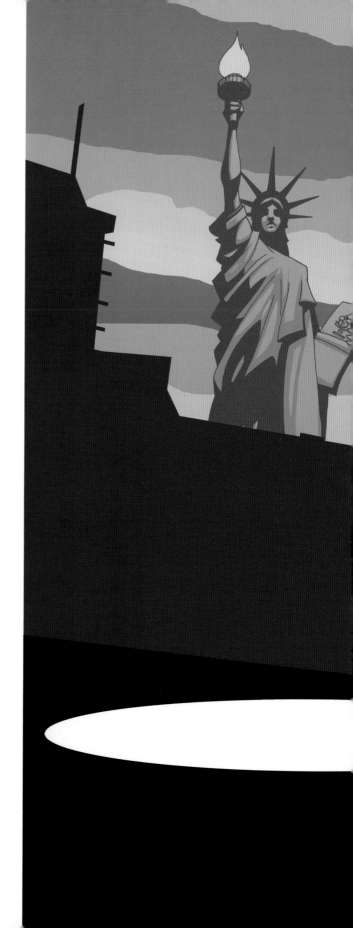

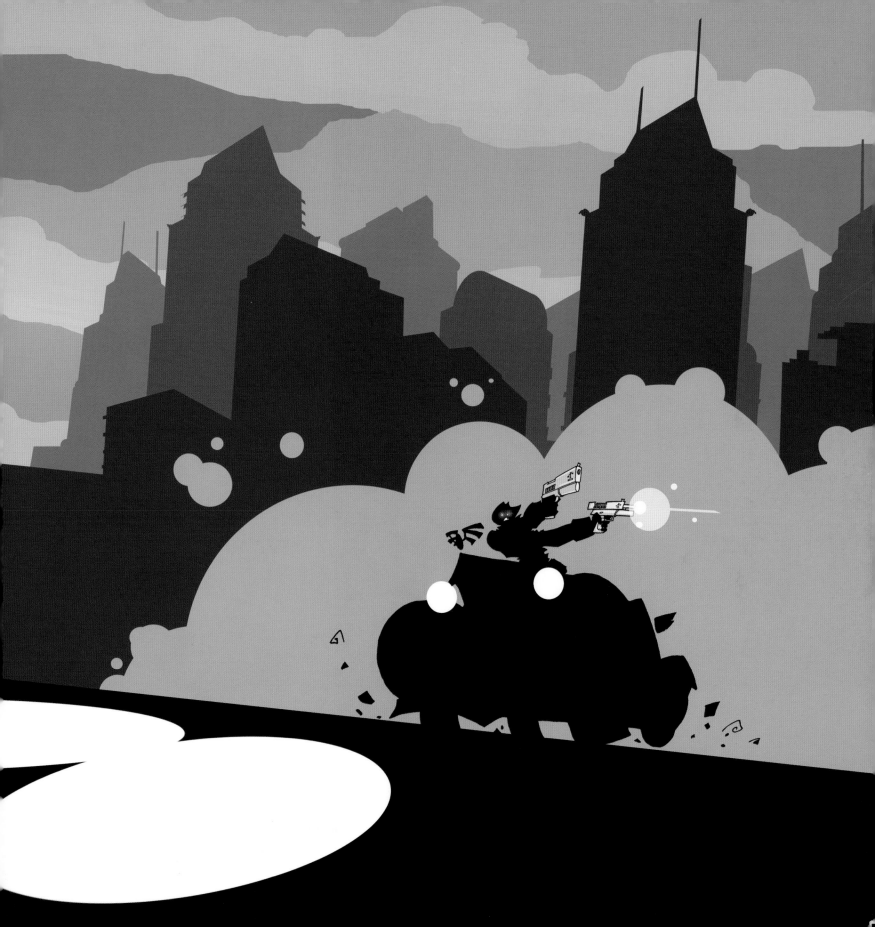

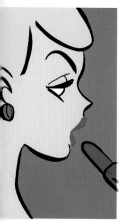

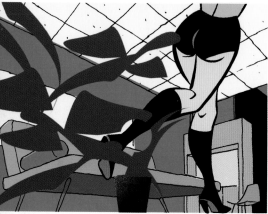
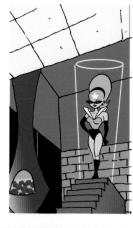

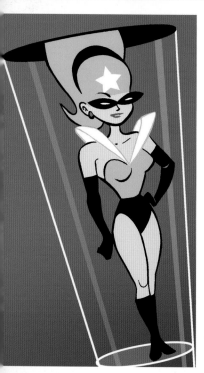
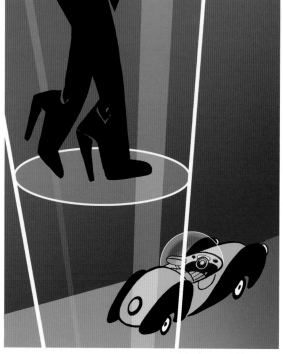

◀ ▶ **Lass Vegas:**
Rockets and Cocktails
James Hodgkins
Olive Press
www.olivepresscomics.net
james.hodgkins@gmail.com

Better known as an inker, Hodgkins recently showed his abilities as a writer/artist when he produced his cynical, but fun observations of a barfly in **I Drink, Therefore I Am** *for his own Olive Press anthology* **Your Round Presents: Tequila.** *He is now set to publish his 1960s retro-romp* **Lass Vegas** *as a three-issue miniseries (scheduled for 2008) which he is both writing and drawing. "Having only made the leap to digital art in the last couple of years, I'm amazed how it's revolutionized my approach to work. It's incredibly liberating— plus I make a lot less mess on the carpet!"*

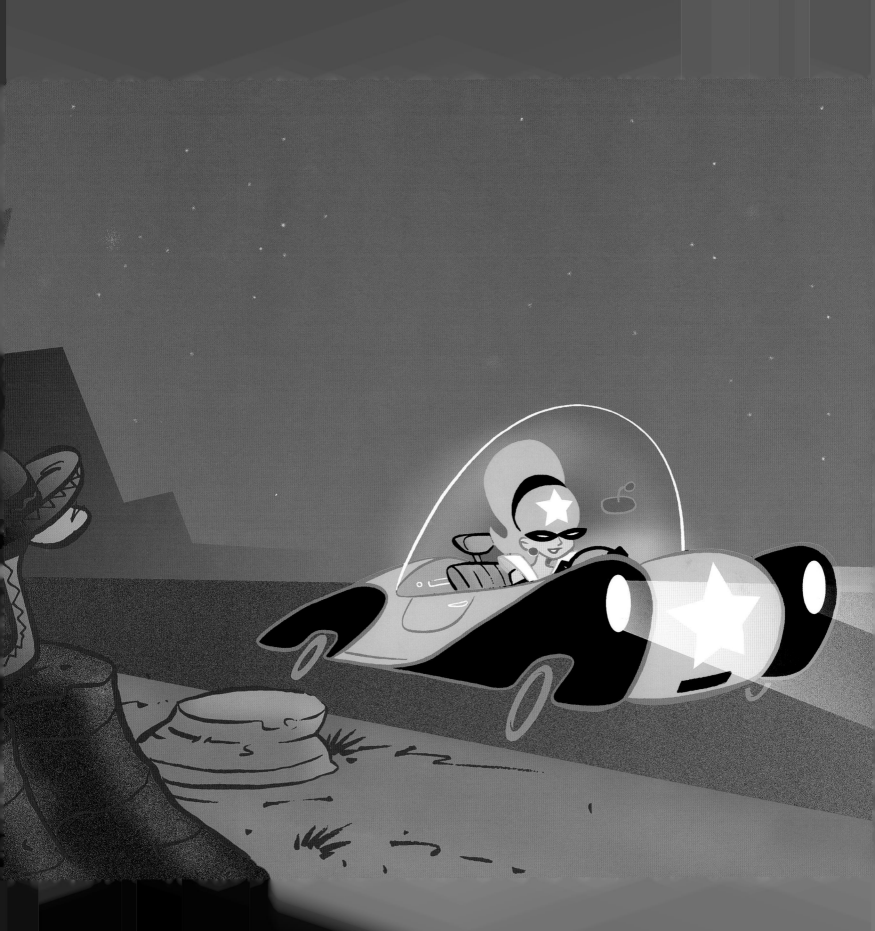

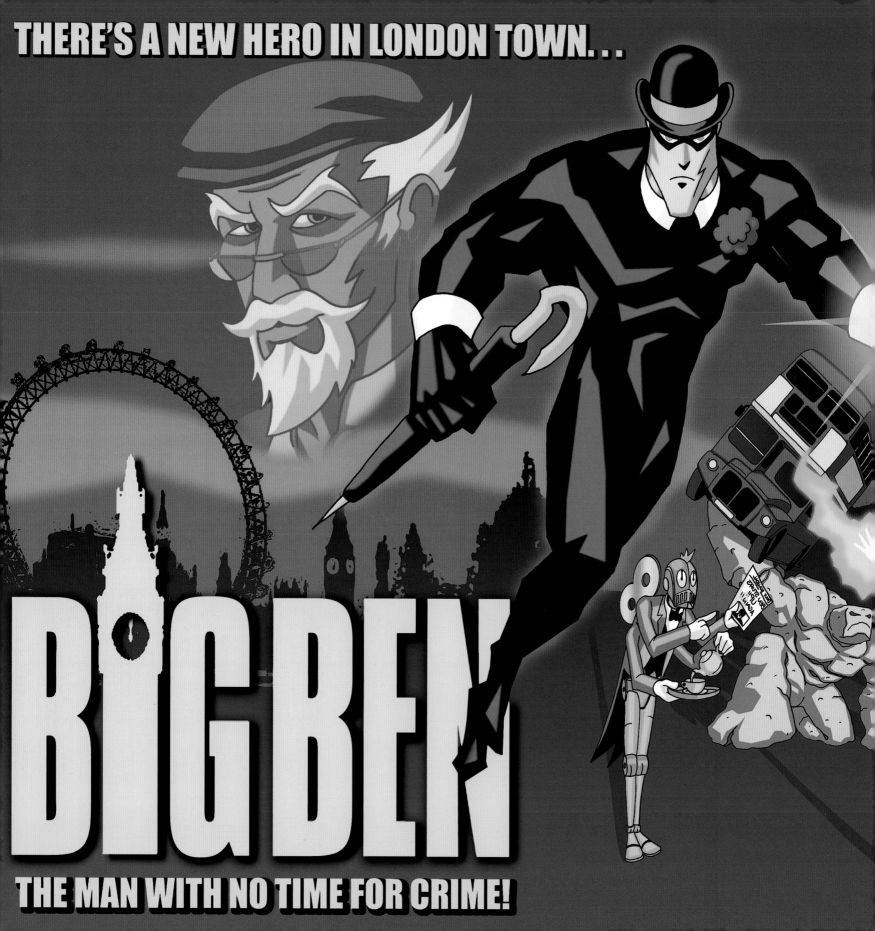

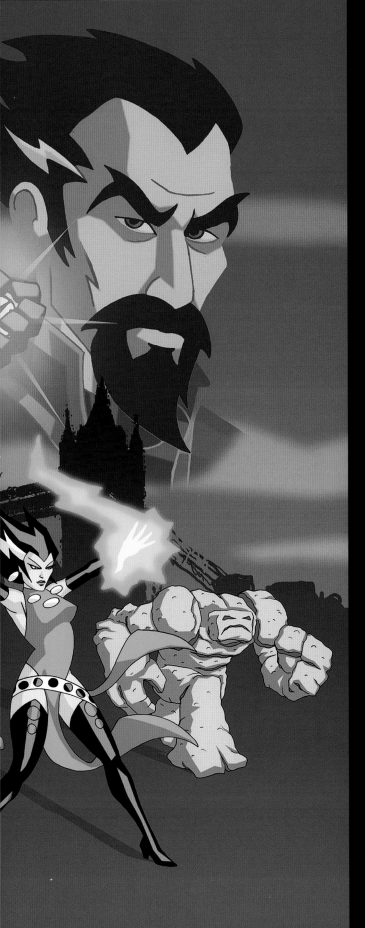

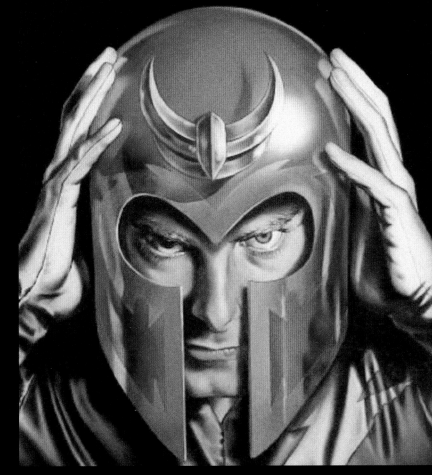

◀ **Big Ben**
Ian Peterson
Quality Communications
Pencil, colored in
Adobe Photoshop
www.idpeterson-art.com
peterson100@btinternet.com

*Created in the mid-1970s and revamped in the 80s, **Big Ben** is currently going through a third reincarnation, this time in the hands of Ian Peterson — an illustrator who usually produces photo-realistic fantasy art. "I realized this was a fantastic chance to take a character from an almost realistic rendering into the realms of full blown cartoon. As the sketches progressed, it became obvious that Big Ben had been a perfect cartoon character all along."*

▲ **Magneto: Son of M**
John Watson
Marvel Comics
www.johnwatsonart.com
watson904@btinternet.com

You can see this character is a villain, even if you don't recognize him. The visual shorthand to convey this goes beyond the slight snear on Magento's lips, with your attention being drawn to the eyes. Heroes never look through their eyebrows as it's far too menacing to reassure those they seek to protect. Of this actual art, Watson says "It's a simple, but effective composition. I'm happy I managed to make the helmet look quite authentic—for reference I spray-painted my old football helmet red."

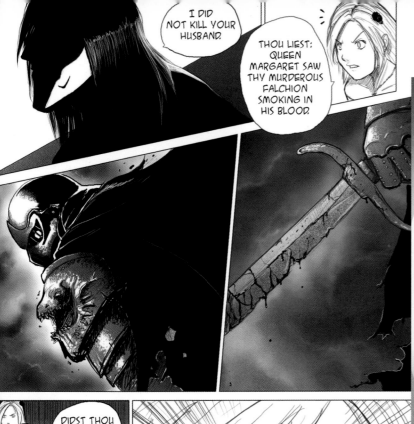

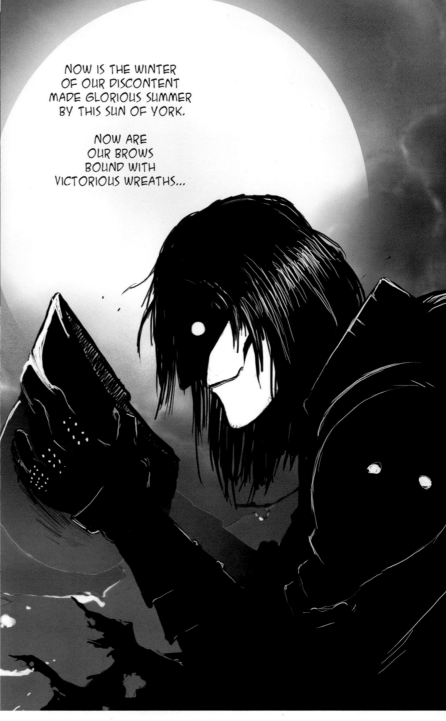

◀ ▶ **Richard III**
Patrick Warren
SelfMadeHero
Pen and ink, colored and tinted in Adobe Photoshop
mrmetallium@gmail.com

Patrick Warren is currently studying Animation at London's University of Westminster. Winner of Tokyopop's first "UK Rising Stars of Manga" competition, his influences include manga artists such as Hiroaki Samura and Tite Kubo. His favourite Western artists are Sin City's Frank Miller and his father, Paul Warren. **Richard III** *is Warren's first full-length illustration work and, unsurprisingly, he found it quite a challenge. "I had to juggle college work during the day with illustrating a full-length graphic novel during the night—which meant zero sleep for about 6 months! Even so, it was great fun to draw a villain-centered story set in a dark and gritty England."*

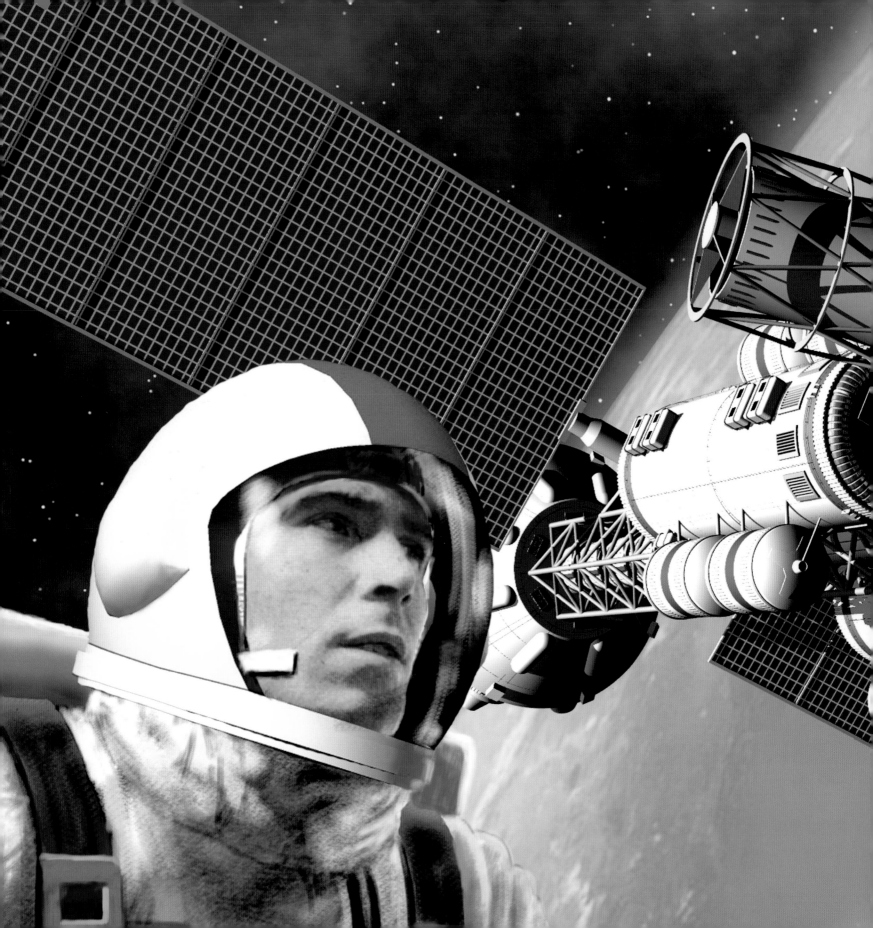

CHAPTER 2
SCIENCE FICTION

◀ **Alternate Earth**
John Ridgway
Computer-generated using
Pov-Ray (Persistance of Vision
Raytracer) and Adobe Photoshop
john@ridgwaydesign.fsnet.co.uk

*Ridgway's Alternate Earth
takes the hero to a parallel world
populated by prehistoric animals,
beast-men and fantastical cities.
It is told using modern CGI
techniques so it becomes visually
familiar to audiences who have
grown up watching Star Wars
and The Lord of the Rings —
"all made possible by the vast
improvements in home computers
and cutting-edge 3D programs".*

▶ **Starship Troopers**
Neil Edwards
Markosia
Pencil and ink, Macromedia
Freehand, Adobe Photoshop
www.thebristolboard.blogspot.com
neiledwards342000@yahoo.co.uk

*A great behind-the-scenes example
of a comic illustration's creation.
This is a page from **Starship
Troopers** in both Edwards'
original finished pencil form and
how it was finally presented to
the public—inked by John Feeney
and colored by Wes Hartman.*

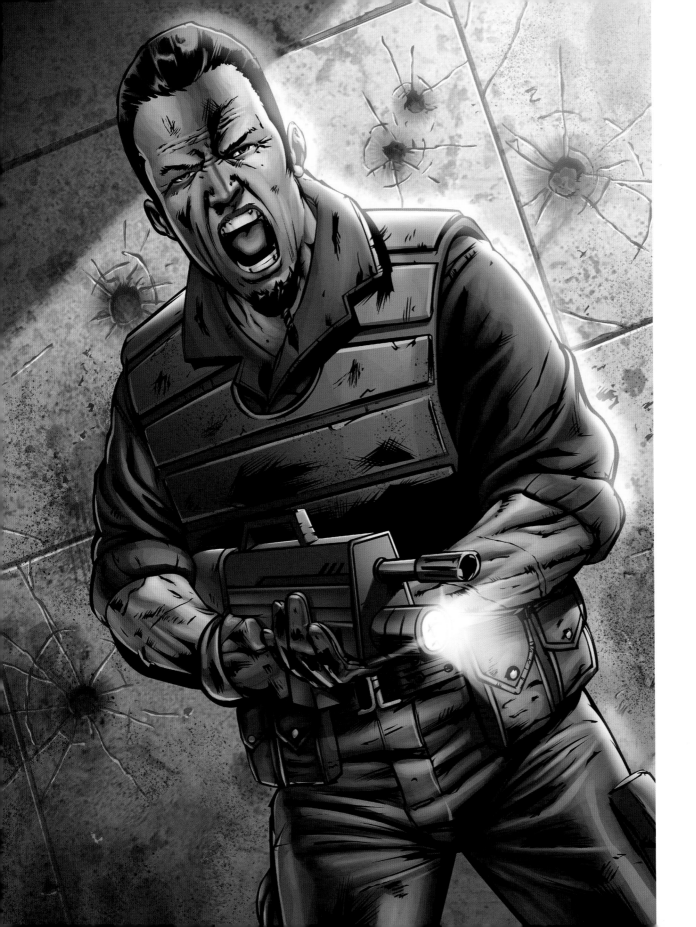

▶ **Codename: Liberty Rocket**
Matt Haley
Rift Software
Corel Painter 9 and
Adobe Photoshop
www.matthaley.com
matt@matthaley.com

Taking full advantage of modern
software, but with a retro feel that
harks back to the deep and moody
*Fleischer Studios' **Superman***
cartoons of the 1940s, this is
a promotional illustration for
*Haley's forthcoming **Codename:***
***Liberty Rocket**. The project is to*
be released as both an Xbox 360
game and a comic book, taking
advantage of the links between
the two markets. In addition to
solo production of the finished
artwork, all the characters have
been designed by Haley, who
describes it as "very much a fun
1950s pulp sci-fi adventure."

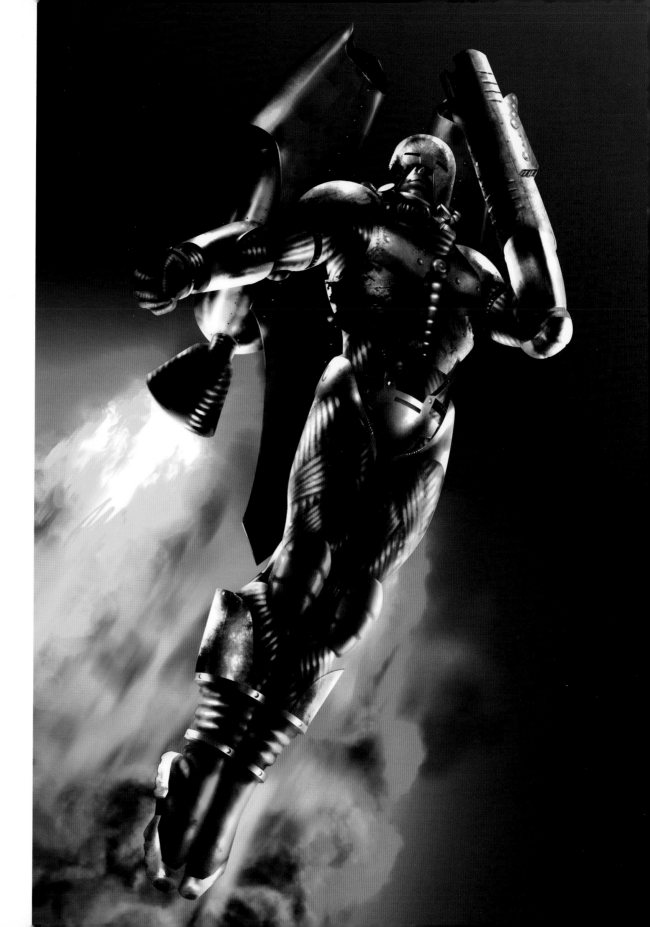

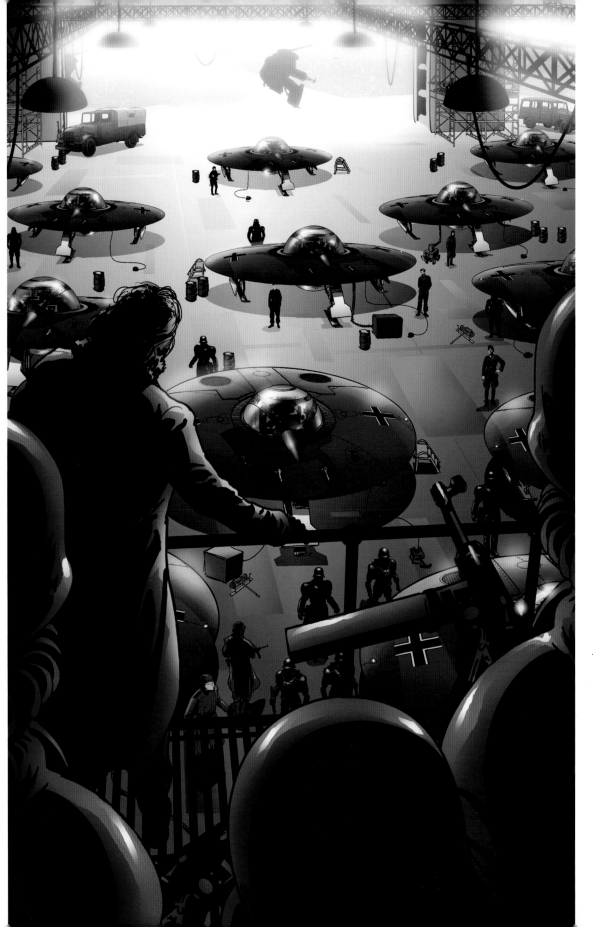

◀ **G.I. SPY**
Matt Haley
Corel Painter 9 and
Adobe Photoshop
www.matthaley.com
matt@matthaley.com

*G.I. Spy is a new comic Haley
is drawing from scripts by
Eureka TV series creator Andrew
Cosby. With its classic cinematic
feel and rich colors, Haley sums
up this highly charged all-age
boys' adventure as "an Indiana
Jones/James Bond mix, with lots
of German flying saucers!"*

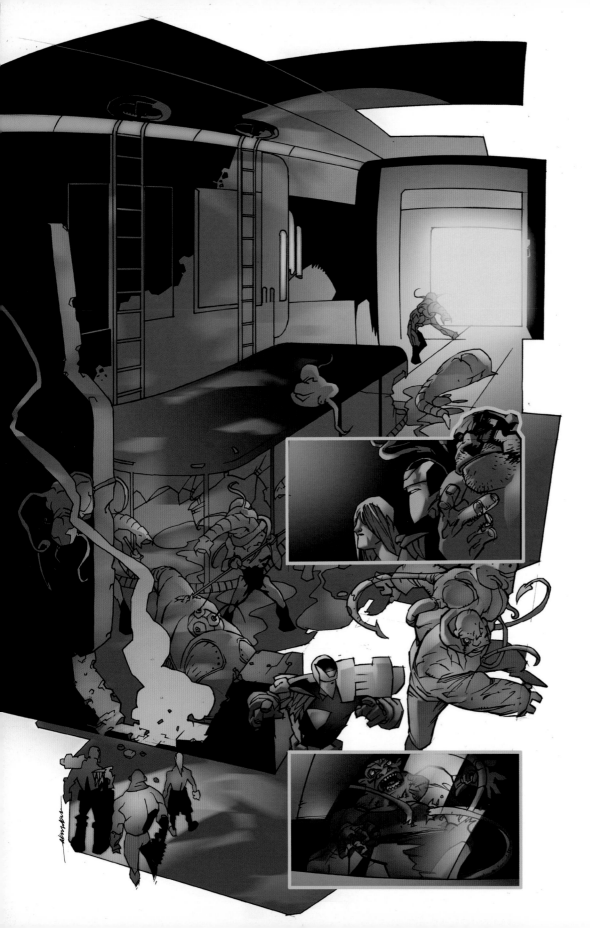

◀ **Judge Dredd: Meat Mongers**
Siku
2000 AD
Pen and ink, colored
in Adobe Photoshop
www.theartofsiku.com
siku@theartofsiku.com

*Siku says of this stunning page;
"My time with UK weekly
2000 AD gave me the freedom
to experiment with layouts—
my training in graphic design
is probably responsible for my
desire to 'push the boundaries.'
Some were effective, others were
a shambles. This is one that I
think worked a charm!"*

▶ **Skreech! Crash!**
Siku
2000 AD
Pen and ink, colored
in Adobe Photoshop
www.theartofsiku.com
siku@theartofsiku.com

*Since the days of the camp
Batman TV series, sound effects
have generally been considered
demeaning to the comics
industry, but artist Siku glories
in their use. "Why shouldn't
typography interact with the
scene? In scripts they are labeled
'SFX' as in 'sound effects,' but
too often in comics they are used
almost as an afterthought. I love
typography and I see it as an
extension of the narrative."*

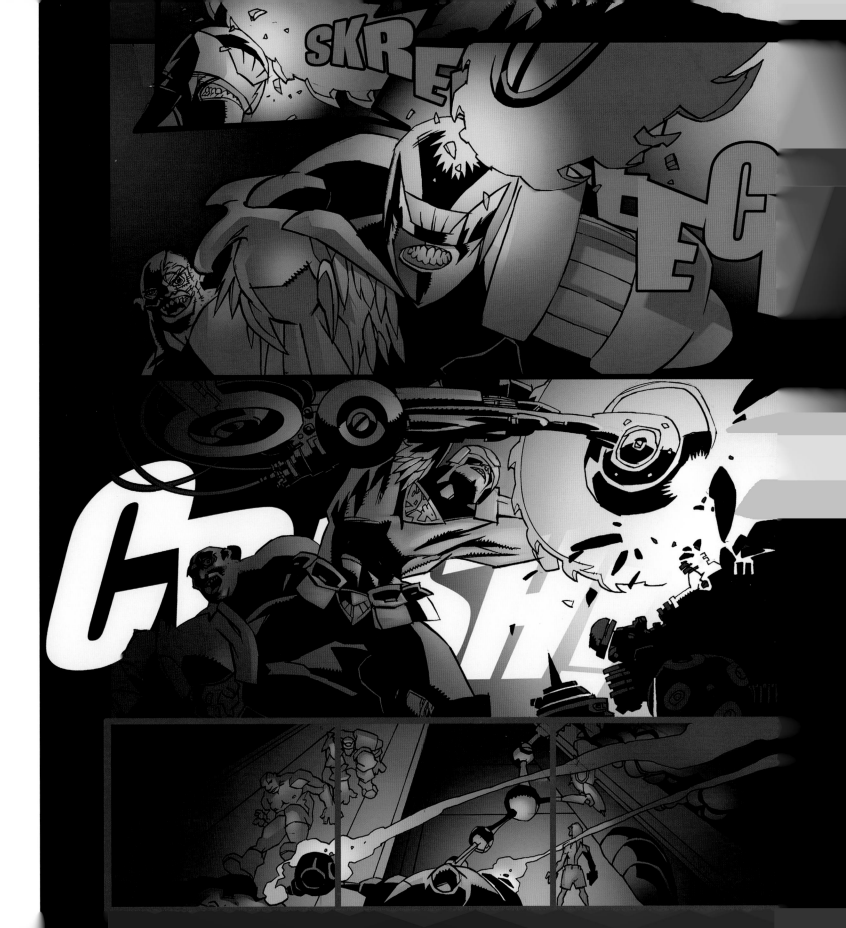

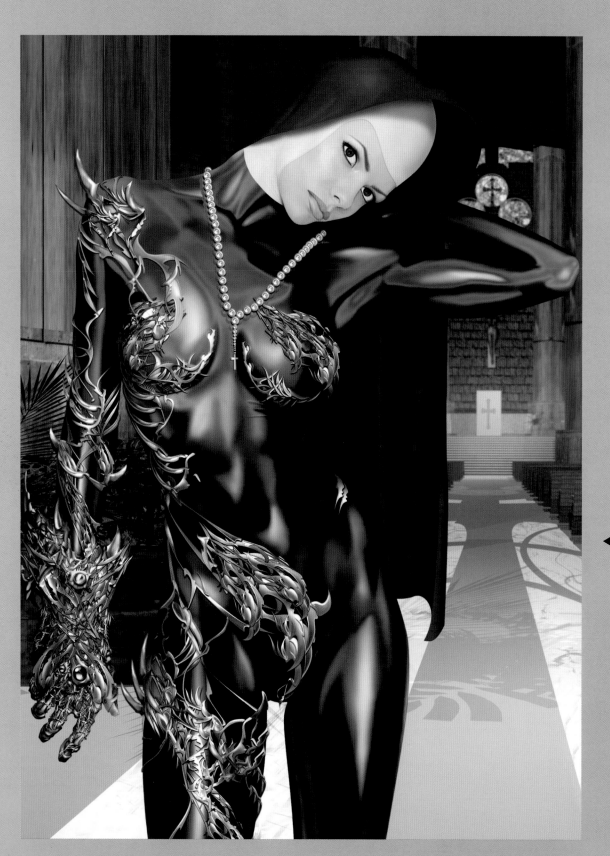

Nunblade
Rick Van Koert
Bryce and Adobe Photoshop
www.4f-creations.com
rikof@xs4all.nl

Netherlands-based Van Koert specializes in digital painting. His uniquely-styled covers bring skin-tight costumes and a photo-reality to his characters that is totally different to any other comic book cover artist.
A perfectionist when it comes to detail, Van Koert says "my Achilles Heel, as you might call it, is that I'm always far too optimistic about when an image could be ready. I guessed 5-6 days for this reworking, but it's way beyond that now."

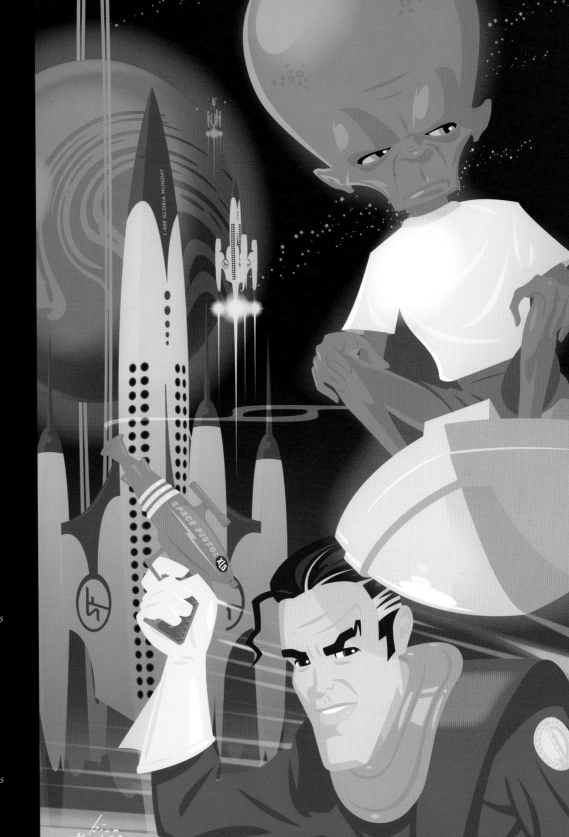

▶ **Dan Dare**
Rian Hughes
Yesterday's Tomorrows art card
Adobe Illustrator
www.devicefonts.co.uk
RianHughes@aol.com

*In addition to being a highly
respected artist, Rian Hughes
is first and foremost a designer.
Fortunately for the comics
industry, he is a designer who
happens to have a passion for
comics. This visual was recently
produced as one of four art cards
that accompanied* **Yesterday's
Tomorrows***, a case-bound,
limited edition book of Hughes'
work, collecting (among other
strips) the* **Dare** *serial he created
with writer Grant Morrison in
1990. He remarks how "It was
interesting to revisit characters
that I'd originally drawn using
pre-digital tools—ink, paint and
marker pen—and bring new tools
(i.e. the computer) to bear."*

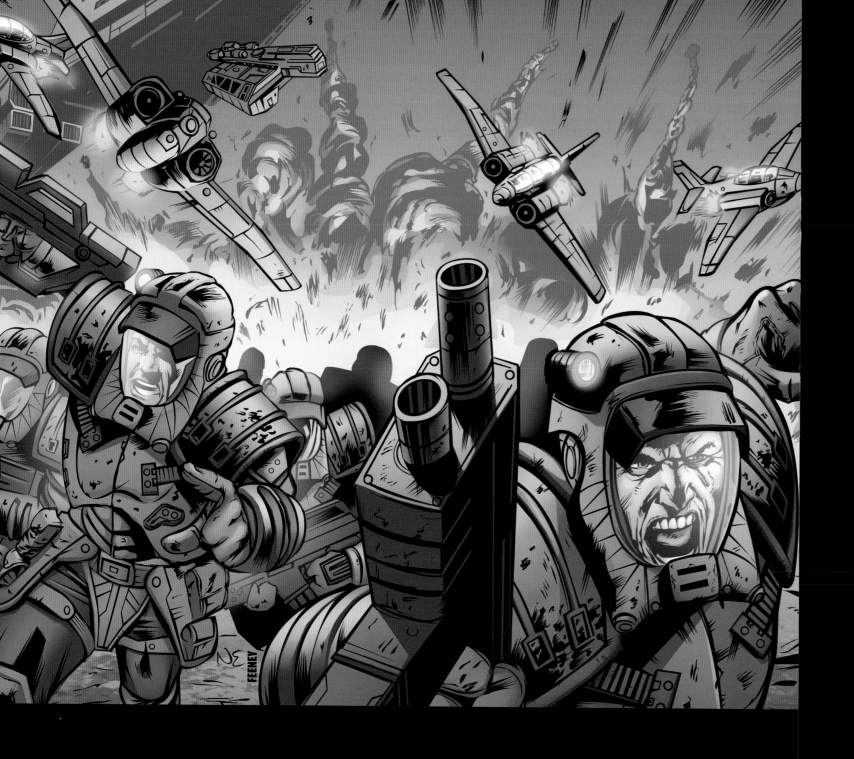

◄ **Starship Troopers:**
Dead Man's Hand
Neil Edwards
Markosia
Pencil and ink, Macromedia
Freehand, Adobe Photoshop
www.thebristolboard.blogspot.com
neiledwards342000@yahoo.co.uk

*This piece started life as a
traditional portrait-shaped cover,
but as it was the finale to a series
Edwards suggested to his editor
that "Maybe it would be cool to
go out with a bang and produce
a full wraparound cover?"
When the idea was approved he
produced the finished landscape-
shaped artwork (with inker
John Feeney and colorist Wes
Hartman)… which was promptly
cut in half and made into two
separate front cover variants!*

▶ **Meta-Physix:**
The Ultimate Transformation
Andrew Wildman
www.wild-ideas.co.uk
andrew.wildman@wildfur.net

Meta-Physix *is Wildman's new
project about giant, time-traveling
robots. But it is also a story about
the environmental, social, and
spiritual crisis facing the human
race in the 21st century and
beyond. Combining the extreme
hardware of* **Transformers** *with
the time-spanning mystery of*
Doctor Who, *Meta-Physix is a
story of the evolution of the human
spirit with identifiable characters
and very big robots!*

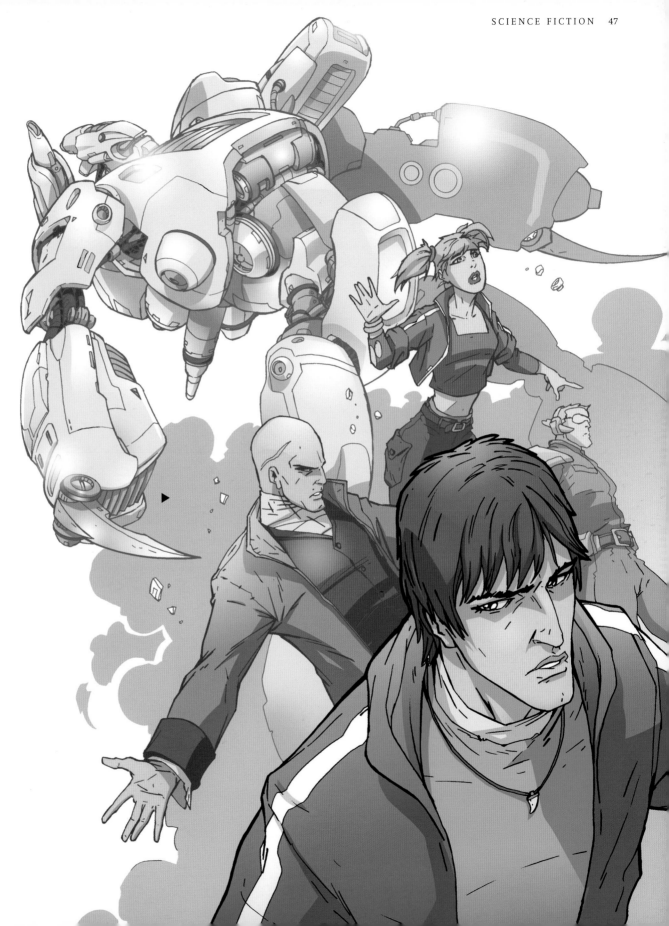

▶ **Making a New Friend**
Paul Cemmick
Acrylic, watercolor and
Adobe Photoshop
www.paulcemmick.com
mail@paulcemmick.com

*This image was used for an
article about how to write
a science fiction short story.
Spoofing TV's* **Pop Idol***,
it was entitled* **Pulp Idol***,
so the commission was for
an old-style pulp fiction look,
but with a touch of humor
to reflect the tone of the article.*

The Danger's Dozen
Norm Breyfogle
Pen and ink, colored
in Adobe Photoshop
www.normbreyfogle.com
nbreyfogle@chartermi.net

*"The high energy and complexity
of the action depicted made
this page a real challenge and
a pleasure to draw," says artist
Norm Breyfogle of this involved
page, containing a veritable
army of figures. Once Breyfogle
had pencilled and inked it, the
colorist (Gabe El-Taeb) chose to
work on three levels: using full
color to project the foreground's
main protagonists, brown tints
to flatten the middle panel's
background, and pale blue to
hold the midground characters
in place. A less experienced
colorist—using Photoshop's full
color range—could have totally
ruined this page.*

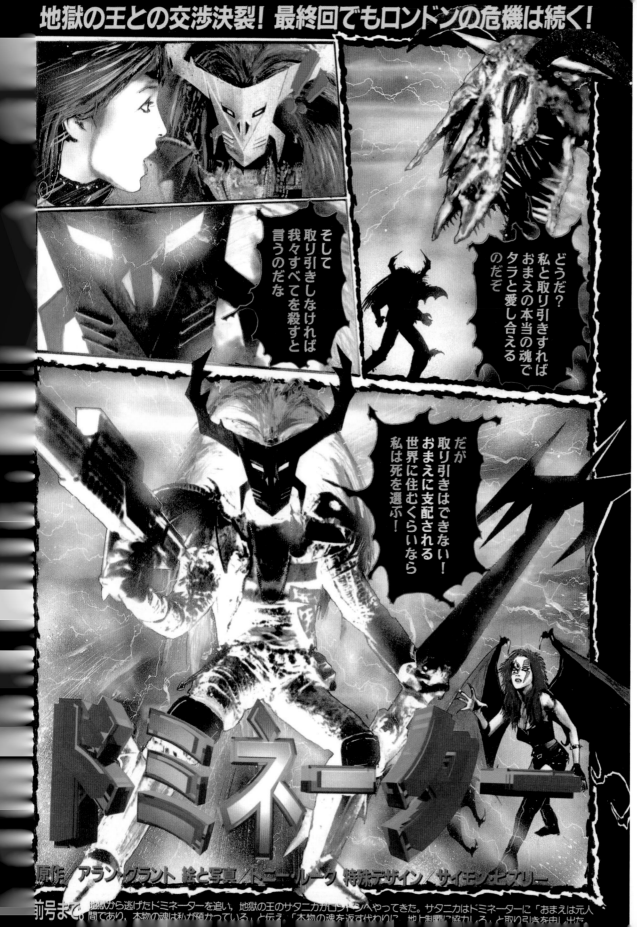

Dominator

Tony Luke
Comic Afternoon
www.rengamedia.com

A trained stop-motion animator, Tony Luke stepped sideways into comics during the industry's mid-90s boom, bringing his manga and anime influences with him. The original version of *Dominator* was a bi-weekly, black-and-white photomontage strip, running in rock mag *Metal Hammer*. When Luke was offered a manga series by Japanese publishing giant Kodansha for their million-selling *Comic Afternoon* title he revamped Dominator in full color, with top editor Hiro Morita (recently of "Akira") overseeing the project.

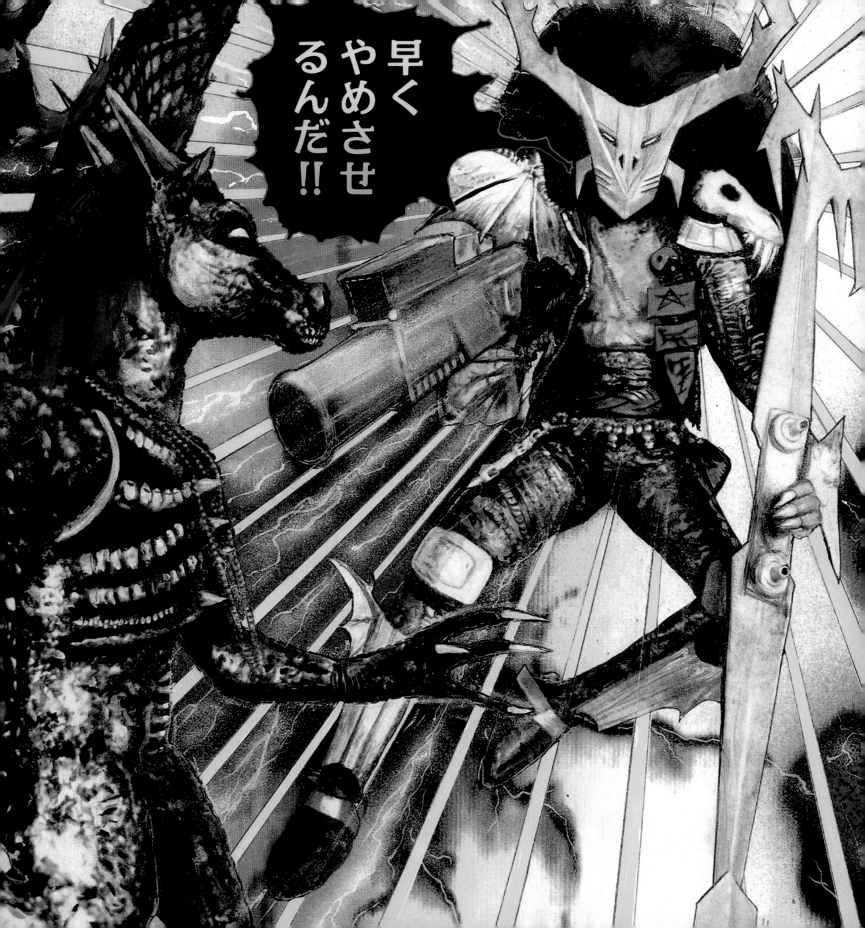

Judge Dredd
Siku
2000 AD
Autodesk 3DS Max and
Adobe Photoshop
www.theartofsiku.com
siku@theartofsiku.com

Weekly **Judge Dredd**
*narratives are especially suited
to decompression and dramatic
lighting, allowing the fascist
future cop's dark, brooding
world to burst through. Siku's
composition is highly stylized,
but the artist comments that
he could not have realized the
"floating screens" without a
3D program. Here, he used
Autodesk's 3DS Max software
to create the geometry and
textures. When rendered as
a Targa file its background
is transparent, allowing
the glowing images to be
superimposed over regular
artwork. To complete the
spread, the 3DS Max image
was imported into Photoshop.*

▼ **Game Grrls**
Duncan Fegredo
Edge magazine
Pen and ink, colored
in Adobe Photoshop
www.fatotto.nildram.co.uk
fegredo@nildram.co.uk

*Created for an article in
Edge magazine about the
(mis)representation of women
in computer games, Fegredo's
visuals are his take on various
game stereotypes.*

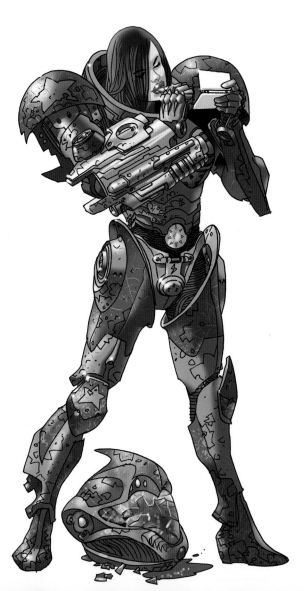

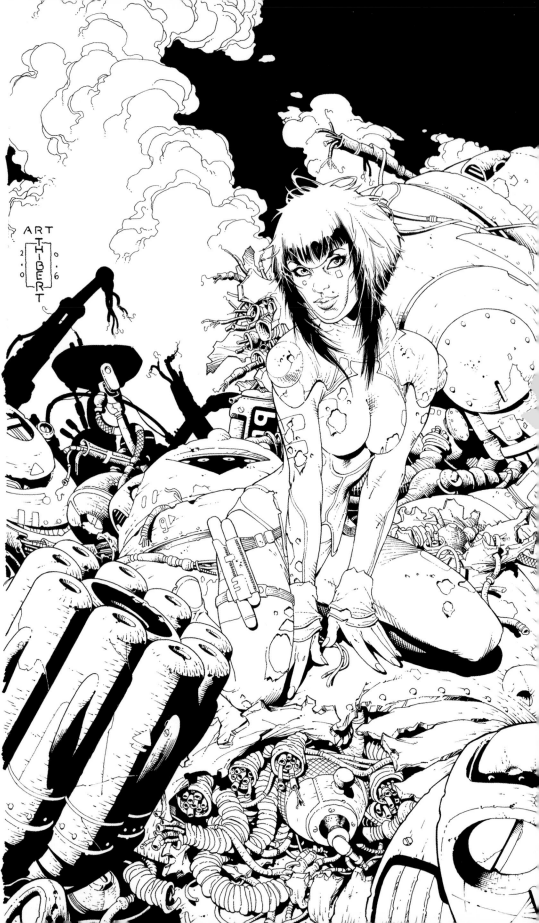

Black & white
Art Thibert
Pencil and ink
www.hackshackstudios.com
hackshackstudios@sbcglobal.net

Art Thibert rose to prominence
through his work on Marvel's
X-Men titles, before joining
breakaway publisher Image to
produce his cult US comic book
Black & White. This visual is
taken from his current revamp
of **Black & White** and shows
co-star White sitting pretty in a
mass of mayhem. When released,
Thibert says the book will be
"New and improved, and will
have something for everyone—
espionage, undiscovered
civilizations, highly advanced
robotics, heroes, and a hot
chick in a battle suit."

► **Lilly MacKenzie and the
Mines of Charybdis**
Simon Fraser
Pen and ink, colored
in Adobe Photoshop
www.simonfraser.net
si@simonfraser.net

One of the printed comic's
biggest foes in the 21st century
is not a costumed supervillain,
but the internet, as artists—
often frustrated by editors'
restrictions—are finding new
freedom by posting their work
online. With Gary Caldwell
helping him on coloring, Simon
Fraser is both writing and
drawing **Lilly Mackenzie** as
a webcomic. The story can be
seen at www.lillymackenzie.com.

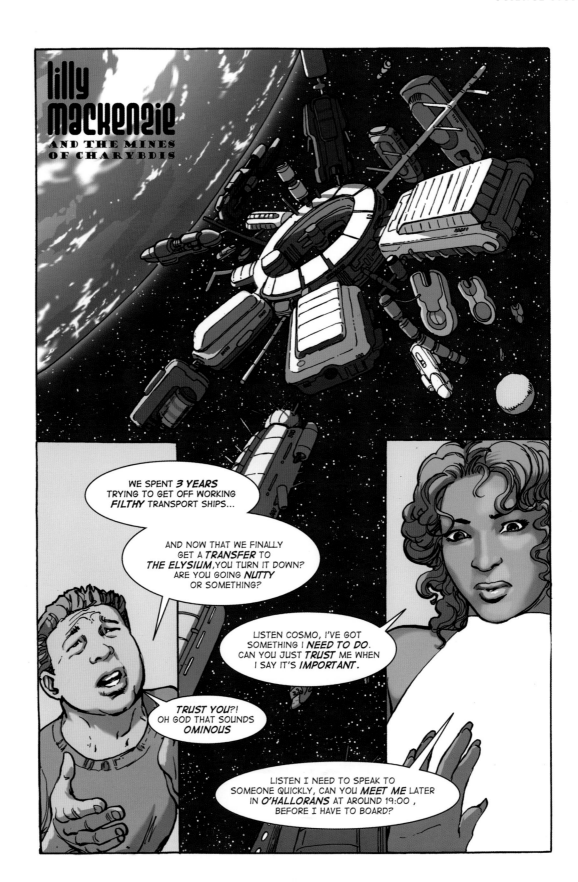

WITH ITS MOTORS PULSING RAW ENERGY, THE SHIP PLUNGES SUNWARD AT FANTASTIC VELOCITY...

MANY MINUTES LATER THE POWER SHUTS OFF AND STARR, SEMI-CONSCIOUS FROM HIS ORDEAL...

WAKEN MAN-THING...

... IS WEIGHTLESS AGAIN.

SEE HOW YOUR SUN BURNS NEAR AND BRIGHT...

...WE GO TO EARTH!

◀ ▶ **Hal Starr**
Sydney Jordon
Pen and ink, colored
in Adobe Photoshop
kolvorok.intergalatic@virgin.com

Sydney Jordan, creator of
***Jeff Hawke**—the UK's longest-
running science fiction
newspaper strip—moves away
from traditional art and into
the 21st century with his latest
graphic novel about a stranded
astronaut who is rescued by a
sentient space pod. Using Adobe
Photoshop's faux brushes to add
color gives a naturalistic texture
that emulates painting, but
offers far greater control and the
opportunity to both correct and
change easily. About the target
market, Jordan comments, "I
wanted to produce an all-age
space adventure after decades
of harder-edged SF."*

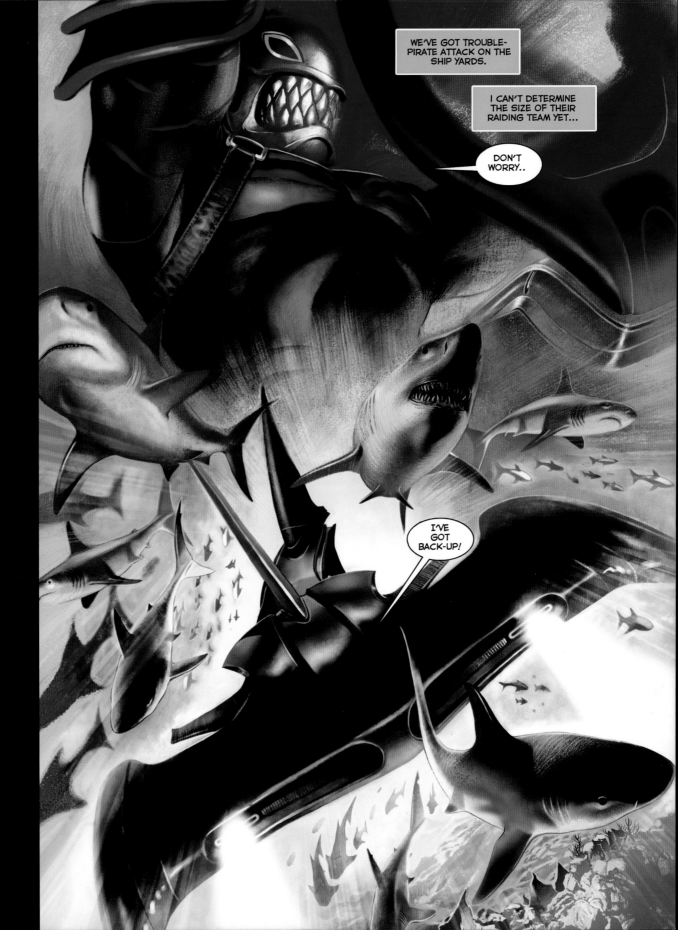

The Thing With Feathers
Angus McKie
Adobe Photoshop
apbh75@dsl.pipex.com

McKie drew in Adobe Photoshop to learn how to use the program, and admits he wanted to see how much he could emulate the real airbrush he generally used. And the conclusion? "Now I can leave the constraints of the real world behind and fly free in the digital realm! No more tedious cutting masks! And, of course, digital techniques allow far more control, especially at high resolution. Plus you don't get noxious cadmium yellow up your nose!"

Sharkman
Steve Pugh
Pencil, smudgestick and Adobe Photoshop
www.stevepugh.com
mail@stevepugh.com

At first glace a single scene, but this establishing shot is made up of two key elements — the central protagonist and his underwater transport. A shorthand used to link these two elements, and show that the character is actually within the sub, is the simple use of an ellipsis (...) between the two speech balloons. This big, nasty splash page provides a great chance for the artist to draw some pretty intimidating shark wildlife, and Pugh also admits he "loved doing the design work on the future vehicles."

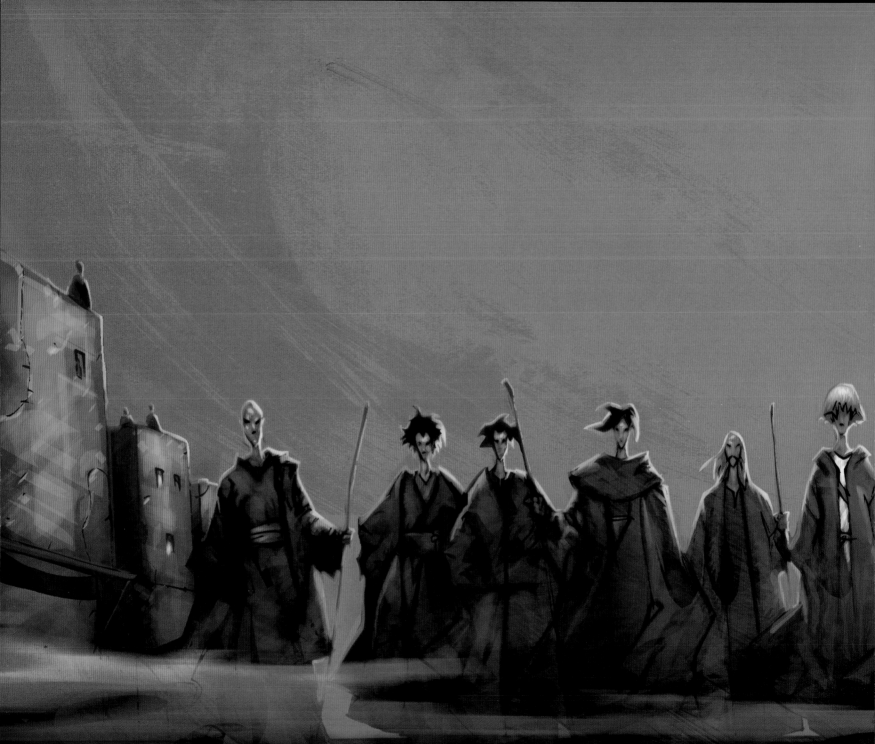

Mrs Moon

Al Davison

Pen and ink, Adobe Photoshop

www.astralgypsy.com

astralgypsy@btconnect.com

Showing his flair for fantasy is
as strong as his better known
depictions of earthier subjects,
Davison is currently coloring
Moom-Moom: The Quest, in
preparation for publication as
a children's comic in which Mrs
Moon directs a group of bored
youngsters on an adventure.

World's End

Tim Perkins

Pencil, colored in Adobe
Photoshop and Corel Painter

www.wizards-keep.com

tim@wizards-keep.com

Having produced work for most
of the major US and UK players
in the comics industry — as well
as concept art for theme parks
and animation — Perkins created
his own publishing company in
2005 so he could work without
editorial restraint. "Now I am
able to tell the stories I have
always wanted to, in the way
I want to tell them." Working
his art up on screen, from
hand-drawn pencils to digital
paintings he admits that "Only
a few years ago I could not see
the need for computers, except
for writing scripts as a glorified
typewriter/word processor.
How times change."

▲ **Fudge**
Ken Reid
Pen and ink, Adobe Photoshop
imagocentral@yahoo.co.uk / fudgetheelf@aol.co.uk

*One of the UK's greatest humor cartoonists, the late Ken Reid was
a mainstay in British comics, working for leading publishers in the
mid-20th century. Ironically, the only property he ever produced
that was completely his own was the beguilingly innocent* **Fudge
the Elf**. *The timeless strip is currently being restored by Reid's
son—Tony—and John Ridgway, and is currently being colored
for a new century and a new generation.*

▶ **Glister**
Andi Watson
Image Comics
www.andiwatson.biz
andicomics@yahoo.co.uk

A cartoonist, illustrator and writer, Andi Watson has notched up an impressive total of 16 graphic novels, and works in a variety of genres — from sci-fi and all-ages fantasy, to drama and romantic comedy. He admits that in part he is producing **Glister Butterworth** *— a magnet for odd occurances such as a haunted teapot filled with ghost writers — because, "I've been reading picture books and children's books since my daughter was born five years ago. In fact, it's longer than that because I was reading to her while she was still in the womb! It will be great to give her something of mine she can read too — something that doesn't involve boring grown-ups!"*

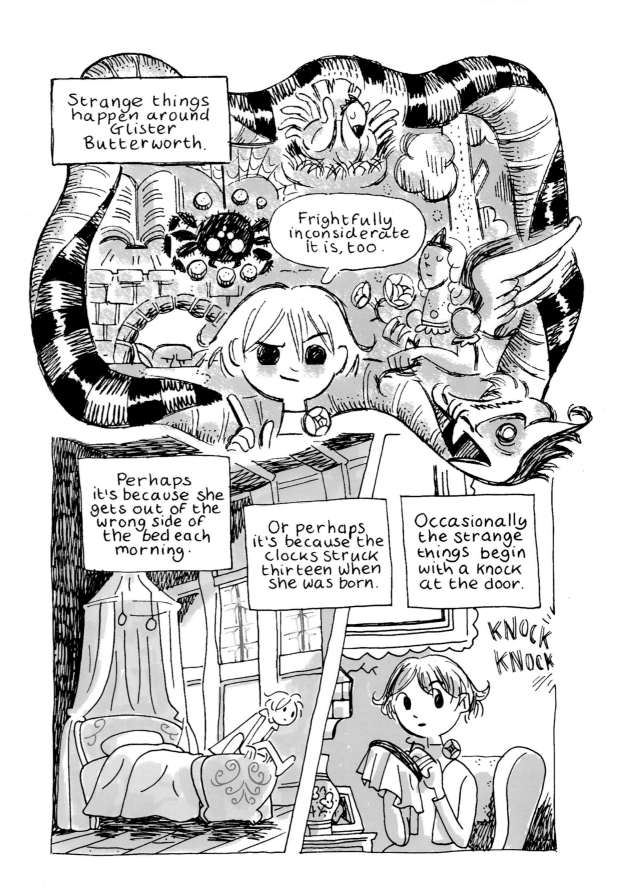

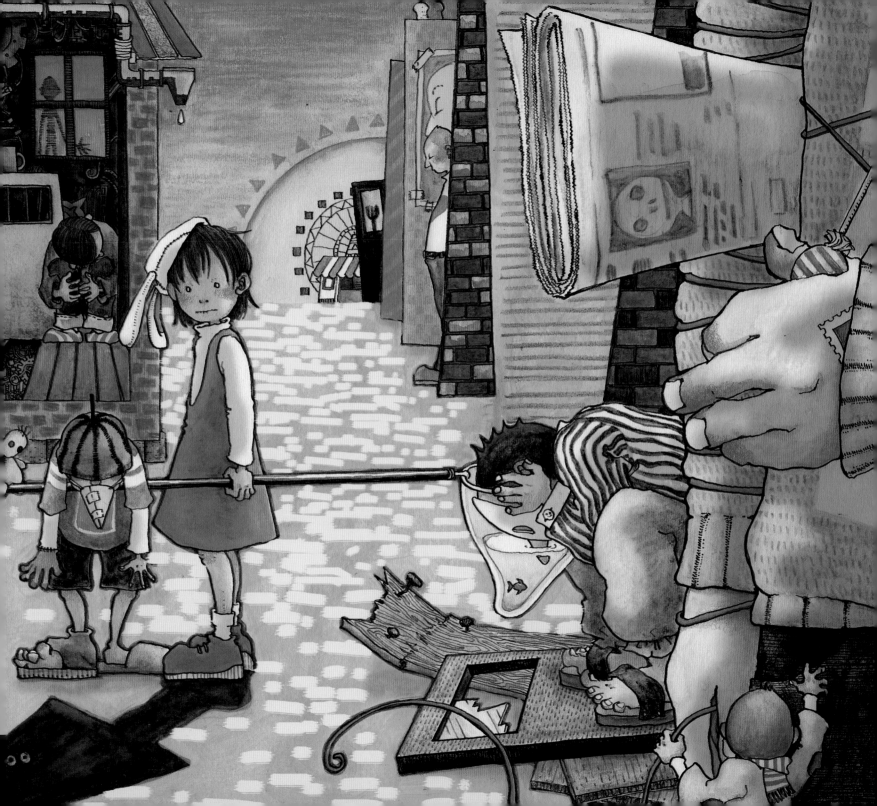

a Corner of Toytown
Michiru Morikawa
Watercolor pencil, acrylic
and Adobe Photoshop
michirum2000@yahoo.co.jp

Throughout her whole life
Michiru Morikawa (Mi to her
friends) has been drawing
and travelling. She was born
in a little town in Japan, but
studied in Tokyo and later in
Birmingham, England, while
working as a freelance artist.
She then returned to Japan,
before leaving for Greece.
The end product of absorbing
so many differing cultures is
that her work is an unusual
blend of the fantastic and the
absurd. Intense inspection of her
work rewards the viewer with
the realization of exactly how
much is actually happening...
in a corner of Toytown.

Falling
Paul Duffield
Pencil, Adobe Photoshop
www.spoonbard.com
spoonbard@gmail.com

Many people creating a self-
contained comic strip will start
with their ending and then
work back to an appropriate
beginning, so the reader is
guaranteed a good punchline,
rather than a whimpered finale
as a reward for their viewing.
This conceptual illustration by
Duffield—drawn to inspire him
to create an as-yet unwritten
story—is no exception. He
describes it as "The tail end of
one of those 'will I wake up when
I hit the ground?' dreams."

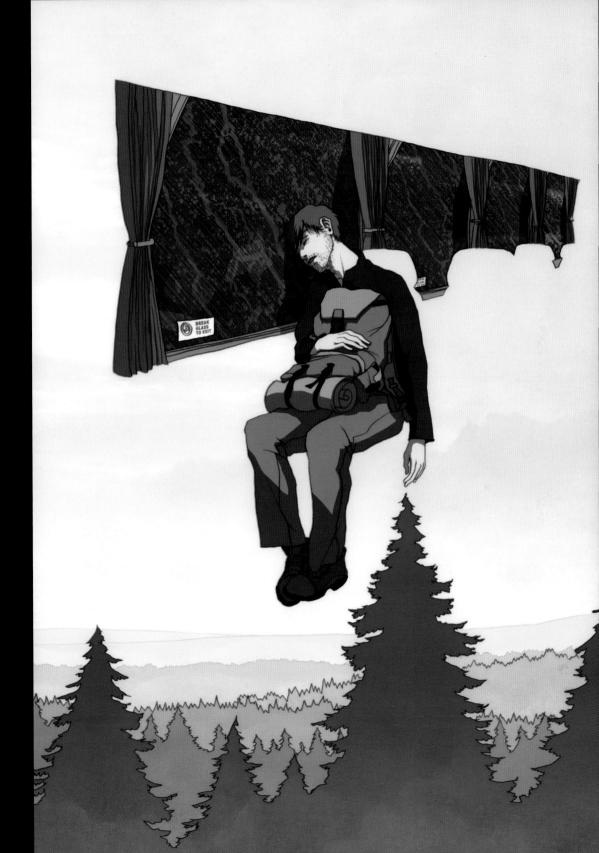

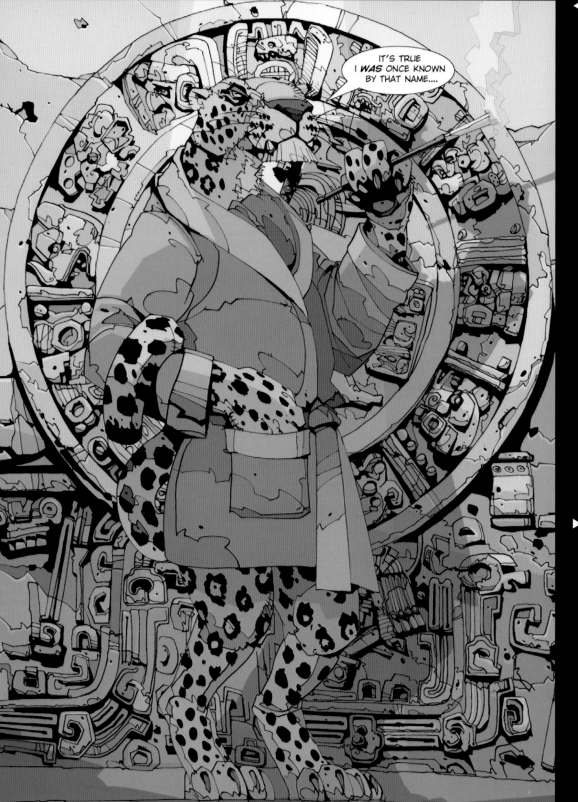

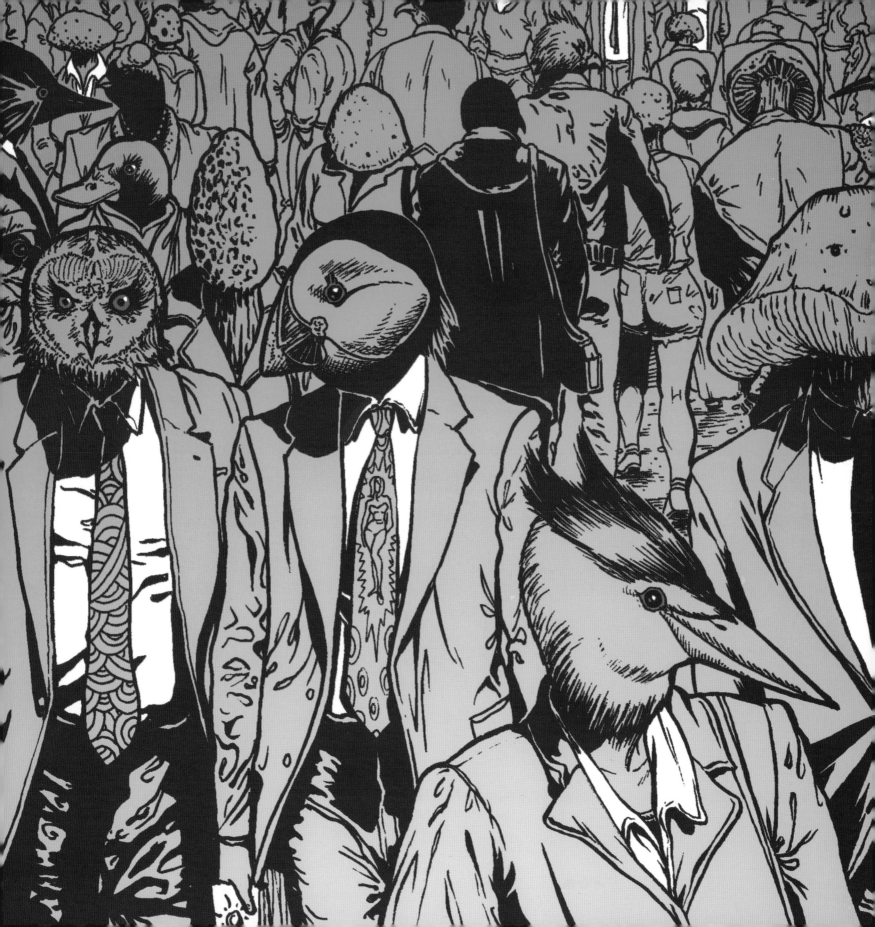

▶ **Bloody Ballerina**
Ben Ang
Pencil, Adobe Photoshop
www.xplixit.blogspot.com
freelance.ben@gmail.com

Singapore-based Ben Ang's concept with this experimental piece was to draw a cute little ballerina and then put her in a situation that was anything but cute. "I enjoy the surprises that come from experimenting. I drew the girl with a pencil and skipped inks to obtain a raw feel. For the background I took a piece of paper and stained it, crushed it, and scanned it in. I played around with the blending modes in Photoshop until I achieved the mood I was looking for. And yes, in true TV advertisement style, the blood is blue!"

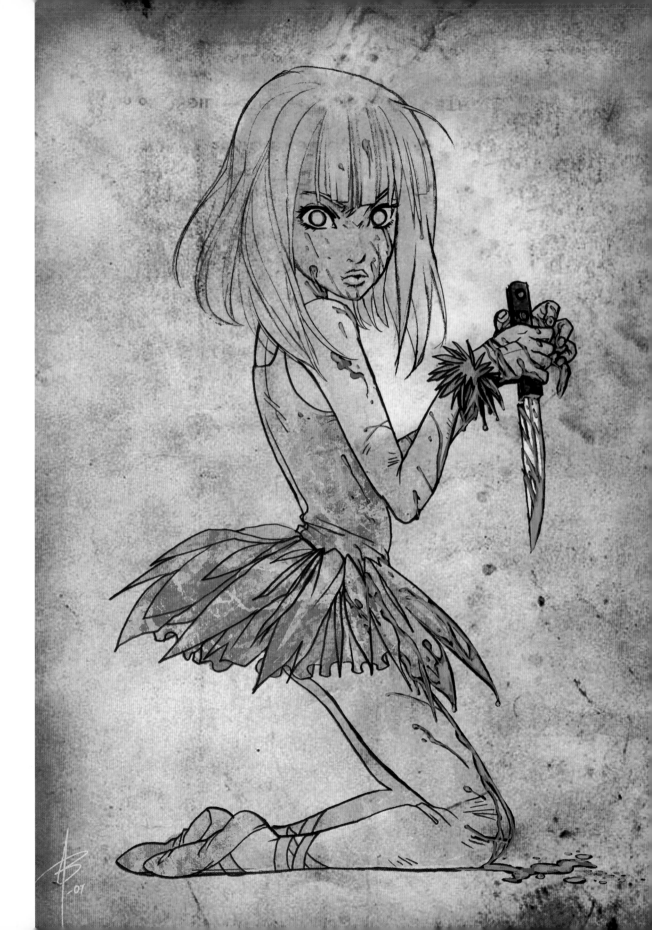

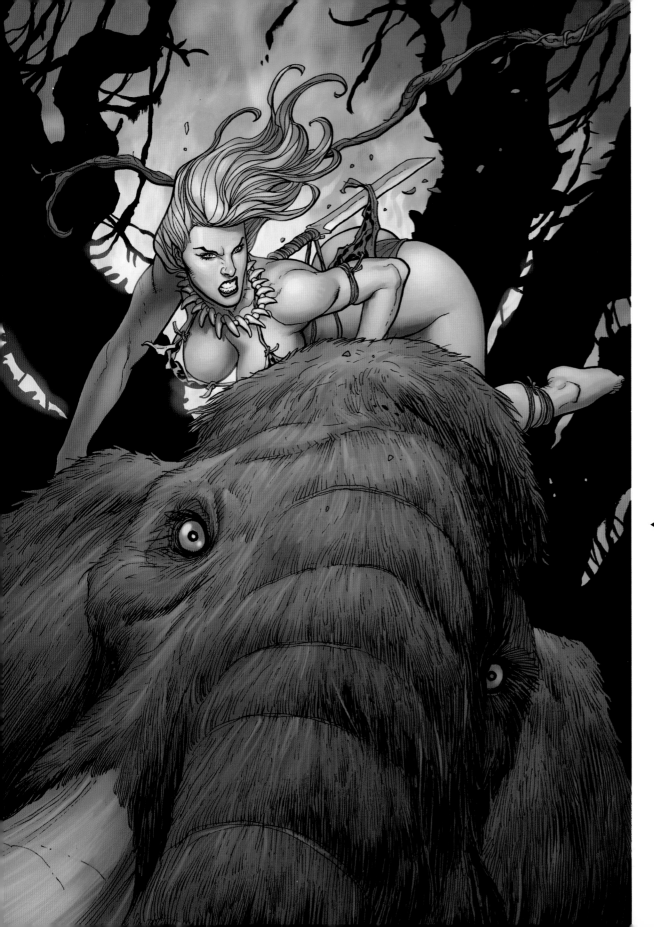

◄ **Jungle Girl**
Frank Cho
Dynamite Entertainment
Pen and ink plus Photoshop color
www.libertymeadows.com

Korea-born writer/artist Frank Cho is a self-taught artist whose artwork for University[2] printed in his college newspaper, before evolving into the hilarious Liberty Meadows strip. It was soon widely syndicated, but Cho tired of censorship and took up collecting the strips through Image Comics instead. Moving to Marvel in 2005, he also suffered from censorship on Shanna The She-Devil, when the publisher decided to turn the mature-audience project into an all-ages one. He now writes and draws cover artwork for Jungle Girl while producing less risqué superhero fare for Marvel.

▶ **Maxwell Cockswagger**
Ben Ang
Tenacious Games
Pencil, Adobe Photoshop
www.xplixit.blogspot.com
freelance.ben@gmail.com

A professional artist of five years, Ang lends
a unique blend of US comics and Japanese
manga styles to Tenacious Games' **Maxwell**
Cockswagger *character. "I decided to pay*
tribute to Chinatown with an oriental setting,
lots of lanterns, and large amounts of red."

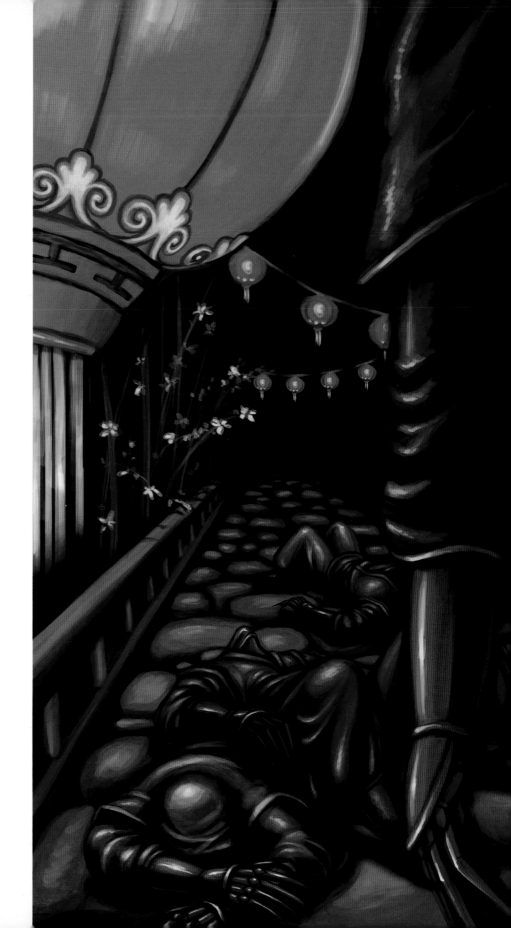

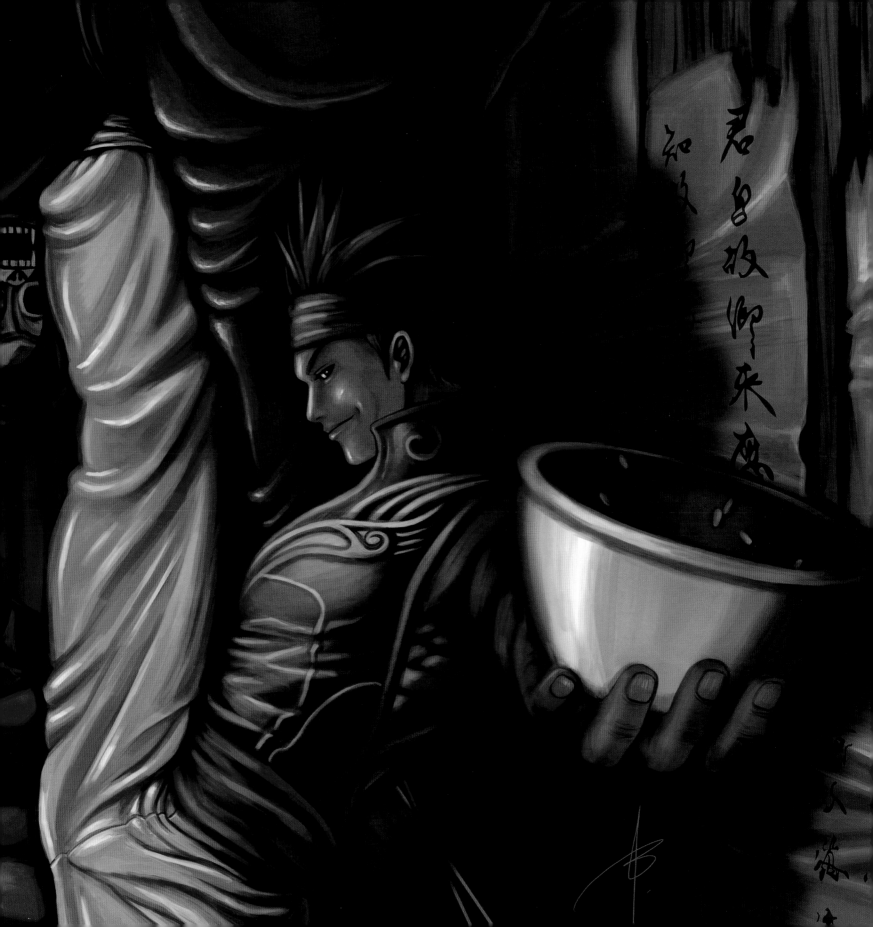

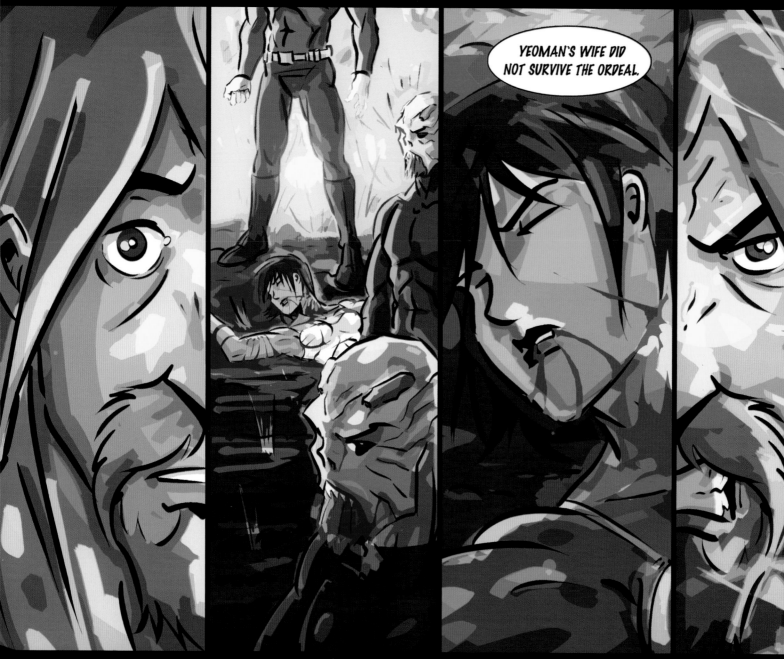

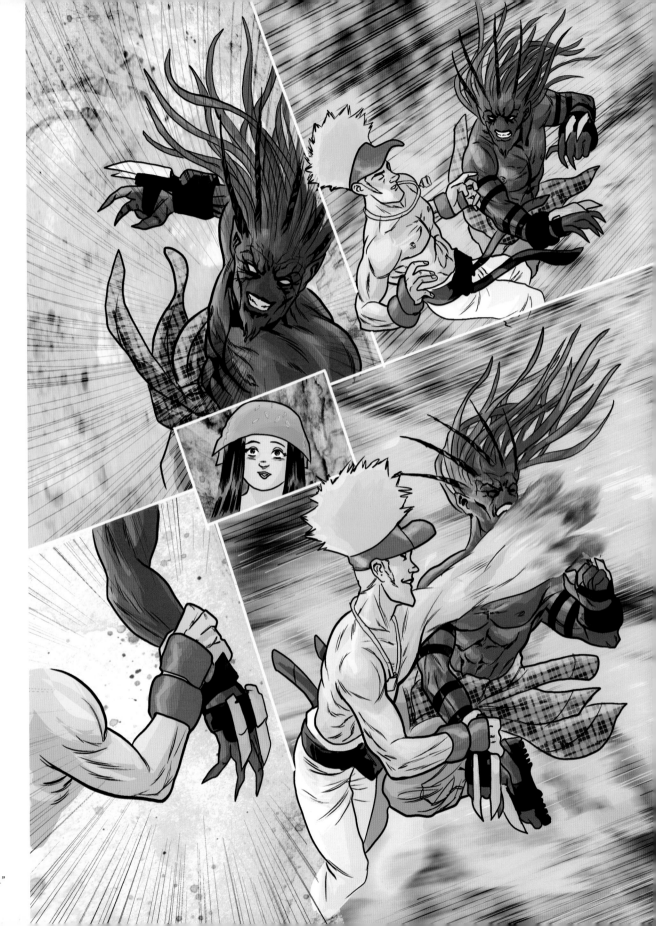

◀ **Unity Rising**
Robert Deas
Sketchbook Pro 2,
Adobe Photoshop
www.rdcomicsonline.com
rdcomics@rdcomicsonline.com

*One increasingly popular route
for exposure in comics is the
internet, and once an artist has
sufficient material online to make
an entire graphic novel or series
of comic books, it becomes more
attractive to deadline-conscious
publishers. This sequence is taken
from a spin-off story from Deas'
science fiction webcomic,*
Instrument of War.

▶ **Thumpculture**
Neill Cameron
Pencil, Manga Studio,
Adobe Photoshop
www.thumpculture.com
neillcameron@googlemail.com

*Cameron illustrates his
webcomic* **Thumpculture** —
*a martial arts sci-fi, romantic
comedy, soap opera — using
a mixture of techniques. The
character art is pencilled
traditionally, then scanned
and inked digitally using
Manga Studio. The color is
then added in Adobe Photoshop.
The background art is produced
separately — painted with
watercolors and then imported
into Photoshop. "The combined
effect is intended to produce the
feeling similar to viewing stills
from an anime film, with flat,
cel-shaded characters moving
through a lush, painted backdrop."*

▶ **The Danger's Dozen: First Salvo**
Norm Breyfogle
Pen and ink, Adobe Photoshop
www.normbreyfogle.com
nbreyfogle@chartermi.net

Two heroes versus an enemy horde! To give the impression of simultaneous events, Breyfogle makes the center panel the main focus by running it to bleed on both sides, while the black-clad **Boss Aman** *(mysterious man of action) is similarly positioned in the frames above and below.*

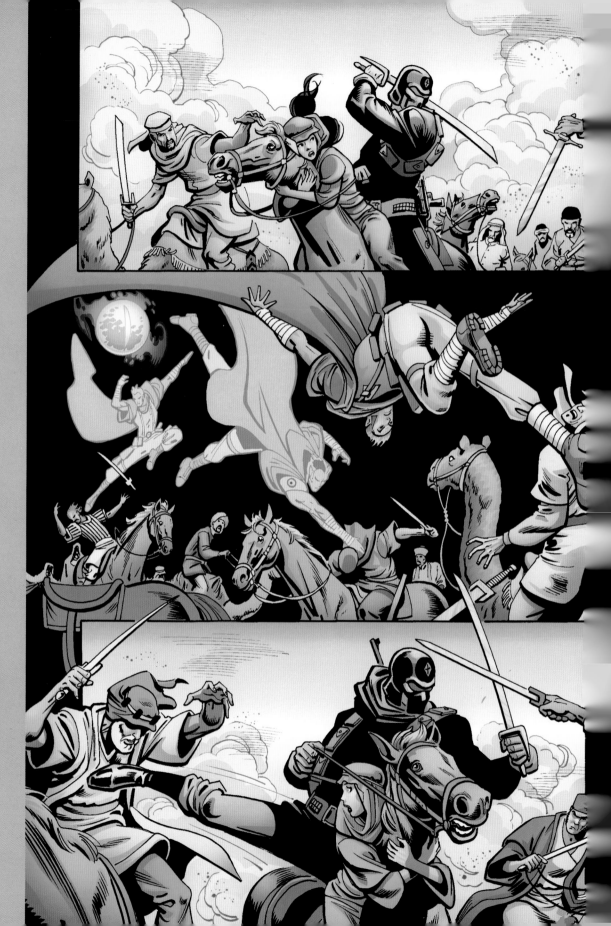

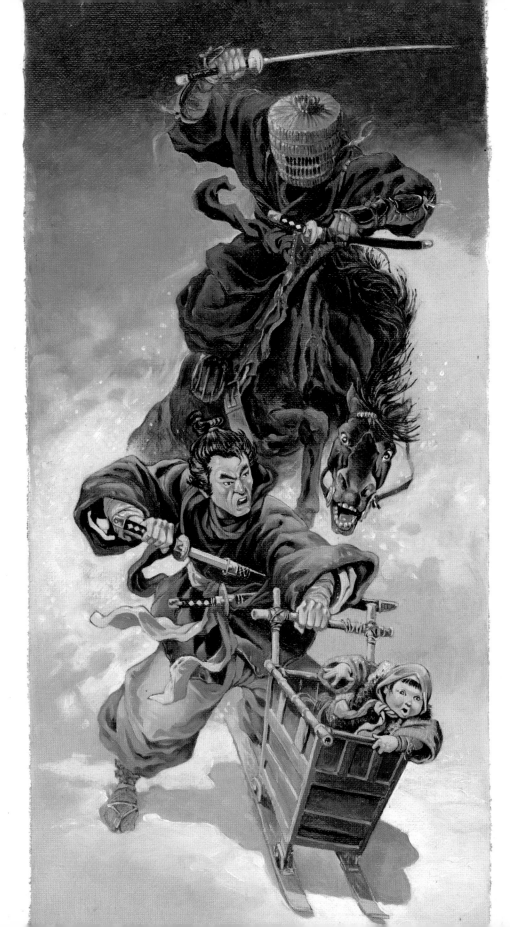

▶ **Lone Wolf and Cub**
Mike Ploog
Dark Horse
Oil on canvas
mike.ploog@btconnect.com

*The challenge to Ploog on this
commission was its shape. The
publisher wanted an instantly
identifiable, tall, narrow area
for art, with typography filling
a similar area to its left.
"To incorporate an action
sequence in such a shape was
not the easiest thing to do,"
Ploog remarked. Jettisoning the
idea of any background "which
would have stilted the action,"
the artist opted for an overhead
shot of the wandering samurai
hero and his son, with his
horseback foe looming down
on them from directly above.*

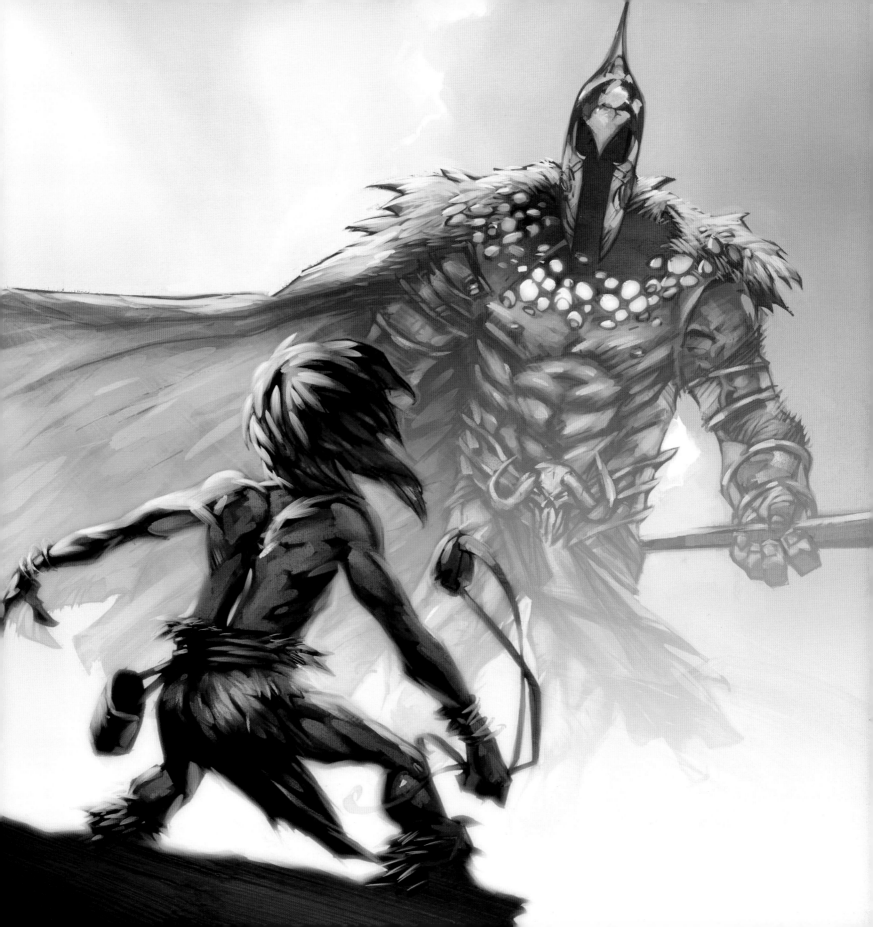

◀◀ **David and Goliath**
Siku
The Manga Bible
Acrylic and Artrage
www.theartofsiku.com
siku@theartofsiku.com

Another stunning spread from Siku's mammoth undertaking, **The Manga Bible**. Almost three-dimensional in its depth of field, and screaming "epic," this one has to rate a perfect ten for its Wow! factor. Its apparently simple design conceals the artist's inspiration in combining several techniques to create such a scene. David is a puny, isolated figure on the edge of a sweeping landscape, yet is firmly rooted in reality—as emphasized by the dark horizon he melts into. Goliath is an almost ethereal dinosaur rising up out of the mists of time to devour him. Even the tears in the giant's cloak resemble vicious beaks, while his face remains hidden— the unreachable unknown.

▶ **Strangehaven**
ILYA
Pen and ink, Adobe Photoshop
edilya@hotmail.com

In film this would be a series of rapid cuts, with only a second on each scene as the artist builds tension between the two protagonists approaching the climax of this jungle showdown. By using extreme close-ups, ILYA heightens the suspense— primal in both its content and execution— with a brash mechanical tint, rather than a smooth wash that would have softened the page. Asked why he chose such a setting for the story, the artist would only comment, "It's set in the Amazon jungle so I can avoid drawing buildings and cars."

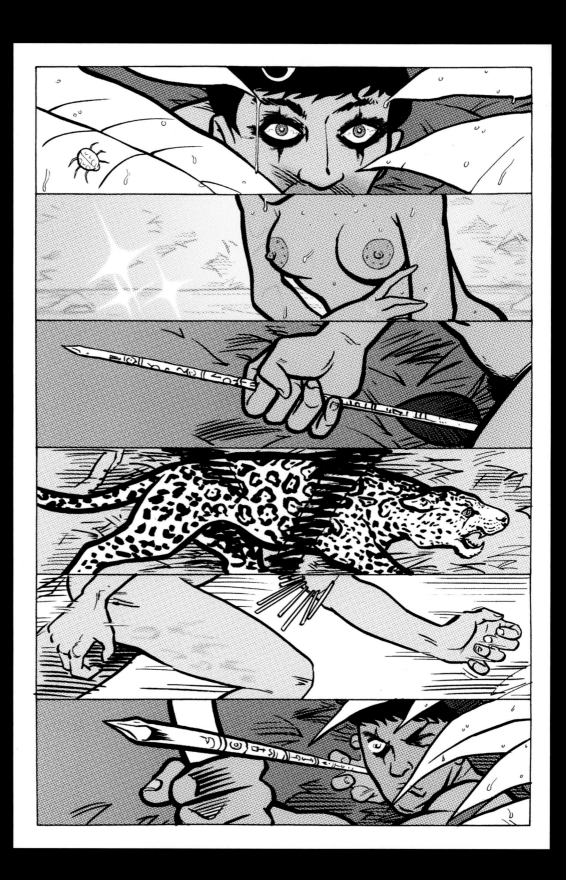

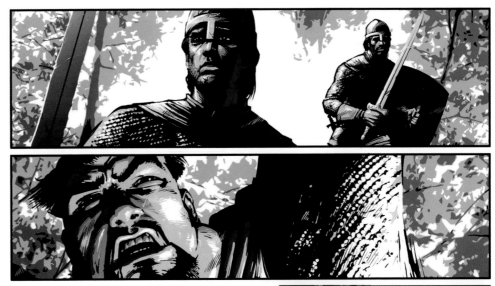

▶ **Robin Hood: Outlaw's Pride**
Sam Hart
Walker Books
Adobe Photoshop
www.samhartgraphics.com

*No stranger to the legend of
Robin Hood, Sam Hart was born
in England, in a small town
in the Midlands. After a short
sojourn to foggy London he left
the inclement isles for the tropical
beaches of Brazil, only to find
himself in the midst of smoggy
São Paulo. He worked as an
illustrator, producing scientific
diagrams, but as a man who
had happily drawn fanzines
throughout school and college
he was easily tempted away to
pursue a career in comics. In
addition to teaching comic art
workshops, and two years spent
on various comic titles, Hart has
embarked on his biggest project
to date; a 140-page Robin Hood
graphic novel, due in 2008 from
Walker Books.*

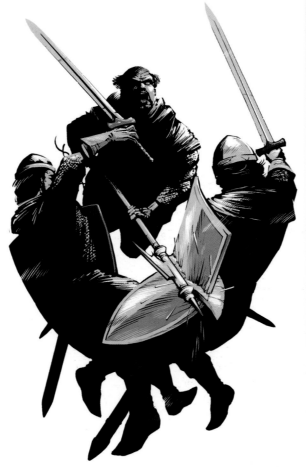

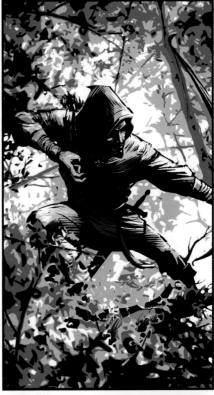

▲ **Dragonlast**
Daniel Atanasoc
Pencils, inks, Adobe Photoshop, Corel Painter
satanasov@gmail.com

*Having been interested in manga since childhood, Atanasoc's unique
blend of styles have won him prizes at various international festivals.
Now the art director for the Bulgarian wing of the game company
Ubisoft, he still finds time to create his own comics. In* **Dragonlast** *he
tells of the downfall of the mighty lizards; how their cruelty turned
them from gods into beasts, and how — in their shadow — the race
of humans arose.*

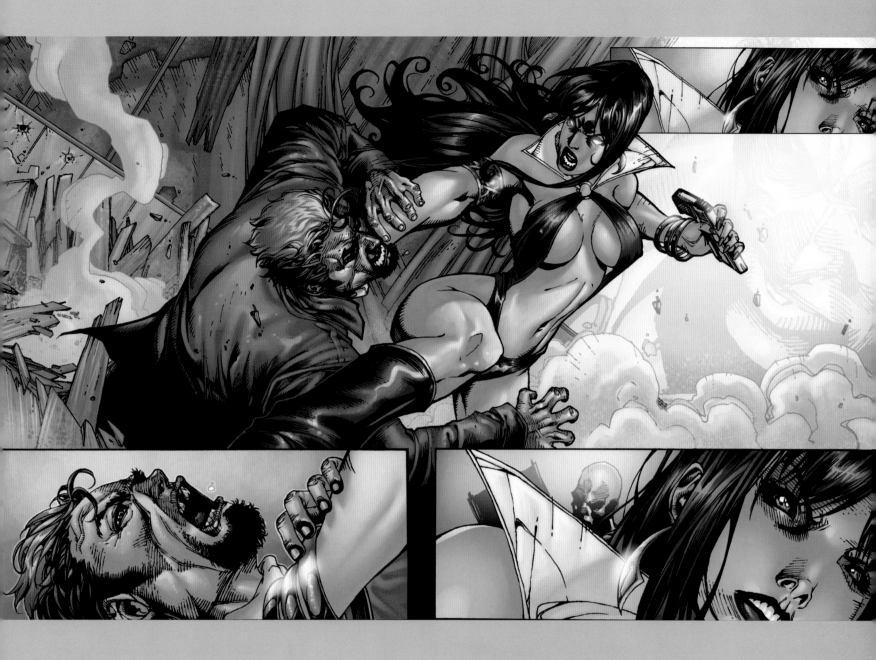

▲ **Vampirella**
Stephen Segovia
Pencil, ink, digital color
www.glasshousegraphics.com
mamaru_chiba_19@yahoo.com

A self-trained artist, 22-year old Segovia started drawing Filipino comics when he was only 16, refining his skill by assisting Carlo Pagulayan as a background artist on **The Fantastic Four**, **X-Men Unlimited**, *and* **Planet Hulk**. *Despite his dynamic sense of design, drawing such titles as* **Vampirella**, *his secret passion is to work in a totally different style… as a manga and manwha artist.*

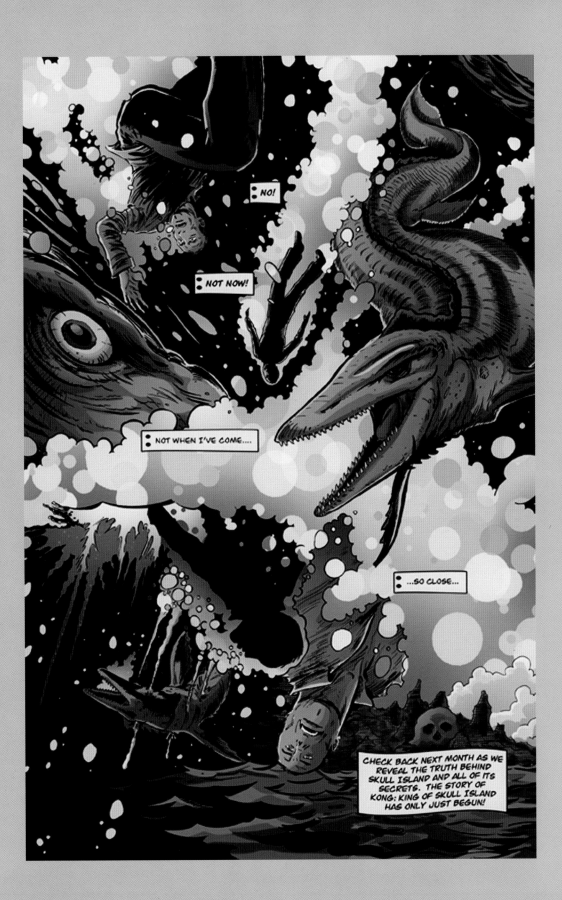

◀◀ **Groomlake**
Jean-Jacques Dzialowski
Editions Bamboo
Pencil and ink, colored
in Adobe Photoshop
jeandzia250@hotmail.com

This is the finished cover artwork
to the second **Groomlake** graphic
novel, published in France by
Editions Bamboo. Jean Dzia—to
his friends—produced layouts,
pencils and inked art for colorist
Cyril Saint-Blancat to "work
his magic on." Like all good
cover artwork, it is intended to
spotlight a pivotal moment from
the story, grab readers, and have
them wondering what is going
on and what will happen next.

◀ **Kong: King of Skull Island**
Dan O'Connor
Markosia
Pen and ink, Adobe Photoshop
www.markosia.com

Celebrating Kong's 75th
anniversary, comics newcomer
O'Connor's first professional
work is on this prequel/sequel to
the original Merian C Cooper
classic. The story begins 25
years after Kong's death and
goes back over a hundred years
as explorers discover the truth
behind Skull Island's many
secrets. O'Connor, who favors
a modern montage approach
to storytelling above the
traditional frame by frame
boxed sequence, is producing
initial breakdowns through to
finished line art, for coloring
by Kris Johnson.

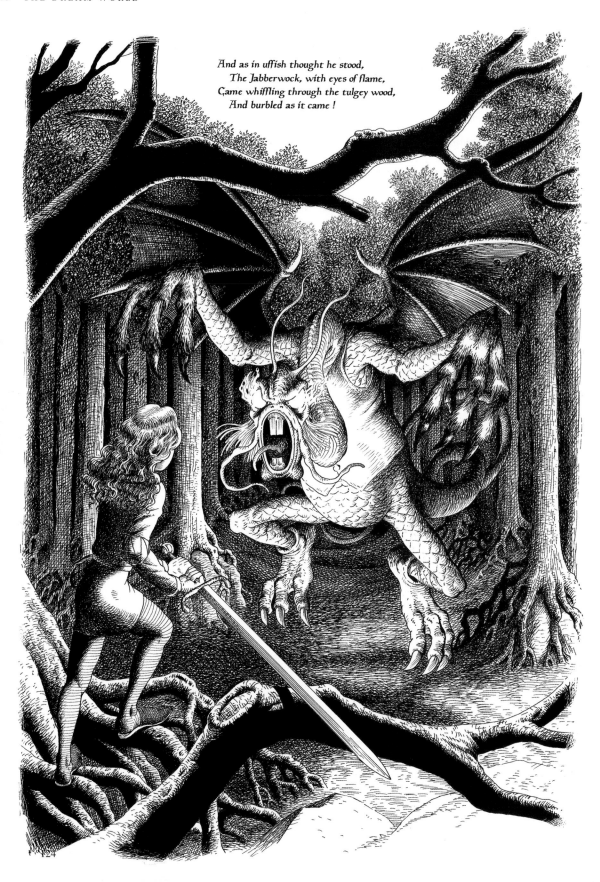

And as in uffish thought he stood,
The Jabberwock, with eyes of flame,
Came whiffling through the tulgey wood,
And burbled as it came !

◀ **Jabberwocky**
Bryan Talbot
Alice in Sunderland
Pen and ink
www.bryan-talbot.com

This is a page from Bryan Talbot's graphic novel **Alice in Sunderland**. *Talbot is internationally renowned for his multiple award-winning* **A Tale of One Bad Rat**, *which focused on an abused child seeking refuge in the world of Beatrix Potter. With his latest work set to be just as popular, he comments that this piece* "Is not really representative of the book as a whole, as each sequence is done in a style that I thought appropriate. This one comes from a three-page adaptation of **Jabberwocky** by Lewis Carroll, and is designed to evoke the work of John Tenniel, the original Alice illustrator."

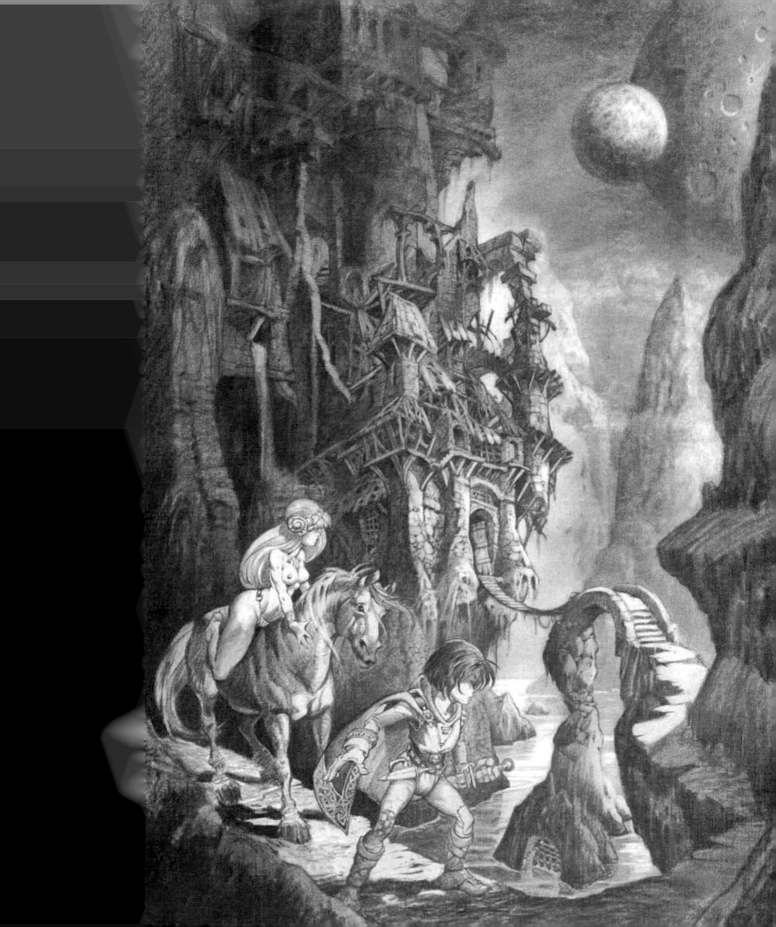

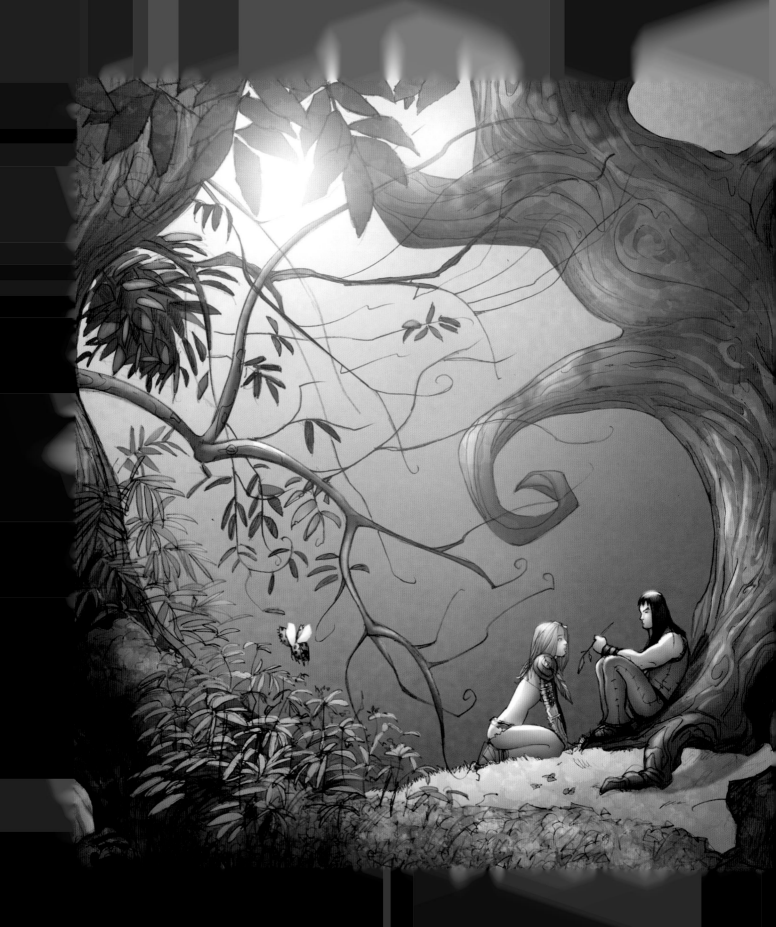

 The Lexian Chronicles
Inaki Miranda
Markosia
Pen and ink, Adobe Photoshop
www.inakieva.com

Born in Argentina, Miranda
moved to California before
finding a home in Madrid
"among the roots of my family
tree." While his first encounters
with professional art were
in animation and then video
games, his passion for comics
was realized through *2000 AD*
and *Judge Dredd*, for which he
drew the syndicated newspaper
strip in 2003. Working closely
with inker and colorist, Eva de
La Cruz, he is now turning
heads with his stunning work
on *The Lexian Chronicles*
for Markosia.

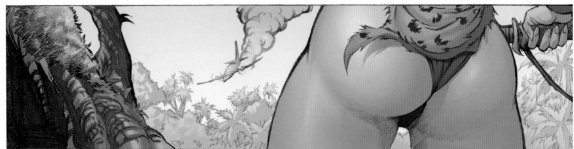

▶ **Jungle Girl**
Adriano Batista
Dynamic
www.glasshousegraphics.com
www.bubbagump.blogger.com.br

Brazil-based Adriano Batista
broke into US comics on such
"bad girl" titles as *Lady Death*,
Bad Kitty, and *Chastity*.
Because of his beautiful depiction
of warrior women, he has
no shortage of projects, from
Witchblade and *Xena*, to *Red
Sonja* and his new series—*Jungle
Girl*. A night owl, he often works
until 6am, but is hoping to
increase his sleeping hours by
training his wife to ink his work.

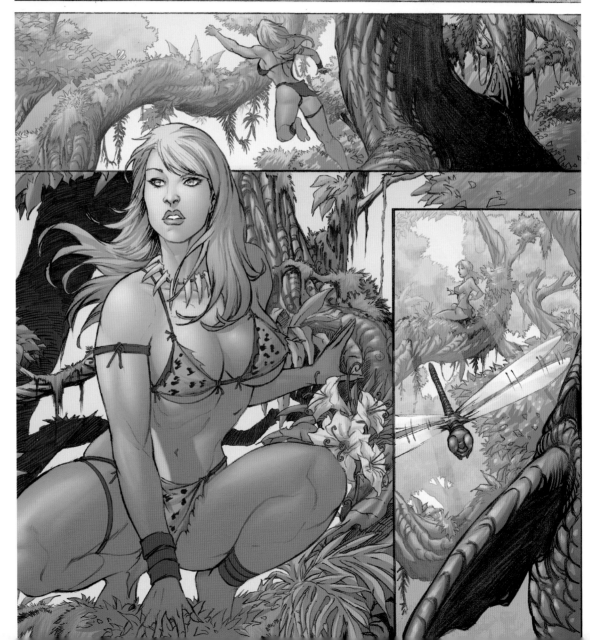

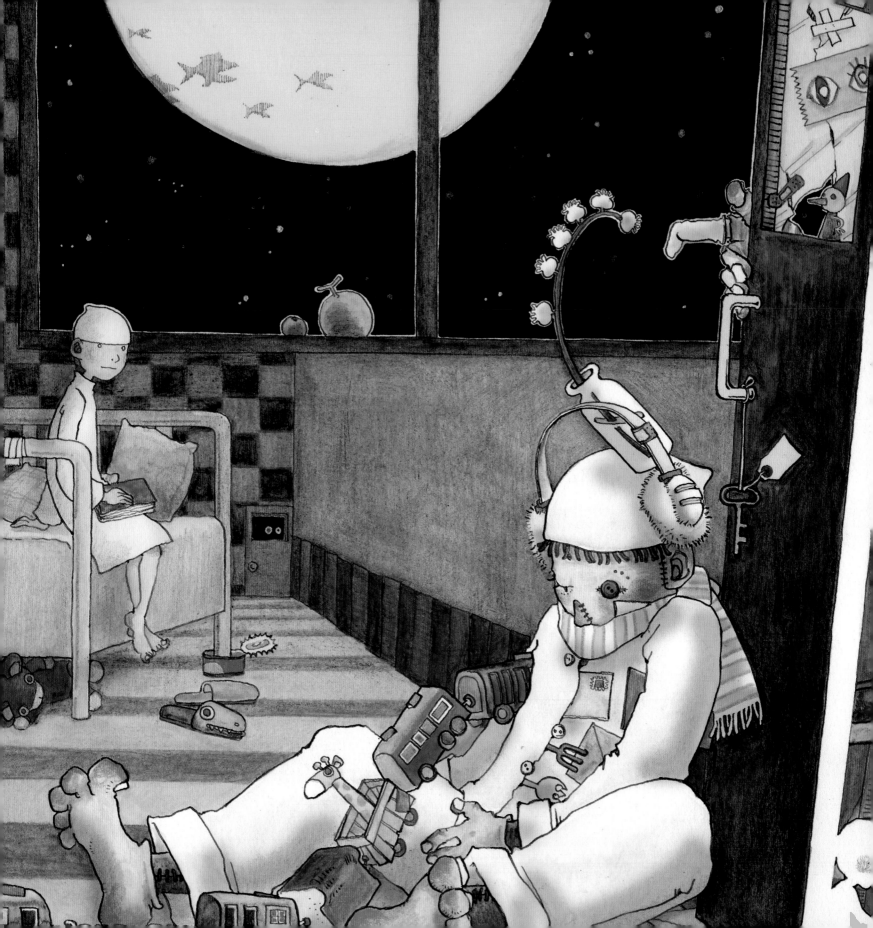

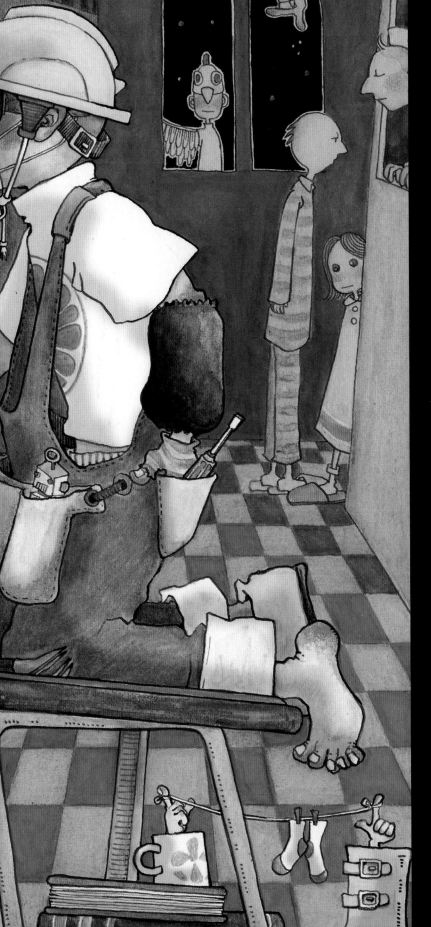

◀ **Isolation and Curiosity**
Michiru Morikawa
Watercolor pencil, acrylic and Adobe Photoshop
michirum2000@yahoo.co.jp

*When asked who is the greatest influence on her seemingly
unique work, Tokyo-based Michiru Morikawa named the author
of* **Absurdities** *(1934), W. Heath Robinson. Heath Robinson was
a renowned English cartoonist and illustrator, best known for his
drawings of eccentric machines and implausible contraptions,
such as The Wart Chair ("A simple apparatus for removing a
wart from the top of the head"), The Mortar Cannon ("for Sending
Luncheon Baskets up to Aeroplanes") and The Multimovement
Tabby Silencer ("which automatically throws water at serenading
cats"). When you look closely at her work, this explains a lot!*

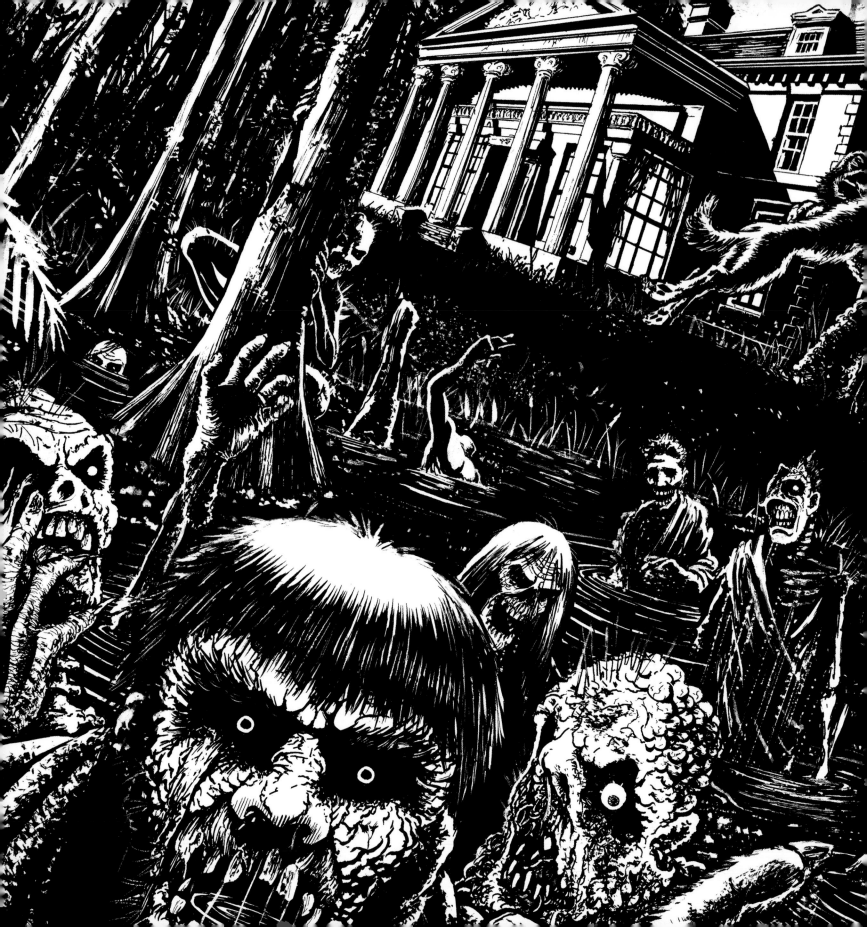

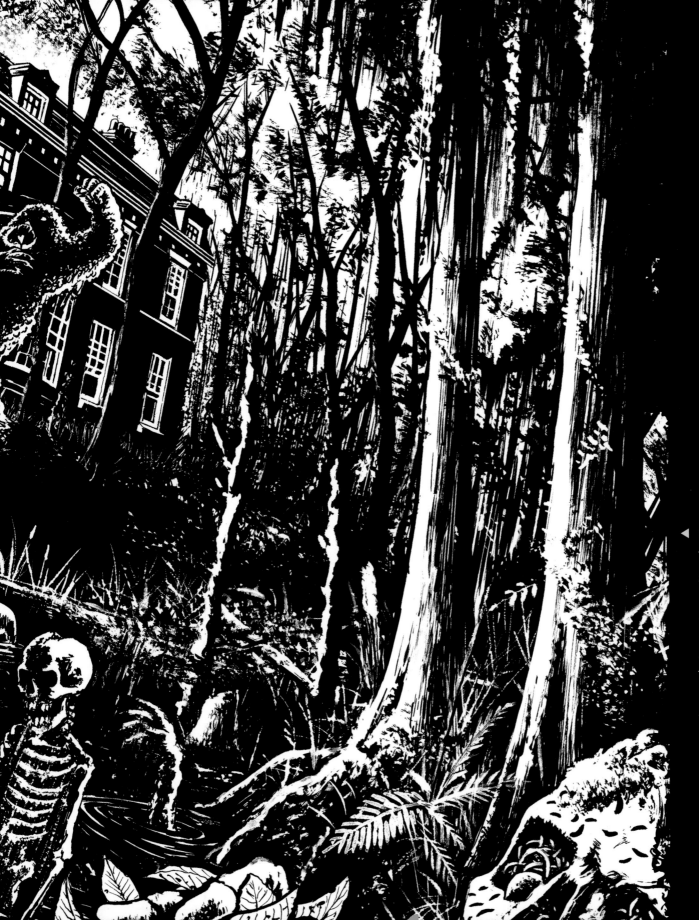

CHAPTER 4

HORROR

◄ **Darkkos Manse**
James Fletcher
Pen and ink
flexographics2001@yahoo.co.uk

1970s America was awash with horror comics. To escape the restrictive Comics Code, they we produced in a larger magazine format, invariably with pulp black-and-white interiors, and had a lasting impact on many young teenagers. James Fletcher has fond memories of them and leapt at the opportunity to recreate one such line, featuring the obscure 1970s Horror-Mood characters from Skywald Magazines. In his defence of the grotesque, he notes "They've gained a cult following for having some of the weirdest and most original horror ever to appear in comics."

◀ DeadShift
Al Davison
Adobe Photoshop
www.astralgypsy.com
astralgypsy@btconnect.com

Digitally created cover art for an unpublished horror graphic novel, written and drawn by Davison. It features reincarnated serial killers, Victorian mystics, day-dreaming humans as transport for spirits, and a contemporary cop—who just happens to be dead. "This story is pretty much transcribed as I dreamt it, as was virtually every other fictional work I've done. DeadShift was dreamt in one night, right down to the layouts, script and final art style—all 140+ pages," he explains.

▶ Wormwood
Ben Templesmith
IDW Publishing
Pen, ink, acrylic, watercolor
and Adobe Photoshop
www.templesmith.com
contact@templesmitharts.com

One of Australia's best new horror artists, Templesmith both writes and draws Wormwood: Gentleman Corpse—a comic book starring an ancient and immortal sentient worm creature from a hell dimension. It has been on Earth for a very long time, but is still only in the larval stage. This cover features Wormwood's ex-girlfriend, Ms Medusa, owner and manager of a club he frequents. "Demonic snake tattoos abound," says the artist.

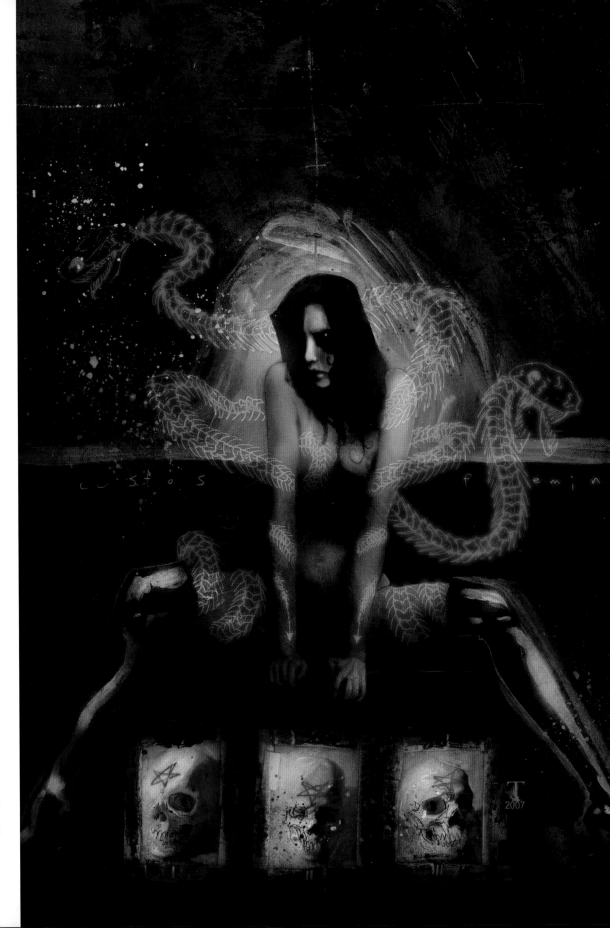

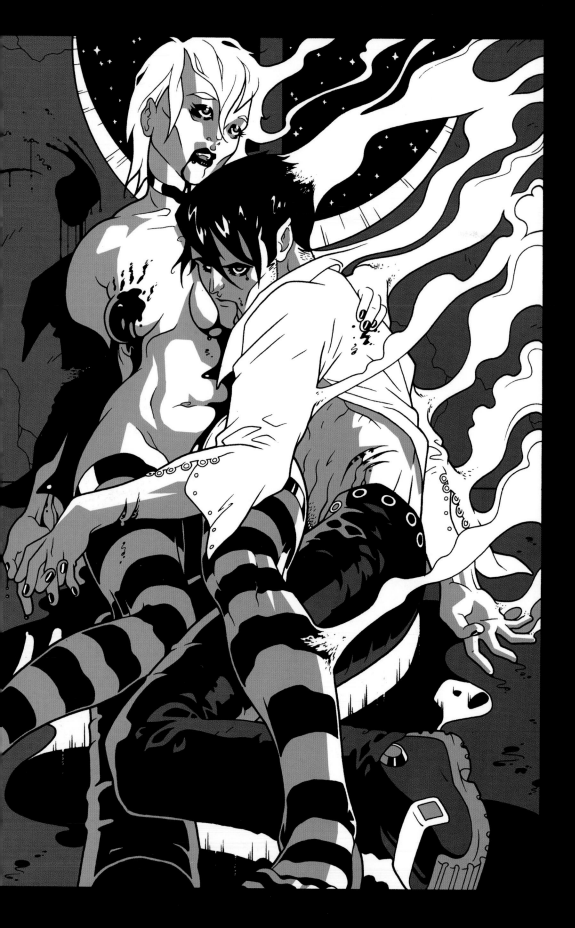

Vamps

Cosmo White
Blue pencil on Bristol board,
felt tips, fine liners and
Adobe Photoshop
cosmo.w@gmx.co.uk

*White sums up these visuals
succinctly as "Goth vampire
eroticism." The artist's intention
was to use only one shade of
gray to give a minimal look,
but as he says, "I bottled out
at the last minute and stuck
in another darker shade. A
'ligne clair' simplicity was the
goal here, but I don't feel that
I managed to remove enough
interior detail. Still, it was fun
trying and in the end the black/
white/gray balance worked out."
He also admits to modelling for
both characters, adding, "I had
to suck my tummy in a bit for
the girl, but surprisingly the
bosoms were not a problem!"*

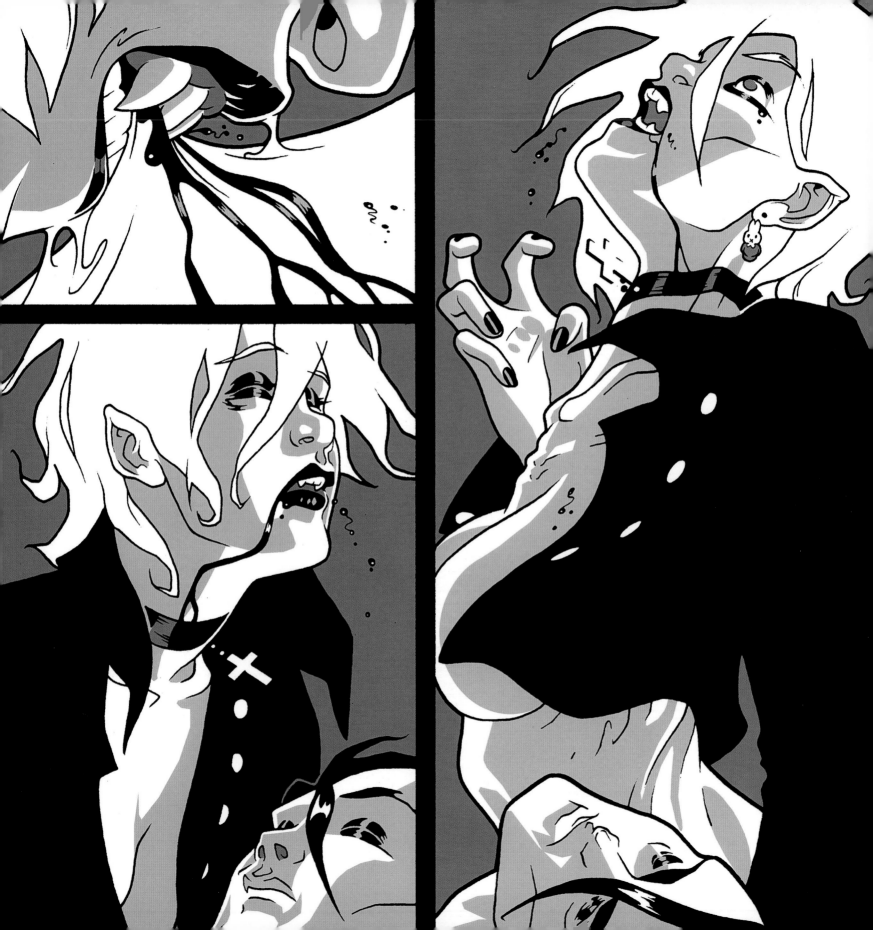

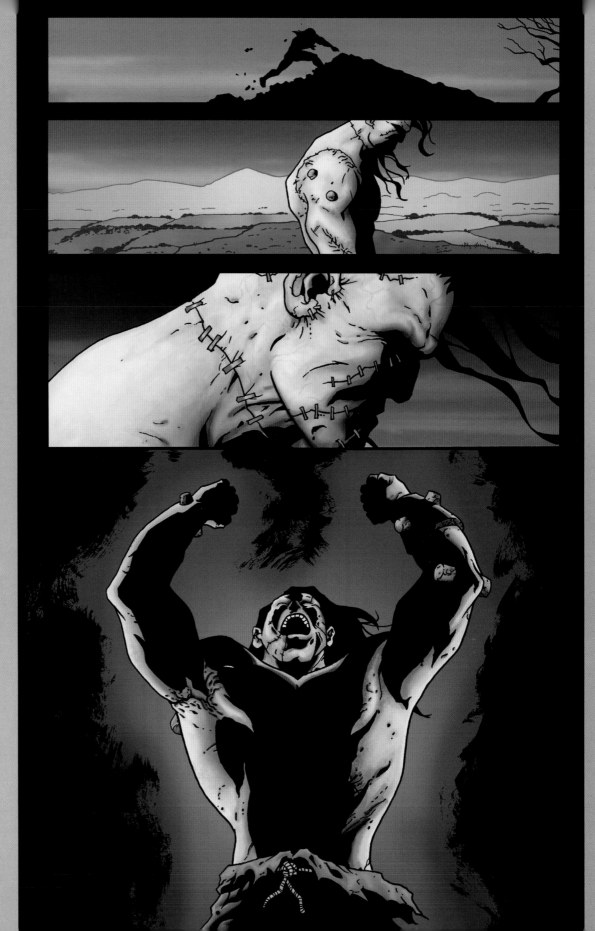

▶ **Frankenstein by Mary Shelley**
Declan Shalvey
Classical Comics
Pencil and ink
www.risecreatives.ie/declanshalvey
dshalv@gmail.com

Telling the original **Frankenstein**
story is Shalvey's first major
work, and this page was done in
the early stages of the project. As
he comments, "I needed a page
that showcased my storytelling
style and that could display what
the colorist could do with my line
work, as we had never worked
together before. I tried to achieve
a brooding look to the monster's
face by casting it in shadow,
while moving the 'camera'
closer to him. I wanted to hide
his expression as he gets more
and more apprehensive, and
finally explodes in a fit of rage.
I dropped the standard borders
for the final panel in favor of a
'halo' effect around him — using
a dry-brush technique to further
emphasise the monster's rage."

▶▶ **21 Demons**
Neil Edwards
Altered Expression
Pencil, ink, Adobe Photoshop
www.thebristolboard.blogspot.com
neil@mako-cs.co.uk

Neil Edwards recalls that the
publisher/author's script for this
new comic asked for "a really
dramatic page of Sati Kahn
rising out of a bath of blood!"
Edwards produced breakdowns
and layouts, worked up to
finished pencil art for an
outside inker (Jimmy Reyes)
and colorist (Eva De La Cruz).

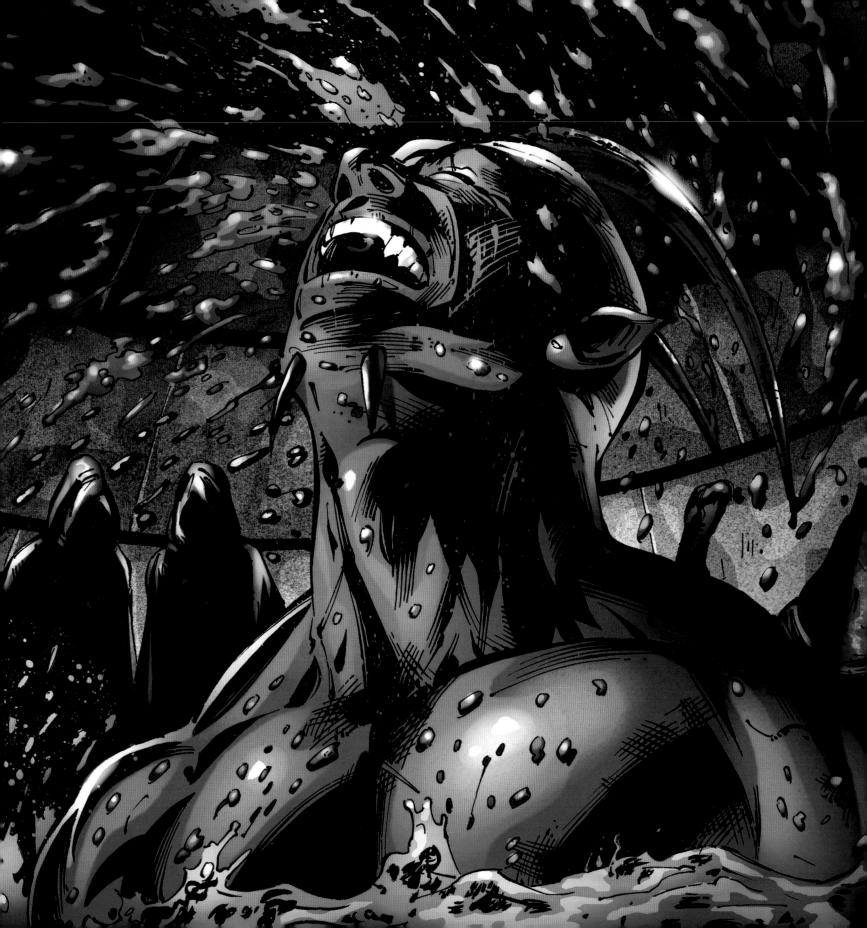

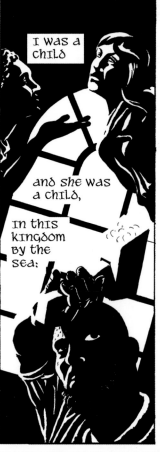
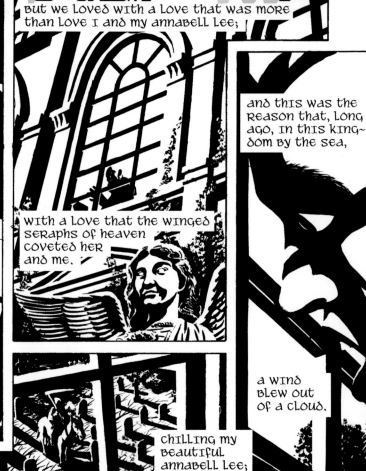

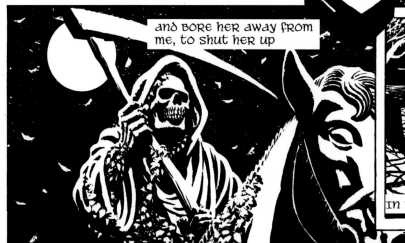

I was a child

and she was a child,

in this kingdom by the sea;

but we loved with a love that was more than love I and my Annabell Lee;

and this was the reason that, long ago, in this king~dom by the sea,

with a love that the winged seraphs of heaven coveted her and me.

a wind blew out of a cloud,

chilling my beautiful Annabell Lee;

so that her high~borne kinsman came

and bore her away from me, to shut her up

in a sepulchre

HERE LIES ANNABELL LEE

in this kingdom by the sea

▶ **Annabell Lee**
James Fletcher
Pen and ink
flexographics2001@yahoo.co.uk

For this adaptation of the poem
Annabell Lee*, written by Edgar*
Allan Poe following the death of
his much-loved wife and cousin
Virginia, Fletcher departed from
his regular drawing style in
favor of one with less emphasis
on outline and a much greater
use of solid black areas. "The
result, hopefully, came out as a
cross between the styles of Mike
Mignola on **Hellboy** *and Frank*
Miller's **Sin City***, thereby giving*
the four page story's build-up an
added air of mystery before its
shock ending."

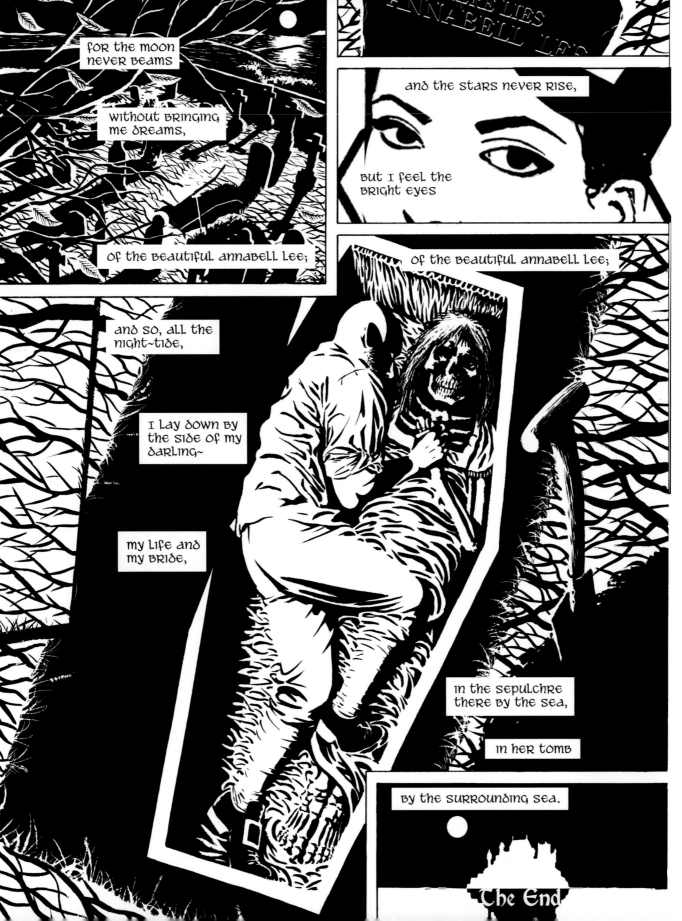

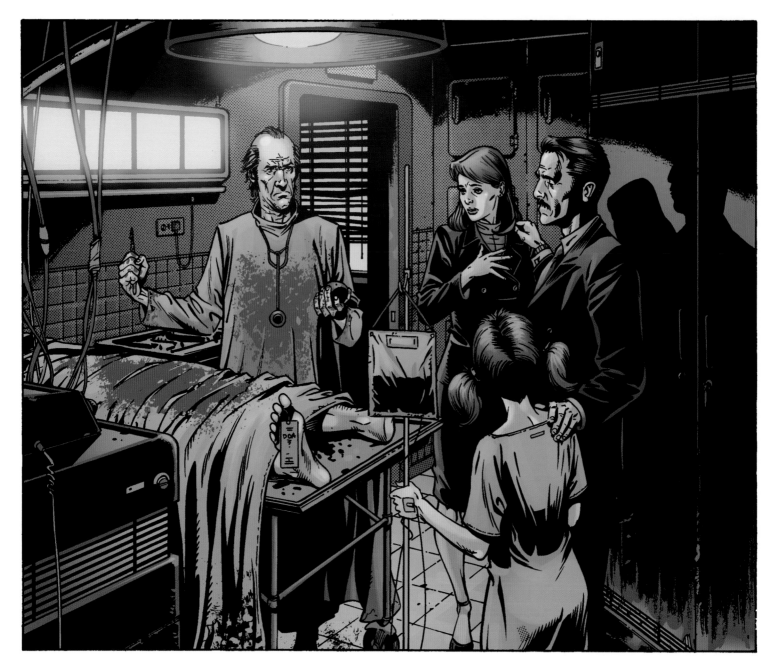

▲ **Donor**
Dylan Teague
Men's Health
Pen and ink, dry brush, Adobe Photoshop
www.dylansdrawingboard.blogspot.com
dylan_teague@hotmail.com

"This illustration was part of a set. It was good fun as I was told to make the scenes as gruesome as possible to illustrate the illegal trade of body organs. I thought going for a dingy green would emphasize the grimness of the situation and really make the red blood pop out!"

▶ **Girls**
Luna Brothers
Pencil and Adobe Photoshop
www.lunabrothers.com
jonathan@lunabrothers.com

Jonathan Luna comments, "Co-creator Joshua Luna and I wanted the art to be bold. We chose to display large, beautiful, washed-out faces splattered with blood. The alien girls in the story have recognizable long black hair, so I used that as a graphic element to frame their faces."

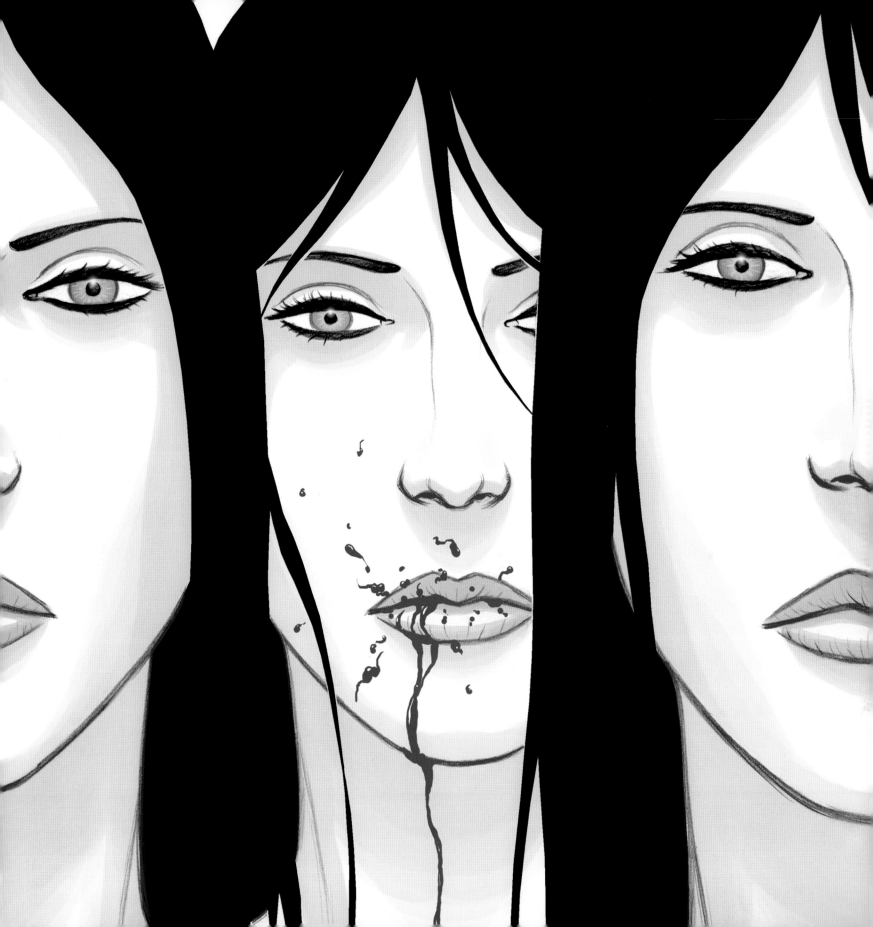

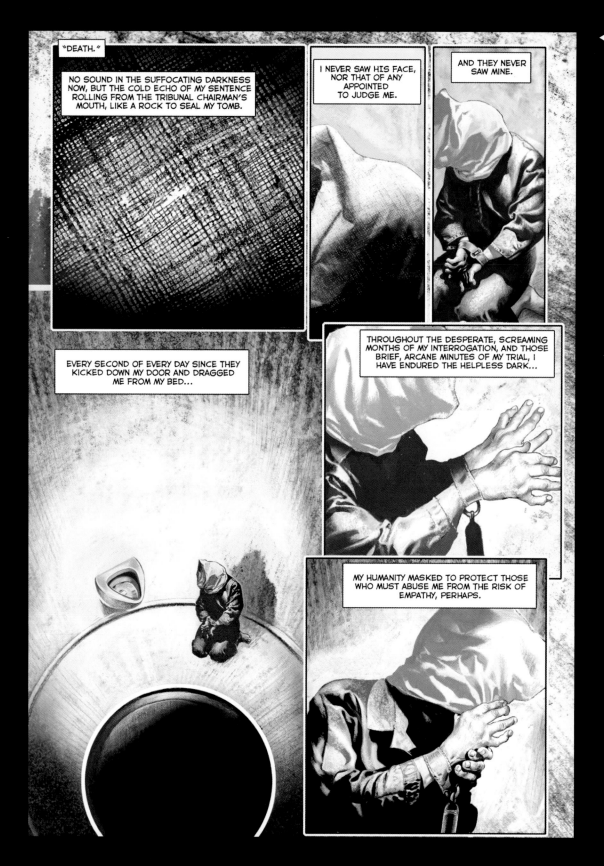

◀ ▶ **The Pit and the Pendulum**
Steve Pugh
SelfMadeHero
Pencil and ink, Adobe Photoshop
www.stevepugh.com
mail@stevepugh.com

Based on the short story by Edgar Allan Poe about a prisoner of the Spanish Inquisition, Pugh's finely detailed black-and-white art beautifully conveys Poe's ability to install pure fear into the reader. Pugh enhances — rather than overpowers — his linework by underplaying the use of Photoshop filters.

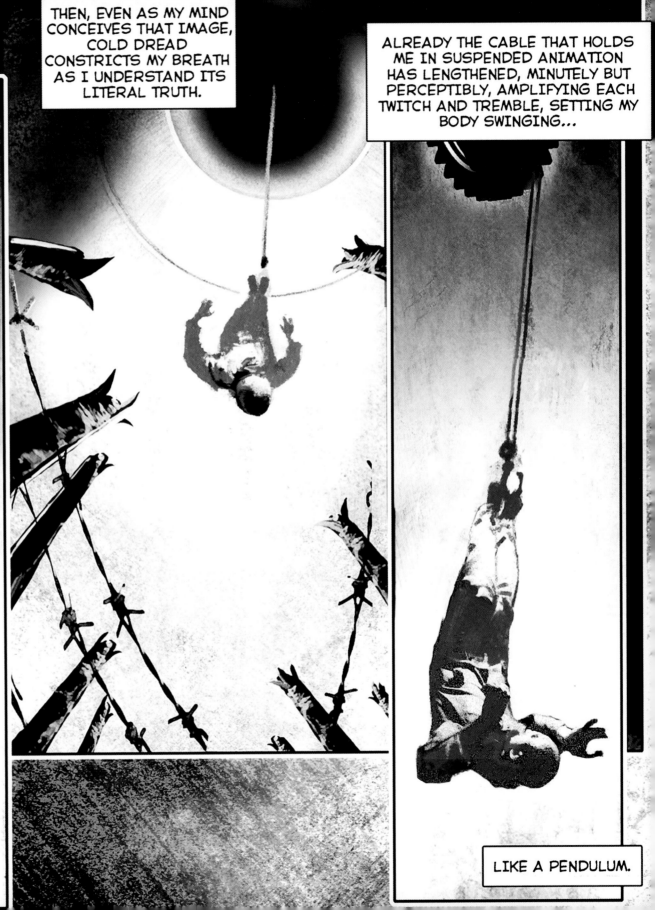
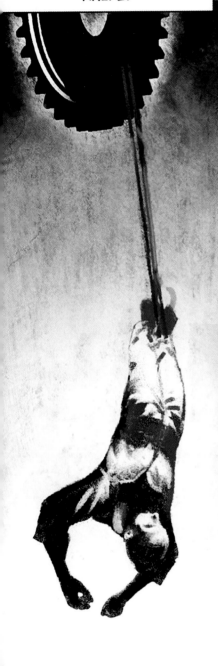

I AM NO MORE THAN MEAT TO THEM, A CARCASS HUNG IN AN ABATTOIR TO AWAIT THE BUTCHER'S KNIFE.

THEN, EVEN AS MY MIND CONCEIVES THAT IMAGE, COLD DREAD CONSTRICTS MY BREATH AS I UNDERSTAND ITS LITERAL TRUTH.

ALREADY THE CABLE THAT HOLDS ME IN SUSPENDED ANIMATION HAS LENGTHENED, MINUTELY BUT PERCEPTIBLY, AMPLIFYING EACH TWITCH AND TREMBLE, SETTING MY BODY SWINGING...

LIKE A PENDULUM.

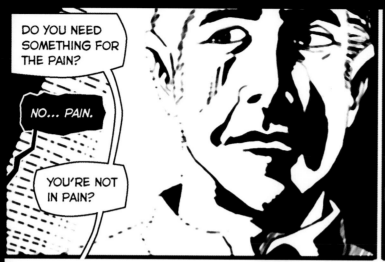

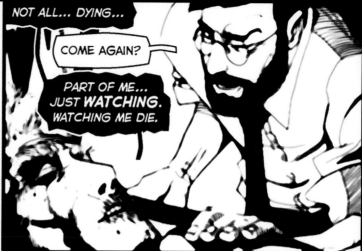

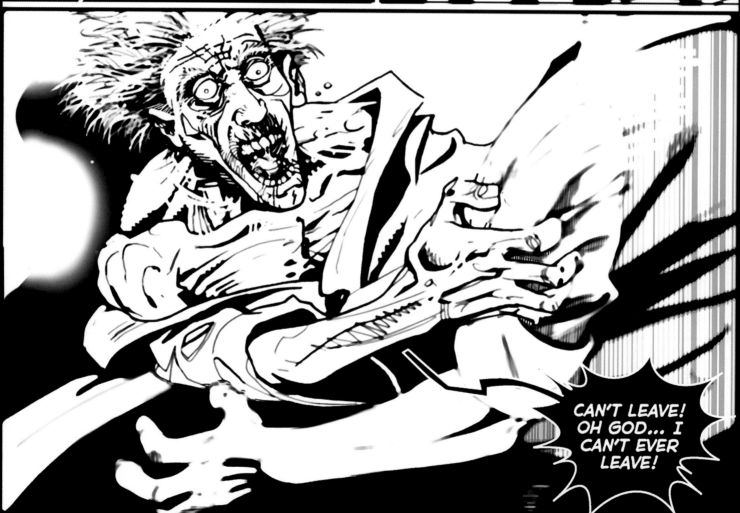

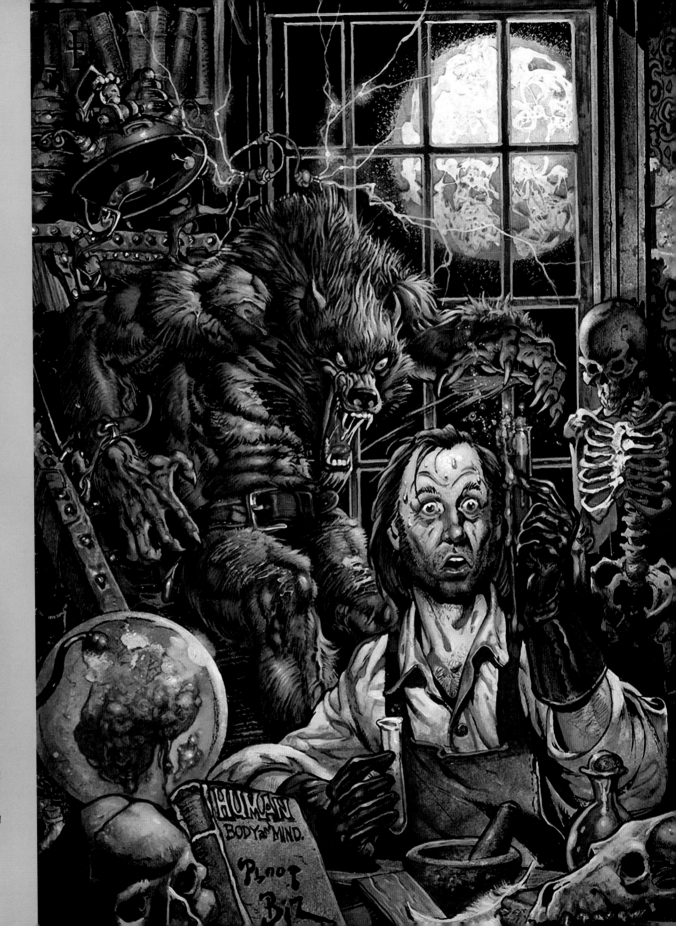

◀ **The Facts in the Case
of Mr Valdemar**
John McCrea
SelfMadeHero
Pencil and Adobe Photoshop
www.johnmccrea.com
john.mccrea@gmail.com

For **The Facts in the Case
of Mr Valdemar**, McCrea
*approached the strip as a totally
digital experiment. Following
his initial layout in pencil, he
used a Wacom tablet and stylus
to ink on screen, trying out a
combination of Photoshop filters
for special effects. "I thoroughly
enjoyed the experiment on
a short story like this. There
are some great effects you can
achieve with filters. I'm still a
pencil and paper guy overall,
but it has made me seriously
consider digital techniques as
an add-on."*

▶ **Thicker than Blood**
Mike Ploog and Simon Bisley
Reed Comics
Pencil, ink and acrylics
www.reedcomics.co.uk
mike.ploog@btconnect.com
sbizbiz@aol.co.uk

*Two industry leaders — one
American and one British —
combined their talents for this
cover. Mike Ploog, best known
for his US horror and fantasy
comics work, took the classic
"Look out! Behind you!" brief —
an homage to an earlier Monster
of Frankenstein cover he produced
for Marvel — and worked up the
layout through to finished inked
line work. Simon Bisley, renowned
for his painted art on both sides
of the Atlantic, then filled every
available space with detailed,
grisly color.*

▶ The Monster In The Well
Kate Brown
Pen and ink, Adobe Photoshop
extra.minty@gmail.com

The title this was drawn for does not run color interiors, but, following a grayscale original, Brown did this previously unpublished version simply for the fun of it. As she says, "The color scheme itself was a bit of an accident... It began as a minty kind of green, but due to overlaying a scanned picture of a piece of papyrus as a texture, it took on this orangey tint that I quite liked, so I left it as that."

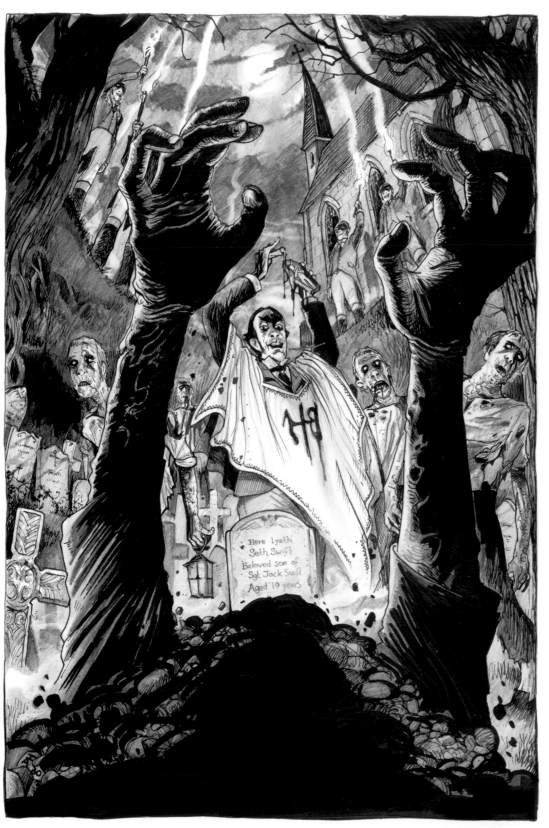

◀ ▶ Zombies
David Hitchcock
Pencil and ink
www.blackboar.co.uk
black_boar1@yahoo.com

Hitchcock produces most of his work in black and white, invariably set in the Victorian era, which he admits to finding "more visually stimulating" than contemporary times. "I pencil and ink the pages, then add further pencil toning in an attempt to give the art a more three-dimensional look. I find this method works particularly well for portraying light, and creating mood within the panels."

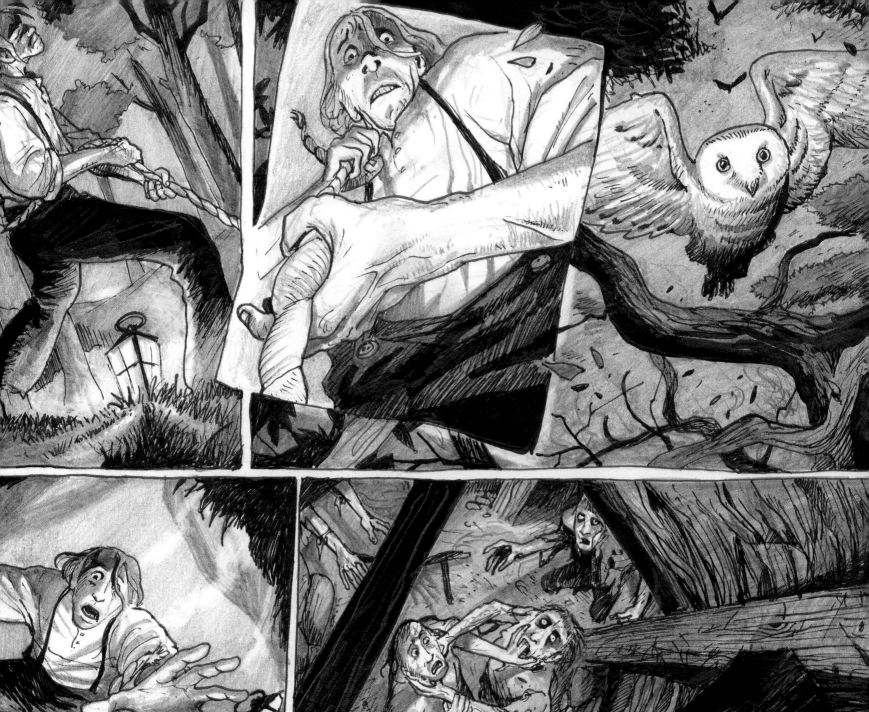
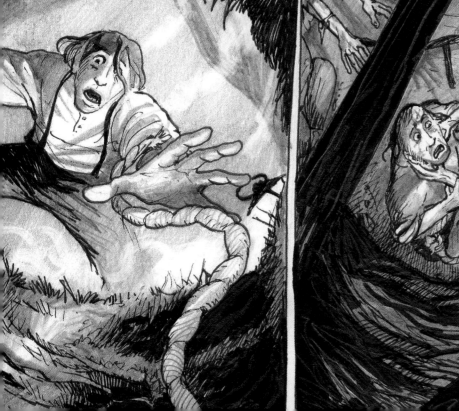
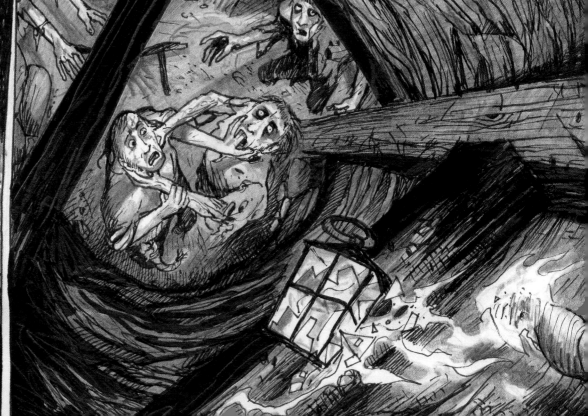

▶ **Raise the Dead**
Hugo Petrus
Dynamite Entertainment
Pen and ink, colored
in Adobe Photoshop
www.dynamiteentertainment.com

A graphic designer and advertising artist turned comic book illustrator, Hugo Petrus works from his studio in Barcelona, Spain, providing pen and ink artwork to be colored in Sao Paulo by Ivan Nunes for a US-published tale of survival and terror in a world being overrun by the walking dead. With the eye of a cinematographer, Petrus moves constantly between action and reaction to convey both the sheer horror of the victims' narrative, and the bloodlust of the living dead. The splash page opposite, with its lull before the storm, tells the reader everything in a single picture: the victims in the background, the hard-faced heroes advancing after a successful defence (visualized through the smashed canister dripping blood on to the ground), and the doors flung wide in defiance of the threat!

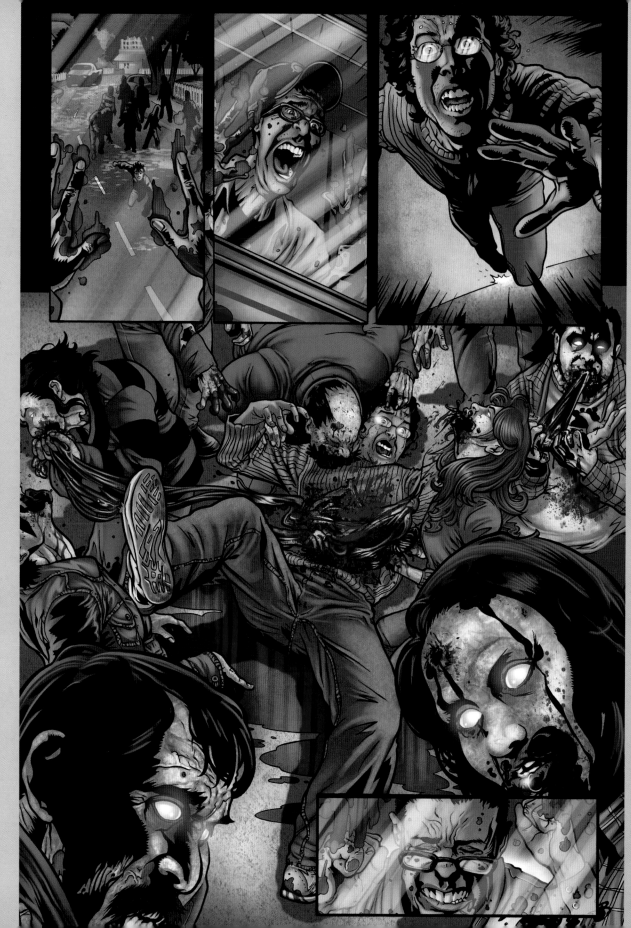

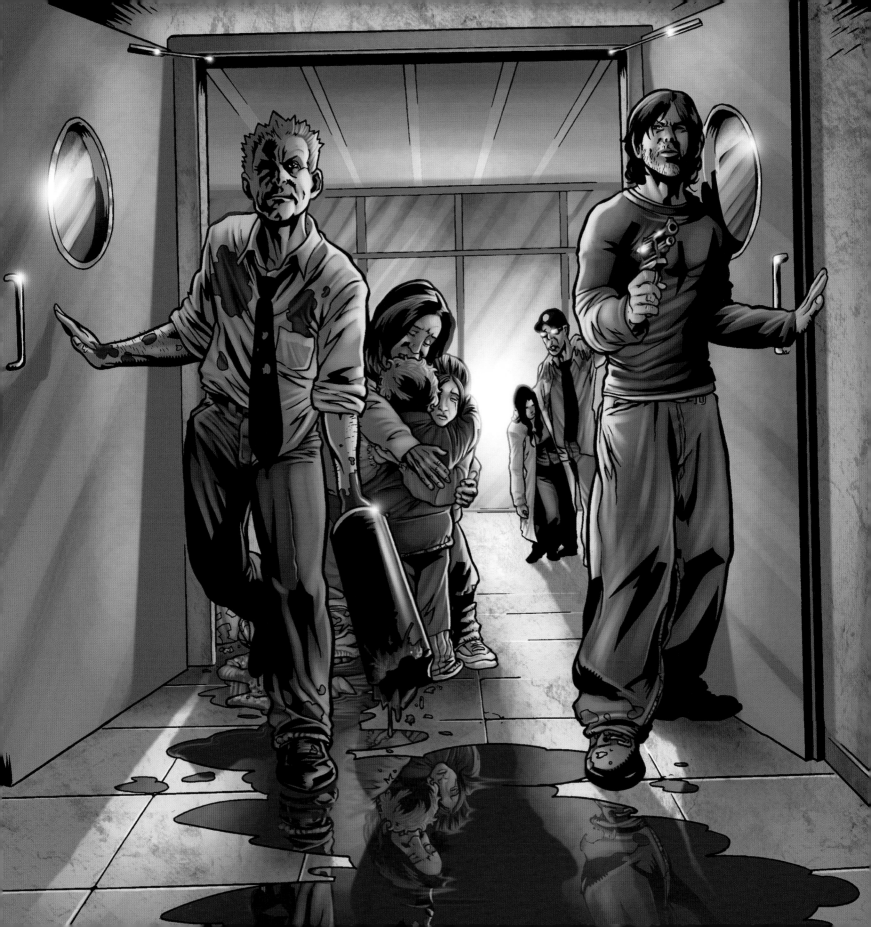

▶ **Contagion**
Cris Bolson
Trepidation Comics
Pen and ink
www.glasshousegraphics.com
crisbolson@gmail.com

Brazil's Cristiano Loureiro Bolson learned how to draw by "looking at artists, new and old, and trying to discover how they do their jobs." He also comments on something all creatives probably feel; "Seeing a printed copy of a title that you worked on — even if only on one illustration — is always a great motivation, as is receiving payment!" Bolson's raw black-and-white art, shown here before being covered in lettering, reveals a variety of "camera" angles between panels, and a confident use of solid black that makes any coloring a bonus.

▶▶ **The Cauld Lad Of Hylton**
Bryan Talbot
Pen and ink
www.bryan-talbot.com

This was produced as a pastiche of 1950s US horror comics, and is based on the story that the ruins of Hylton Castle (in Sunderland, Northern England) are haunted by the ghost of a murdered stable boy. Talbot's version appears as one of many stories drawn in a range of styles for his graphic novel, **Alice in Sunderland.**

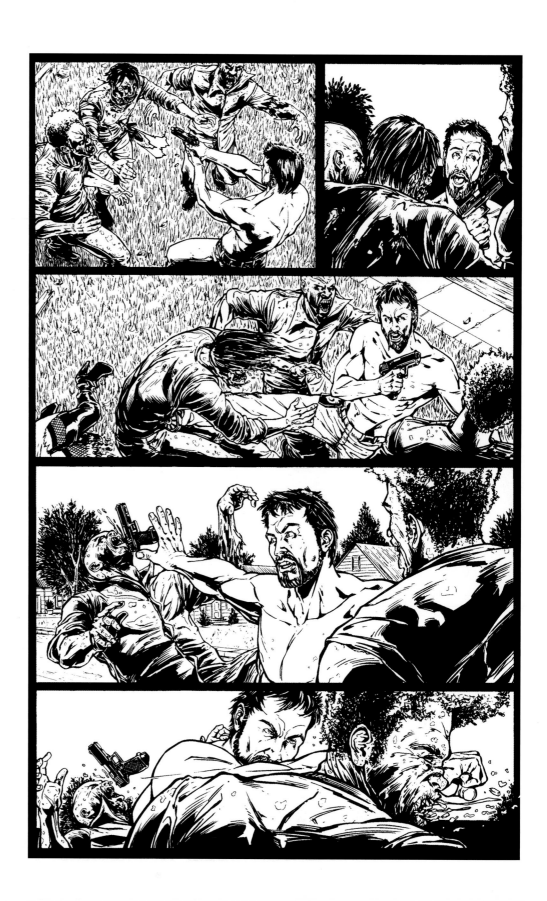

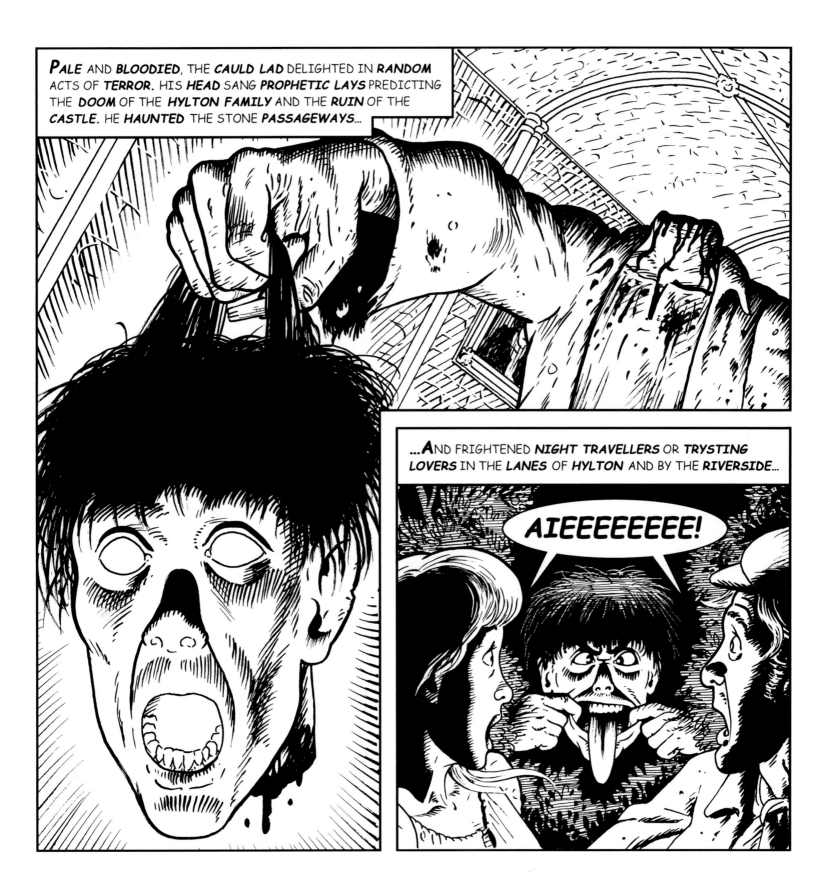

▶ **Beowulf**
Chris Steininger
Markosia
Brush/dip-pen and ink
www.christophersteininger.com
csteininger@gmail.com

*For his 64-page graphic novel
based on the greatest surviving
Anglo-Saxon poem, the self-taught
Canadian artist brought together
both his artistic loves to create a
black-and-white painted comic.
An epic tale of the legendary
warrior and his darkly evil
nemesis—the man-ogre Grendel—
Beowulf is a grisly tale of
monstrous proportions that
remains faithful to the original
material, but has been adapted
for a modern audience. "I have
looked forward to working on
something like this for a long
time," Steininger says. "Fantasy
adventures like Beowulf are
very few and far between.
It's incredibly fun work."*

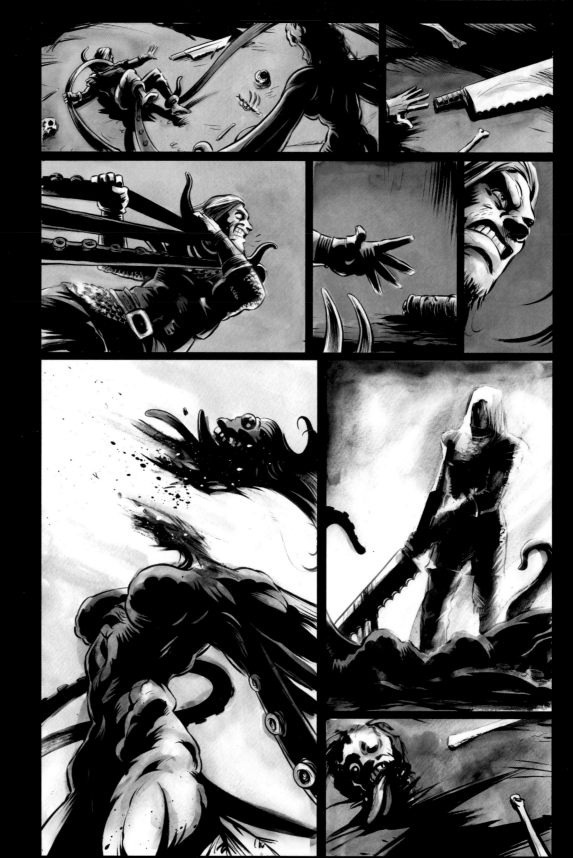

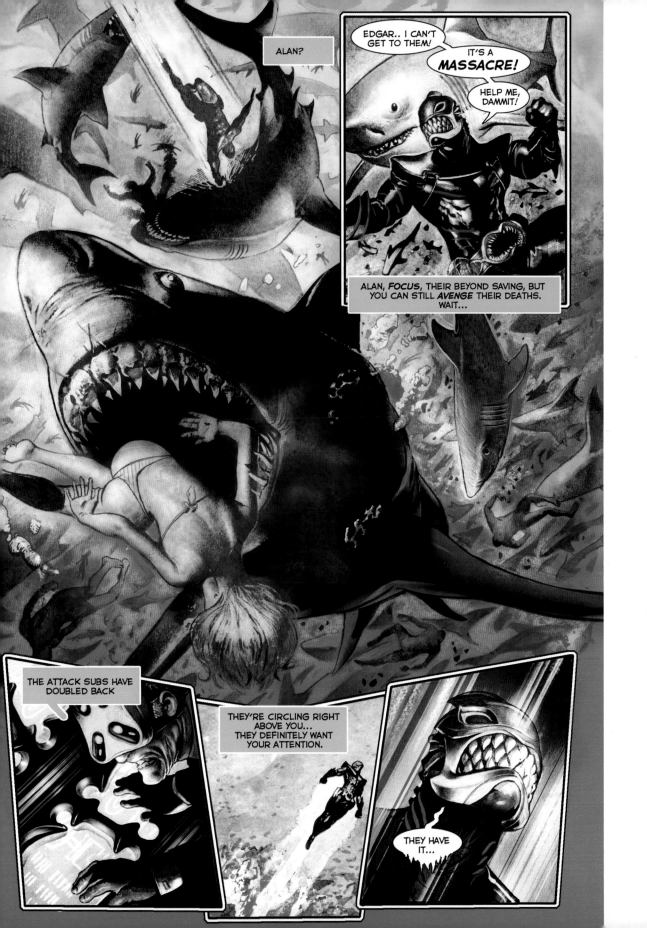

◀ **Sharkman**
Steve Pugh
Pencil, smudegestick,
Adobe Photoshop
www.stevepugh.com
mail@stevepugh.com

*Shark attack! Pirates sink a
luxury cruise liner in the shark-
fields to keep Sharkman busy.
"Evil stuff," says the artist,
"but the kids seem to like it!"
After ten years in US and UK
comics producing black-and-
white line art for titles such as
Preacher: Saint of Killers, **X-
Men: Generation-X**, and **Judge
Dredd**, Pugh recently made the
leap to full color artwork. He says
he is hoping—
in some small way—that he
will be able to recreate the lavish
and colorful heyday of 1960s
UK comic book illustration for
a new generation of readers.*

30 Days Of Night
Ben Templesmith
Pen, ink, acrylic, watercolor
and Adobe Photoshop
www.templesmith.com
contact@templesmitharts.com

*A cover painting to the award-winning **30 Days of Night** comic book co-created by Templesmith and US writer Steve Niles, and now a feature film from Columbia Pictures. The book's title is taken from its location — Alaska — where nights can last for an entire month. Templesmith, who admits to working very long hours, maintains he has a system where, incredibly, he can usually create 2-3 finished pages a day.*

◄ **Wormwood**
Ben Templesmith
IDW Publishing
Pen, ink, acrylic, watercolor
and Adobe Photoshop
www.templesmith.com
contact@templesmitharts.com

*"This is a cover to the horror/
black humor comic book
that I write and draw called
**Wormwood: Gentleman
Corpse**. It's about a demonic
worm-thing that wears various
corpses like suits and has an
unhealthy fixation with beer and
sounding clever. This one was a
riff on the Demi Moore magazine
cover when she was pregnant, as
Wormwood is also with child in
this particular episode."*

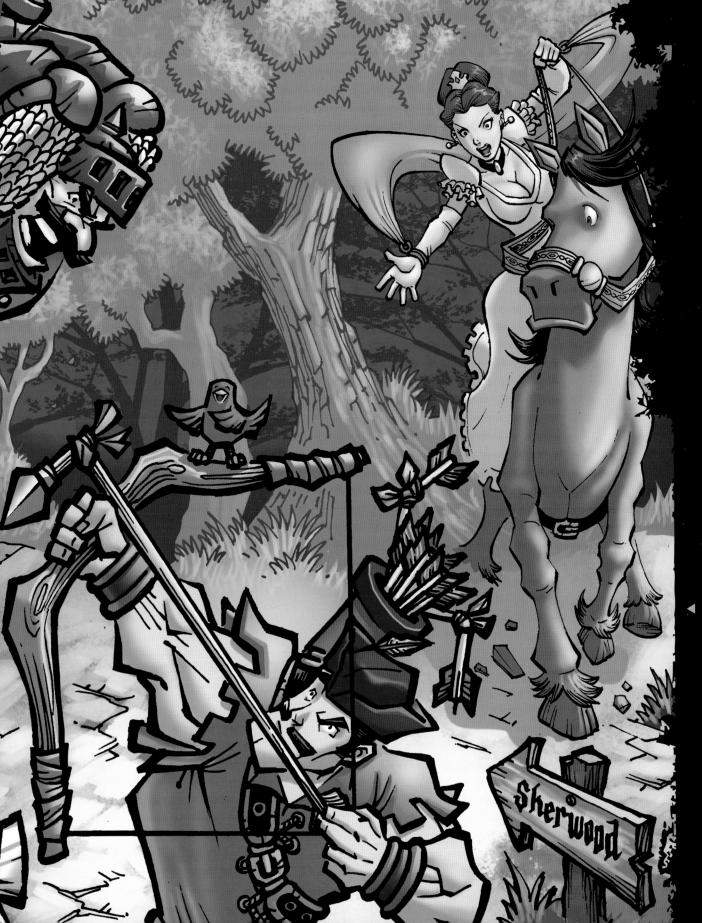

◄ **Sherwood**
Anthony Tan
Line art and digital color
www.glasshousegraphics.com
aug224@yahoo.com

*Working in the Philippine comic
book industry since 1993, Tan i̇
beginning to make his mark in
the USA. "I almost gave up, bu
I didn't lose hope. Instead, I go
in touch with regular artists fo
some advice." As well as the ne
Sherwood series, he has produc
cover work for the second seaso
of* **Who Wants to be a Super-
Hero** *and for* **Tokyopop**, *the
first official "Bratz" manga.*

◀ **Tozzer**
Peter Lumby
www.tozzer.com
pete@tozzer.com

*Lumby is a storyboard artist who focuses on commercials, music videos and the occasional movie, but "over the last eight years I've dabbled in just about every other form of commercial illustration." **Tozzer** — a bitingly humorous graphic novel and series — is a collaboration with an old friend from art school. "I forced my Mum to read Tozzer. I don't think she got any of it, but she was still proud of her son and took a copy to show her friends."*

▶ **Alcohol and Me**
Ben Naylor
Black Biro and Photoshop
benjaminnaylor@yahoo.co.uk

Trained as an illustrator, Naylor prefers working in black and white on fantasy and comic art projects. Here, his quirky lettering style becomes an almost integral part of the page, typical of more personal tales. "I am keen on slice-of-life stories that take a surreal look at the ordinary, or an ordinary take on the surreal."

▶ **OiNK!**
Hunt Emerson
Pen and ink
www.largecow.com

Alternating between underground and mainstream publishers, Emerson has been drawing comics for 35 years. He gives his excuse for not getting a proper job or attempting a more realistic style by saying; "I discovered that if I drew a hand with five fingers it looked like it had one digit too many, so I was inevitably propelled towards "humorous" comics, and that has been my style ever since — big noses, big feet, four-fingered hands. And the bigger the nose, the less space there is to fill with other drawing!"

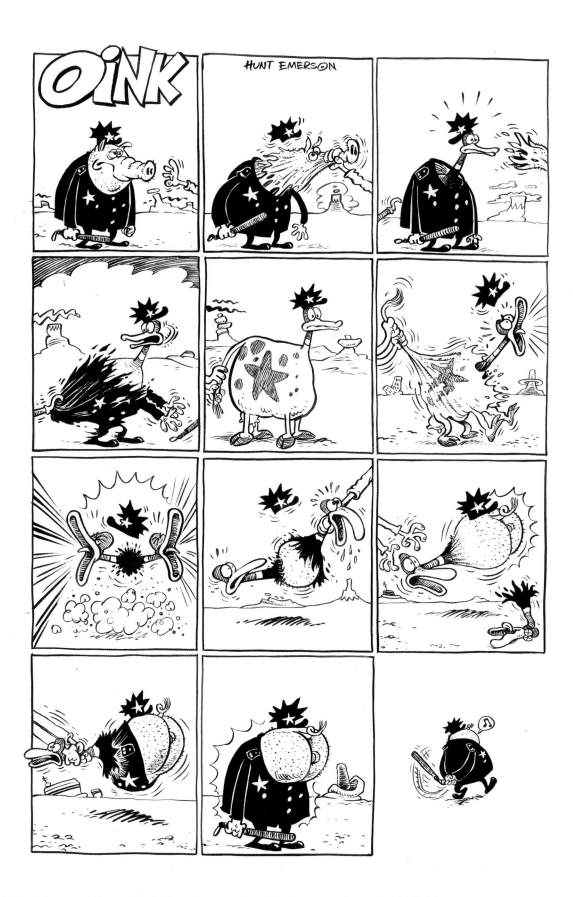

Bitchy Bitch
Roberta Gregory
Pen and ink
www.robertagregory.com
roberta@drizzle.com

*This is a previously unpublished page of Gregory's best known creation—**Bitchy Bitch**— who the artist describes as "A very complex character, short tempered, short sighted and someone most people can relate to." Bitchy appears in collections in German, French, Spanish and Swedish—as well as English— and Gregory is working on a graphic novel "Which just seems to be taking forever, but it will be really cool when it is finished."*

And THEN my born-again co-worker Marcie decided she was going to save my soul...

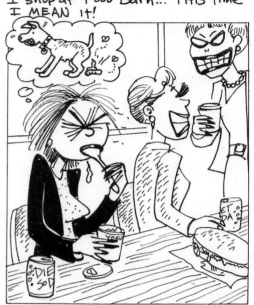

Actually, THIS part was kind of FUN!

Then the YOGURT I brought for lunch tasted crappy! I'd just BOUGHT it. and the expiration date was a MONTH ago! That's the LAST time I shop at Food Barn... THIS time I MEAN it!

So, I decided to TREAT myself to a nice, messy, greasy BURGER! But, there was so much TRAFFIC I ended up coming in late from lunch... RIGHT in front of Ms. Rottweiler.... of COURSE!!

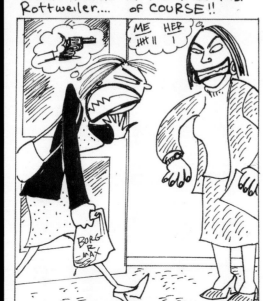

AND, Marcie got to leave EARLY that afternoon... just because she's working at some stupid CHURCH CAMP-- and I had to finish her WORK...

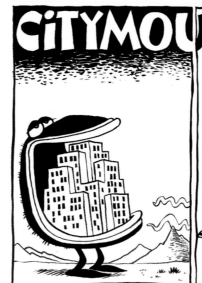
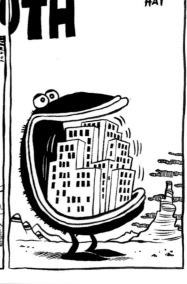
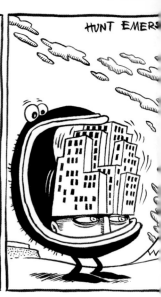

CITYMOUTH HAT HUNT EMERS

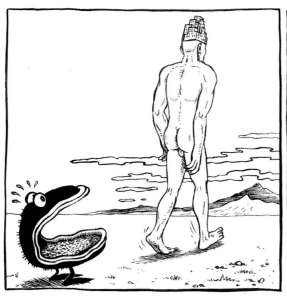
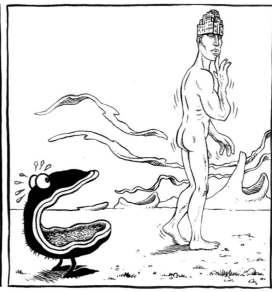

◀ **Citymouth**
Hunt Emerson
Pen and ink
www.largecow.com

"*The first* **Citymouth** *characters
I drew were for a poster in the
early 80s, for an Art College Ball
in Derby. The idea came from
a doodle, and further doodling
led to possibly my strangest
comics characters—giant oyster-
type things with cities in their
mouths. I drew a series of stories
about them over the following
decades, all without words (so
they could be easily published
abroad). This strip is the final
one in the series.*"

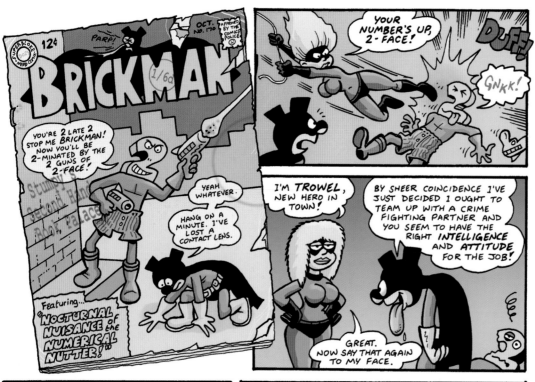

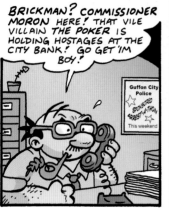

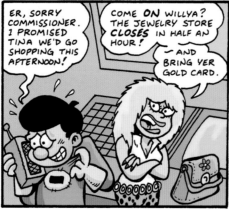

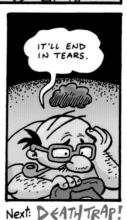

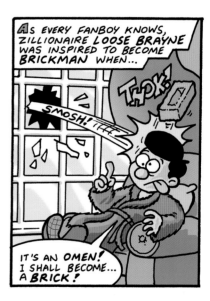

◀ **Brickman**
Lew Stringer
Pen and ink, Adobe Photoshop
www.lewcomix.tripod.com
lew.stringer@btinternet.com

*Lew Stringer has been writing
and drawing humor strips
for all major UK publishers,
plus comic album* Suburban
Satanists *for the Scandinavian
market, and* Brickman *for
US publisher Active Images.
In Brickman (an obvious parody
of Batman), Stringer revels in
the nostalgia of the absurd.*

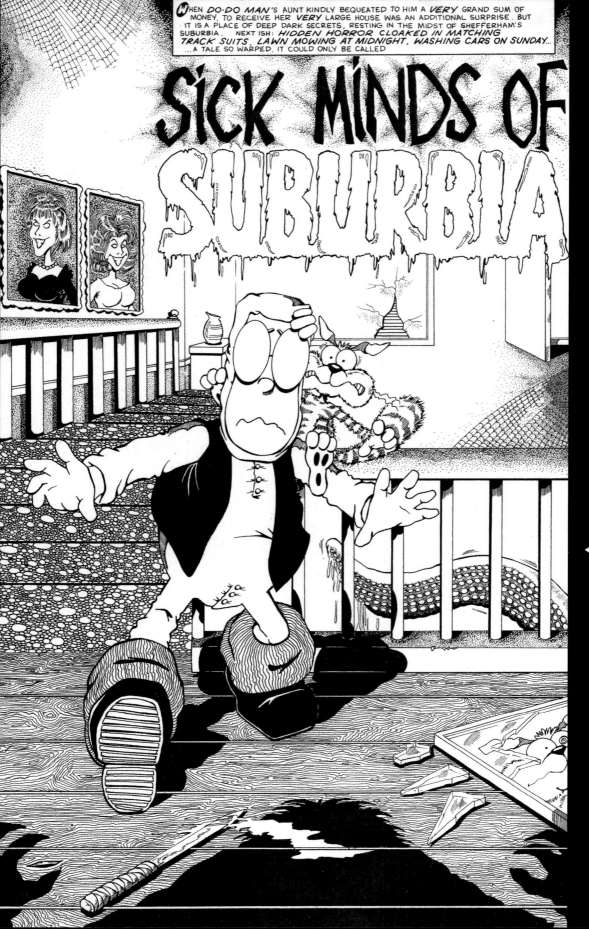

WHEN *DO-DO MAN'S* AUNT KINDLY BEQUEATED TO HIM A *VERY* GRAND SUM OF MONEY, TO RECEIVE HER *VERY* LARGE HOUSE WAS AN ADDITIONAL SURPRISE. BUT IT IS A PLACE OF DEEP DARK SECRETS, RESTING IN THE MIDST OF SHEFFERHAM'S SUBURBIA. NEXT ISH: *HIDDEN HORROR CLOAKED IN MATCHING TRACK SUITS, LAWN MOWING AT MIDNIGHT, WASHING CARS ON SUNDAY...* ...A TALE SO WARPED, IT COULD ONLY BE CALLED

SICK MINDS OF SUBURBIA

◀ **Do-Do Man**
Mychailo Kazybrid
Pencils to pen & ink
mychailo@btinternet.com

People generally assume that art in humor comics is little more than basic outline work. Kazybrid has obviously never heard these people, as his detailed penmanship on his backgrounds is little short of 19th century engravings, and in stark contrast with the foreground hero and his cat. "Do-Do Man was created to give a face to Joe Public," say creators Mychailo Kazybrid and Sarah Sier. "While researching a cure for insanity, our protagonist inadvertently drinks Chemical X instead of tea. This results in 'Do-Do Man,' a wonderfully wild and playful psychotic."

The Bizarre Adventures of Gilbert & Sullivan

▶ **The Bizarre Adventures of Gilbert & Sullivan**

Laura Howell
Pen and ink, digital toning
www.laurahowell.co.uk
nyanko@blueyonder.co.uk

"I've been drawing and writing *The Bizarre Adventures of Gilbert and Sullivan* since about 2003, with over fifty stories completed—and counting. Originally I made them up as I went along, drawing on scraps of paper just to amuse myself. Then, in 2006, I re-did one of my favorites in a manga style and submitted it to the International Manga and Anime Festival's Best Comic category. It won. Despite having been a doodler for as long as I can recall, I succumbed to my primal urge to write and draw stupid stuff full-time in 2006. Now my client list ranges from MAD Magazine to Harvard University."

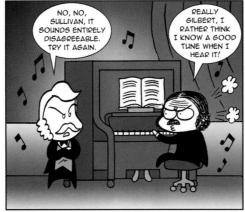

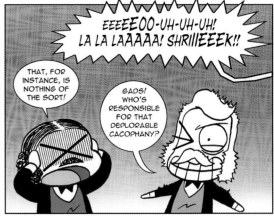

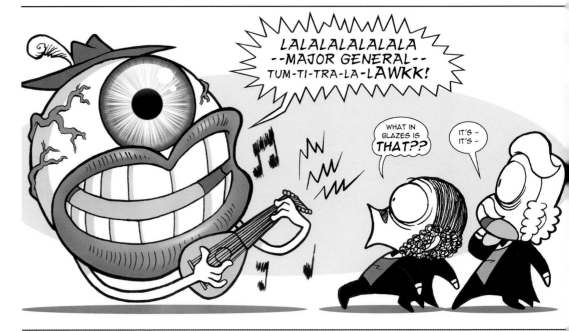

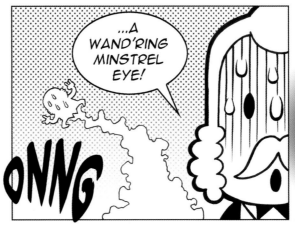

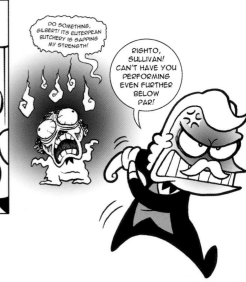

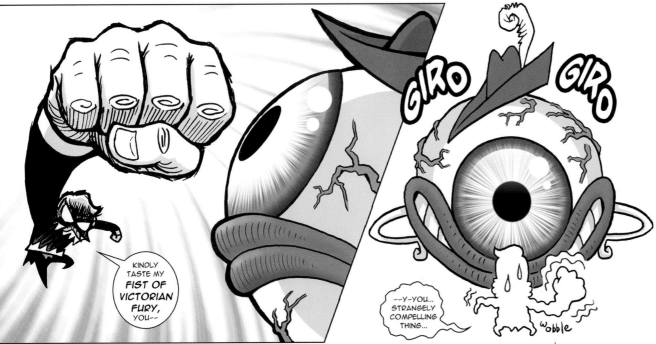

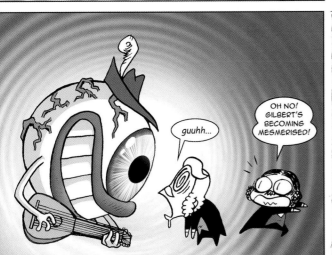

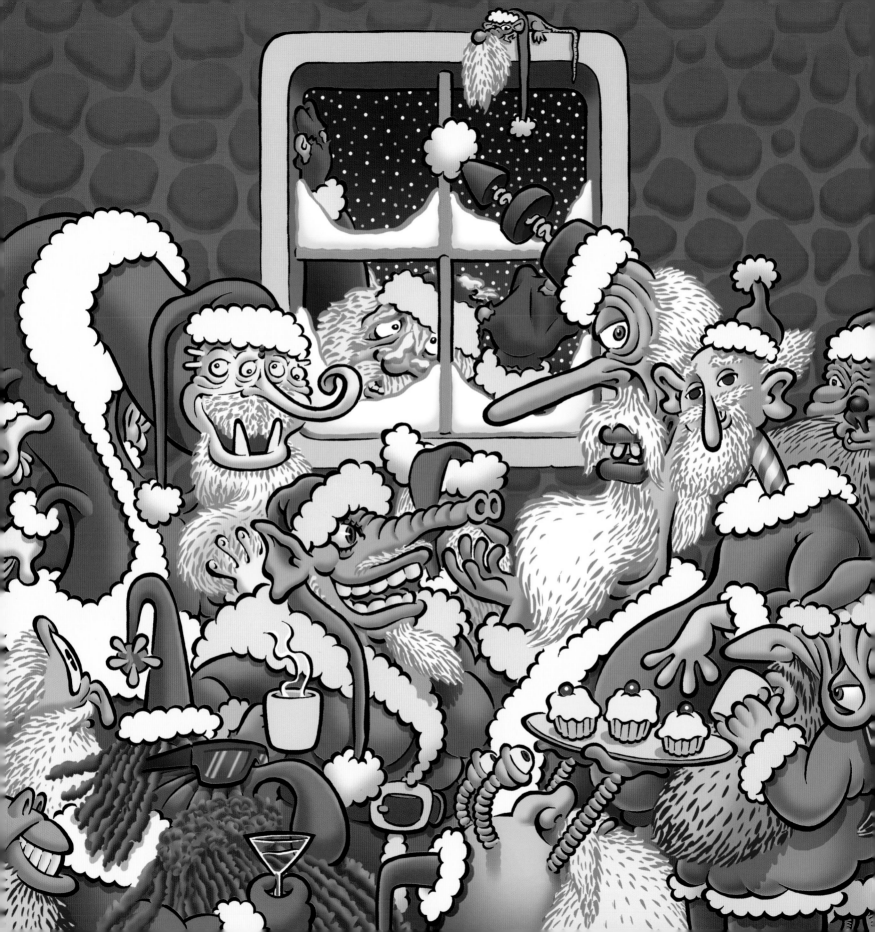

◀ **Destroy All Santas**
Howard Cruse
Birmingham Weekly
Pen and ink, colored
in Adobe Photoshop
www.howardcruse.com
howardcruse@verizon.net

J'Mel Davidson's satirical
Christmas story—which Cruse's
drawing illustrates—involves a
proliferation of bizarre pseudo-
Santas. "Anyone who has paid
attention to my work since my
underground comix days will
know that I love drawing weird
and hallucinogenic creatures,
with at least a few cross-species
attributes, distended eyeballs,
and grotesquely sagging folds of
flesh. So this assignment allowed
me a nostalgic return to my
acid-head roots under cover of
comedic yuletide respectability."

▶ **Lincoln's Heart**
Ben Ang
Pencil and Adobe Photoshop
www.xplixit.blogspot.com
freelance.ben@gmail.com

A sample page from a new comic
Ang is currently working on
between commissions, displaying
his somewhat humorous
approach to action storytelling.
Being based in Singapore, he
admits "My pocket money went
on **Dragonball** and **X-Men**,
resulting in my art style being a
mixture of both east and west."
Instead of the industry norm of
producing finished pencil art
and then laboriously repeating
the line work in ink, Ang chose to
retain the spontaneity of finish
by inking over very rough pencil
sketches, digitally cleaning up
the end product and adding
halftones in Photoshop.

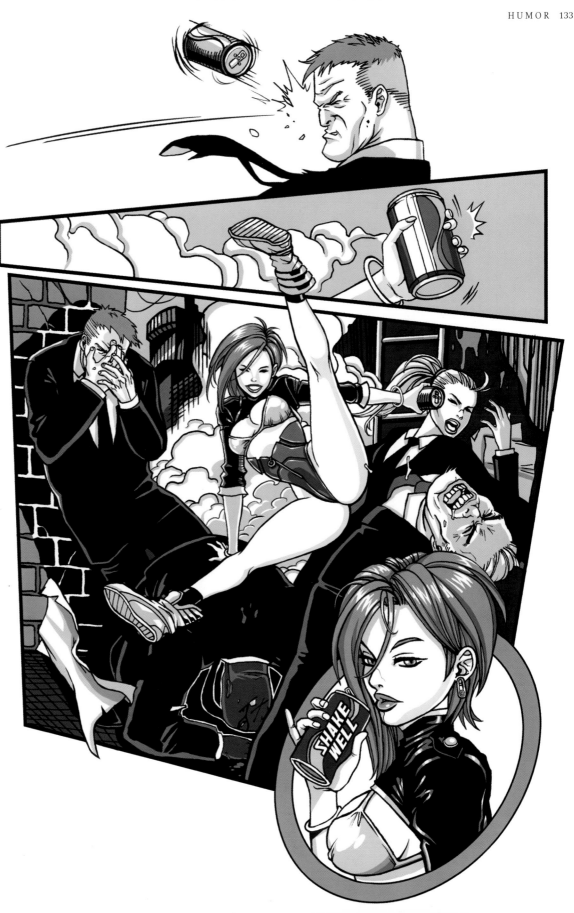

Diary of a Genus

Roll up! Roll up!

▶ **Dix**
Pen and ink, colored in Adobe Photoshop
www.grimreality.co.uk / dix@grimreality.co.uk

Fine artist and newspaper cartoonist Andy (Dix) Dixon has a dark and surreal sense of the absurd. Happy to work within the limitations of a three-panel newspaper grid, he admits that "It can be quite inspirational, and having such severe restrictions can distil the essence of my drawing and my humor. The beauty of black-and-white is there's less chance of blurring, off-register printing or color change, so there are no nasty surprises… beyond my humor, of course!"

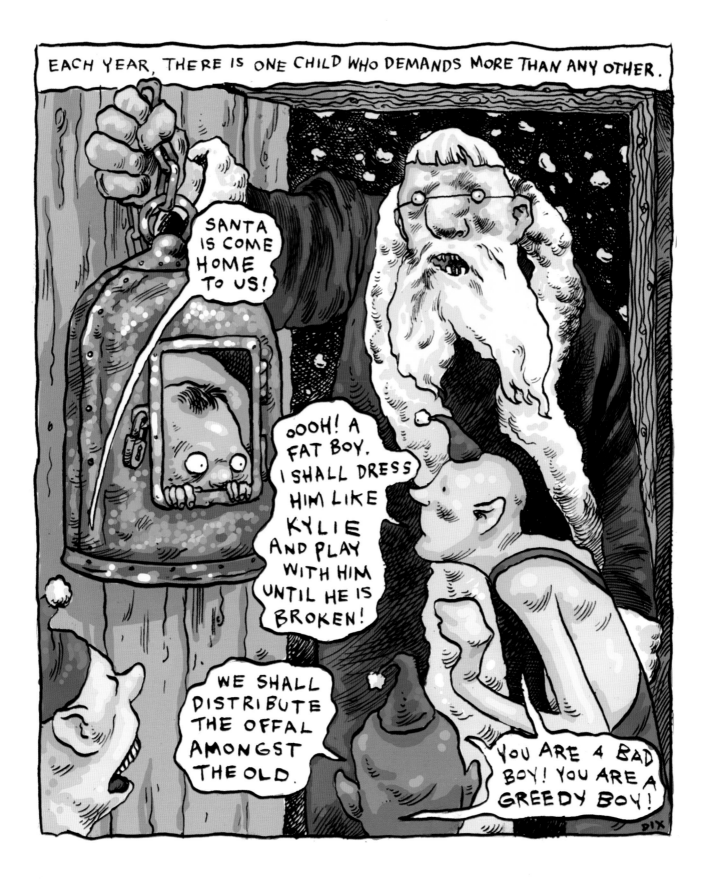

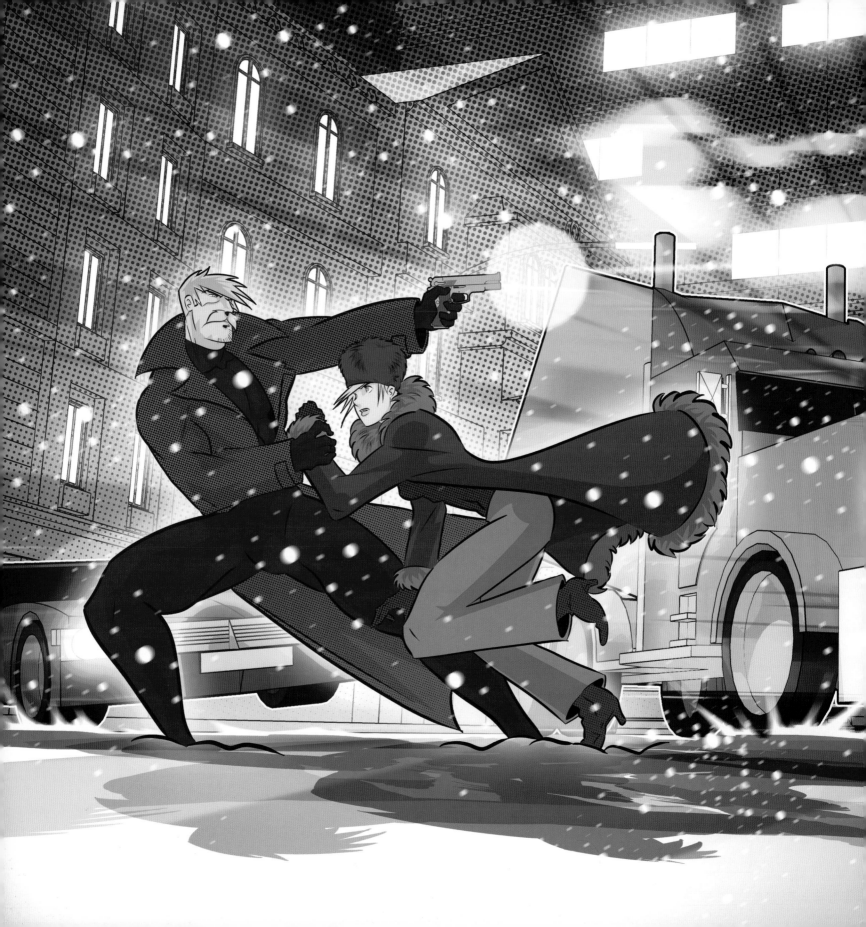

CHAPTER 6

COMIC NOIR

◀ **November**
Robert Deas
Sketchbook Pro 2, Adobe
Photoshop and Google Sketchup
www.rdcomicsonline.com
rdcomics@rdcomicsonline.com

*A promotional image for the
prologue Deas is working on
for his intriguingly entitled
November. Following the
popular route for creator-owner
properties, he says "It is going to
be available as a webcomic on
my site as I produce it, although
I am planning to eventually
self-publish it. The prologue is
hopefully going to help cross-
promote my site and the book."*

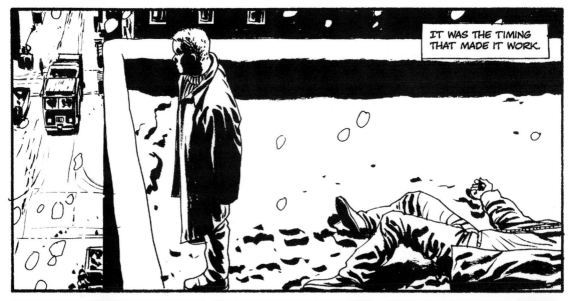

IT WAS THE TIMING THAT MADE IT WORK.

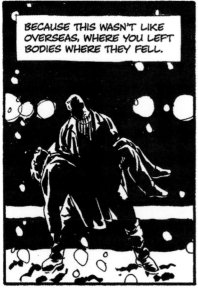

BECAUSE THIS WASN'T LIKE OVERSEAS, WHERE YOU LEFT BODIES WHERE THEY FELL.

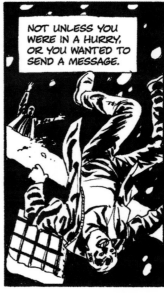

NOT UNLESS YOU WERE IN A HURRY, OR YOU WANTED TO SEND A MESSAGE.

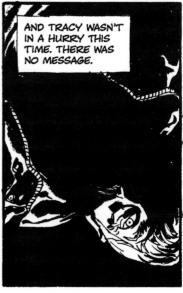

AND TRACY WASN'T IN A HURRY THIS TIME. THERE WAS NO MESSAGE.

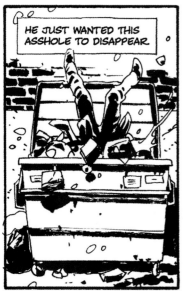

HE JUST WANTED THIS ASSHOLE TO DISAPPEAR.

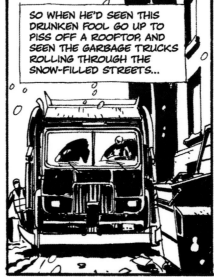

SO WHEN HE'D SEEN THIS DRUNKEN FOOL GO UP TO PISS OFF A ROOFTOP, AND SEEN THE GARBAGE TRUCKS ROLLING THROUGH THE SNOW-FILLED STREETS...

...IT HAD ALL CLICKED INTO PLACE.

HE'D BE ROTTING IN A LANDFILL BY MORNING, AND NO ONE WOULD EVEN KNOW.

AND NOW TRACY HAD A WAY IN.

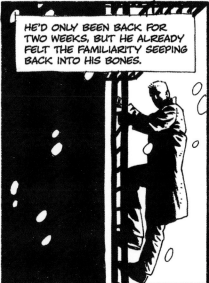

HE'D ONLY BEEN BACK FOR TWO WEEKS, BUT HE ALREADY FELT THE FAMILIARITY SEEPING BACK INTO HIS BONES.

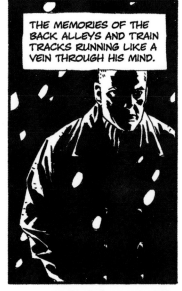

THE MEMORIES OF THE BACK ALLEYS AND TRAIN TRACKS RUNNING LIKE A VEIN THROUGH HIS MIND.

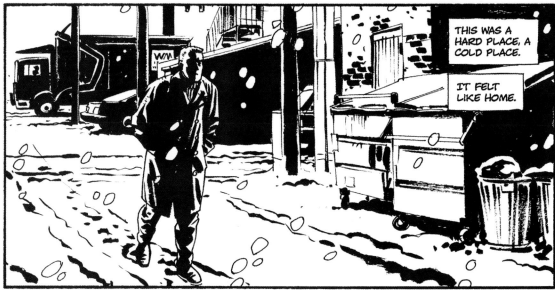

THIS WAS A HARD PLACE, A COLD PLACE.

IT FELT LIKE HOME.

◀ **Lawless**
Sean Phillips
Marvel Comics
Pen, brush and ink,
and Adobe Illustrator
www.seanphillips.co.uk
sean@seanphillips.co.uk

Working to a rigid panel layout on a standard three-bank grid, Phillips' use of solid blacks make these pages work perfectly, without the need for color. When composing a page, the importance of solid areas to contrast with open line work cannot be overestimated. In fact, many artists start by producing thumbnail roughs simply to "spot the blacks," and enhance the page's balance. Phillips simply remarks, "If this doesn't make you want to read more, nothing will."

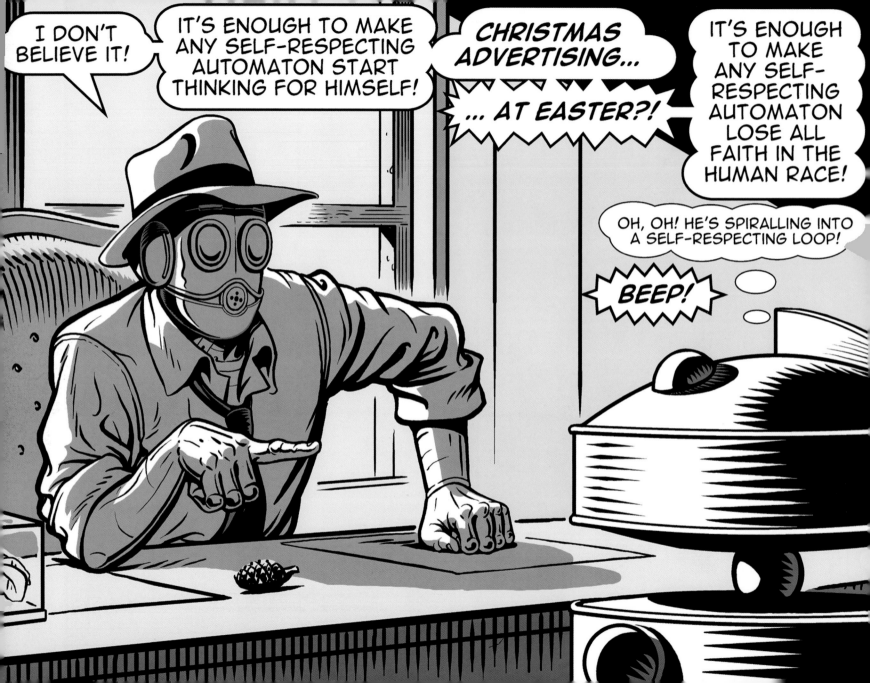

▲ **The Blue Lily**
Angus McKie
Brush (and ruler) and Adobe Photoshop
www.angusmckie.com.uk / angus.mckie@dsl.pipex.com

The color visual was produced as an ad for **The Blue Lily** — a creator-owned project that was part published by Dark Horse Comics, but has yet to be completed. Of the interior panels, McKie says, "Line art is probably the toughest to do well because there is nowhere to hide. But one of the great attractions of the digital domain is the ability to alter easily. Of course, nothing comes free—it can be a deadly temptation too."

◀ **Hope Falls**
Dan Boultwood
Markosia
Pencil art, inked and colored
in Adobe Photoshop
baronvonbloodshrimp@gmail.com

*An angel, free-falling towards
hell, returns to the town she
lived in to gain revenge against
the four men who raped and
killed her 20 years earlier.
The main challenge facing
Boultwood was that he had to
mature his usually light and
humorous style to fit the tone
of this new series because, as
he says, "Saturday morning
style cartoons shouldn't run
around murdering and raping
people." He also tried a different
technique, inking his pencil using
Photoshop and a Wacom tablet:
"The ability to undo any mistake
instantaneously makes you feel
like a cheat and a genius at the
same time."*

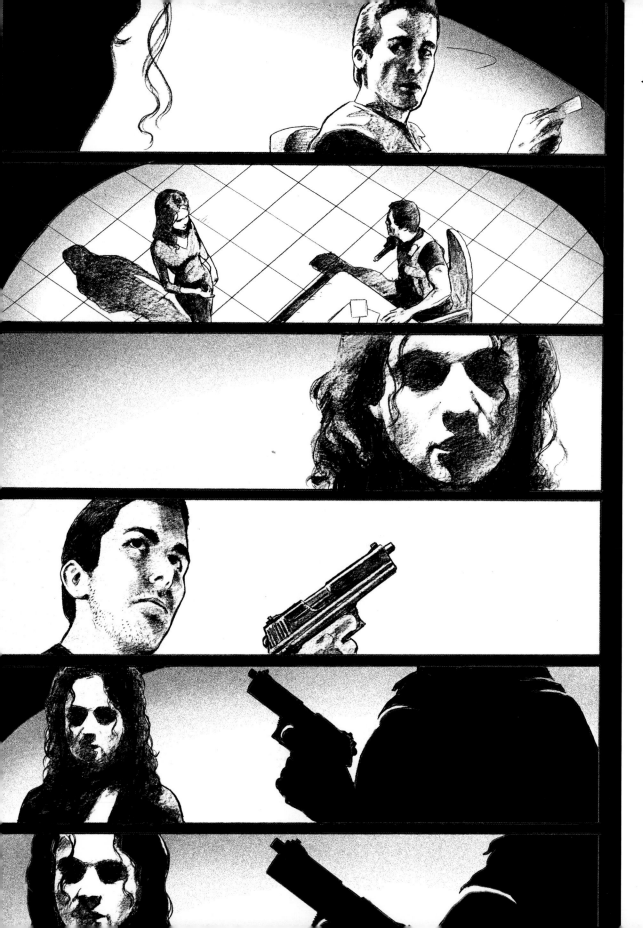

◀ **Echoes of Dawn**
Cliff Richards
Trepidation Comics
Pencil artwork
www.glasshousegraphics.com
cliffic2@yahoo.com.br

*This is a horror story very much in the vein of the **Silent Hill** franchise, so Brazilian artist Richards decided to go with a dark and moody look, working without inks. "The gritty pencil finish seems to fit like a glove." Best known as the regular **Buffy the Vampire Slayer** artist, he says of this strip, "Drawing so many comics based on real people, I used movie stars for reference on this one too, and am really happy with the final result."*

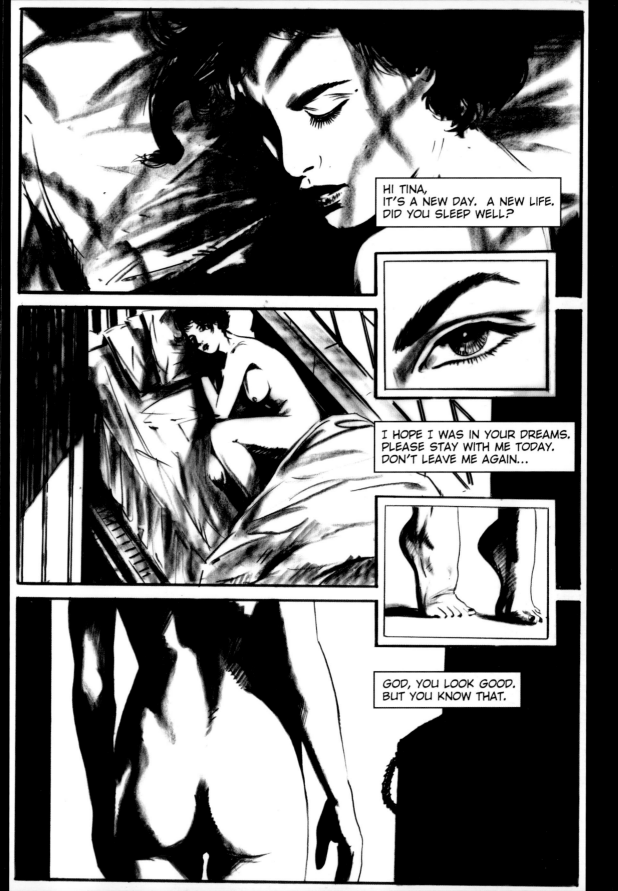

The Building
Trevor Goring
Black prismacolor on vellum
www.electricspaghetticomics.com
kaskgor@verizon.net

The first page of a five page short story, and part of Goring's contribution to the BLVD Studio Sketchbook 3.0. A virtual studio, rather than a crowded room, the BLVD collaboration of artists (Goring plus Tommy Lee Edwards, Jean Paul Leon, Bernard Chang and Sean Chen) are spread out across the United States and meet only at major comic conventions. However, their union breaks the usual isolation comic artists find themselves in as they get to collaborate on multiple projects and, being kindred spirits, are able to support each other with critiques and ideas.

▶ **November**
Robert Deas
Sketchbook Pro 2
and Adobe Photoshop
www.rdcomicsonline.com
rdcomics@rdcomicsonline.com

For this experimental strip the artist deliberately rejected the softening effect of color and pushed himself into drawing in a totally new style. "At first this was a little out of my comfort zone, as I'm so used to working in color. But the stark line work and use of manga tones really suited the cold atmosphere that I was going for."

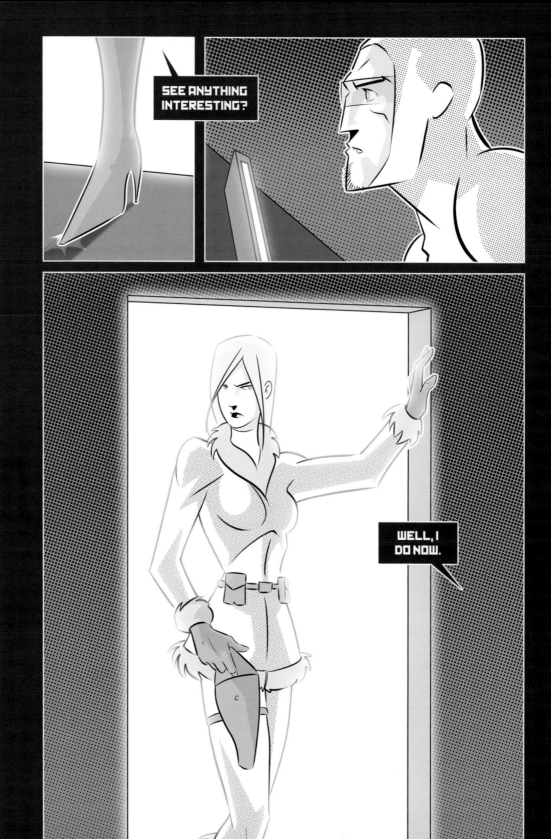

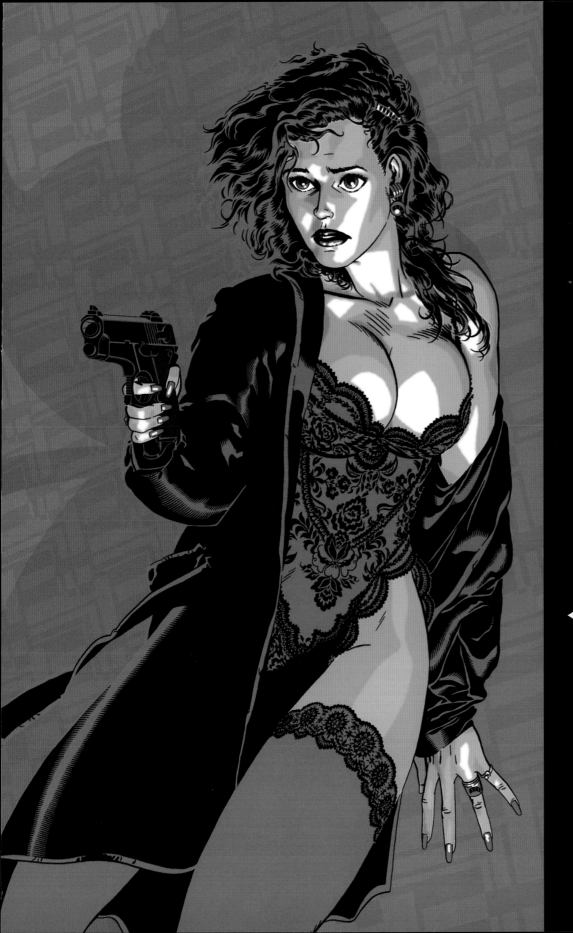

◄ **The Woman In Red**
Michael Golden
Pen and ink, colored
in Adobe Photoshop
www.evaink.com
evaink@aol.com

Exuding excitement and tension, Golden doesn't miss a trick with this dramatic shot. The heroine is backed against the wall, one hand finding no retreat behind her, emphasized further by the closeness of her shadow. Dramatic highlights draw the eye in and emphasize the threat, while her hair is as loose as her clothing, underlining her vulnerability. Even the background is a frantic staccato, operating almost as a soundtrack to the scene. But her wide-eyed, almost pleading expression seems to say, "Don't make me shoot you," as she points her semi-automatic pistol at her unseen assailant.

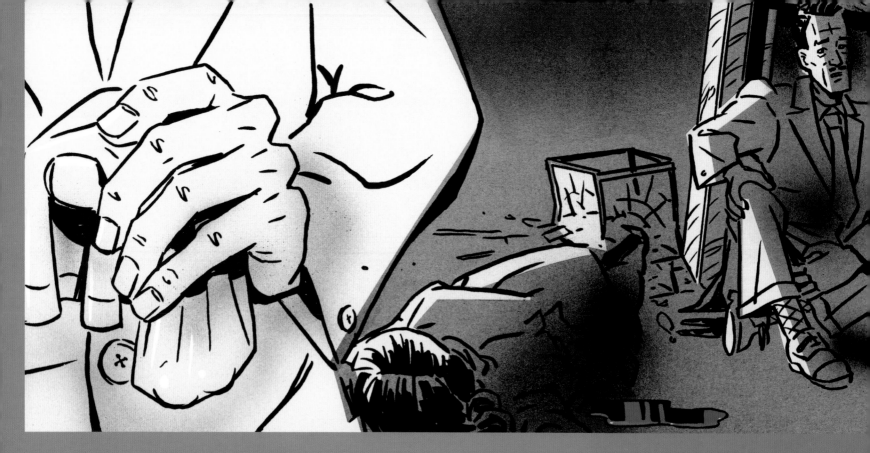

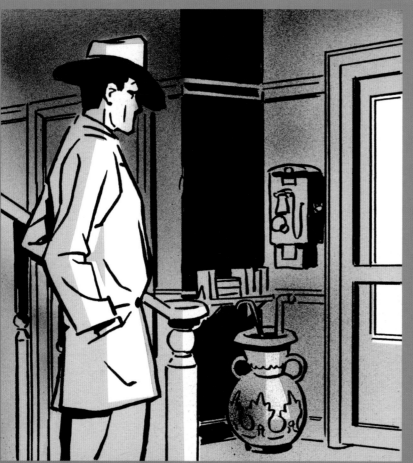

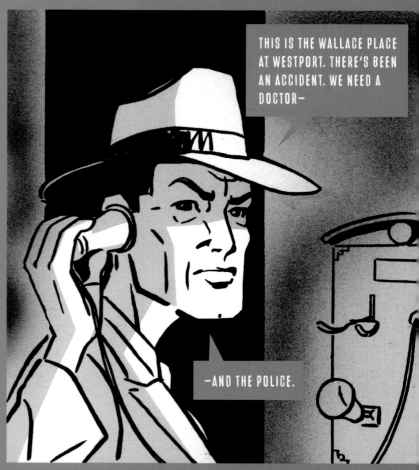

THIS IS THE WALLACE PLACE AT WESTPORT. THERE'S BEEN AN ACCIDENT. WE NEED A DOCTOR—

—AND THE POLICE.

Goldfish

Rian Hughes
Pen and ink, and
Adobe Illustrator
www.devicefonts.co.uk
rianhughes@aol.com

Serge Clerc had been a major
influence on the young Rian
Hughes, who says of the French
artist having "The angularity of
the classic Hanna Barbera style,
mixed with a (then) modern
sensibility formed the perfect
confluence of graphic design
and illustration." For these
pages Hughes worked in ink
on paper, then photocopied
them onto several colored
sheets. These were cut up and
laid over each other to give the
bold shadow effects, to create
mood and show lighting, or to
highlight important elements
to better tell the story.

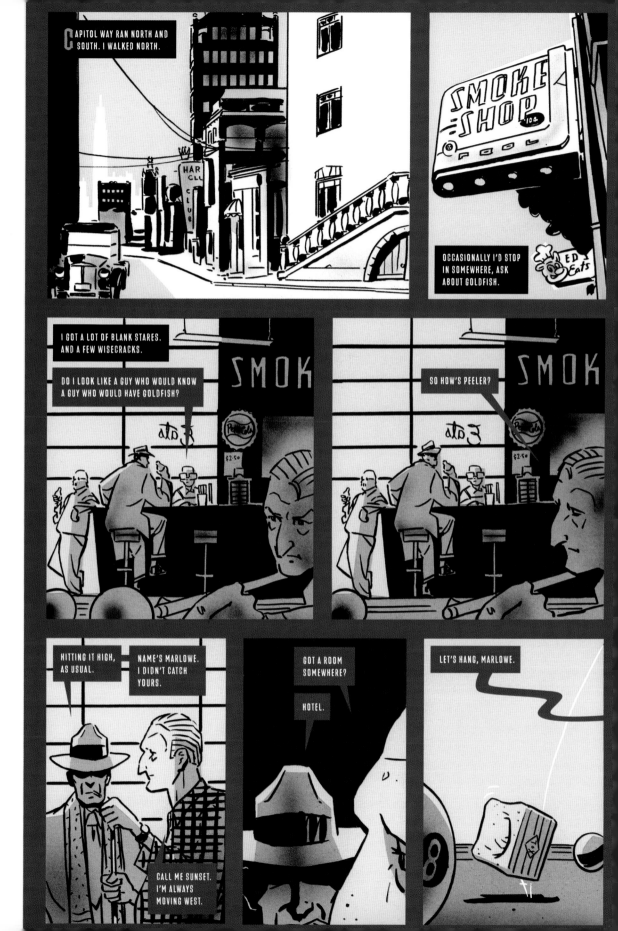

▶ **Ballast**
ILYA
Pen and ink (mainly brushpen)
toned in Adobe Photoshop.
edilya@hotmail.com

*"This indie comic has been so
woefully under-ordered that
barely anyone's seen it! It
balances goofball and grim-
and-gritty elements in a story
centered on a guilt-ridden hired
killer with a stone face. In this
sequence he flashes back to his
childhood — an accidental death,
but not his first kill. I had to
crank five pages of pencils per
day (three if inks), and that
coming off a 200 page book
in eight weeks!"*

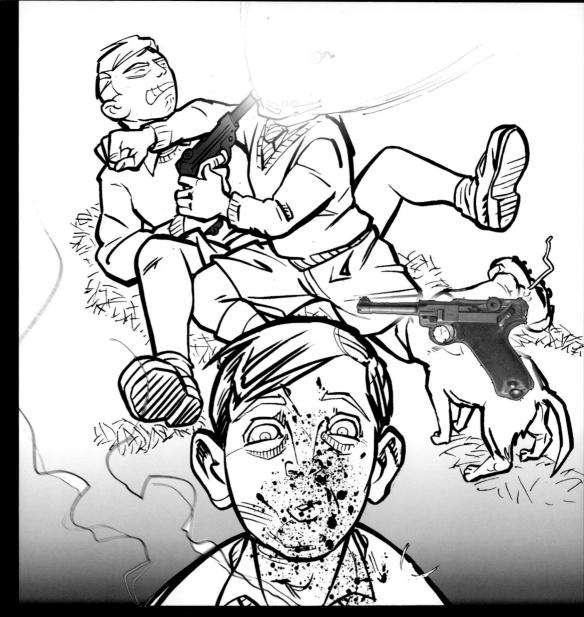

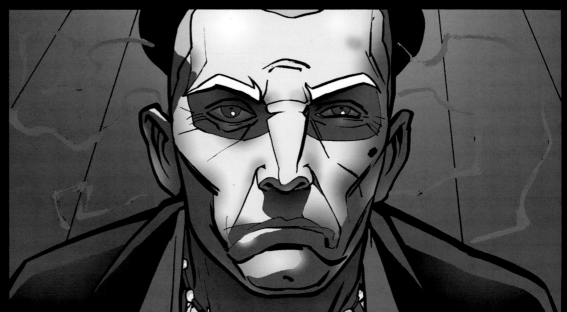

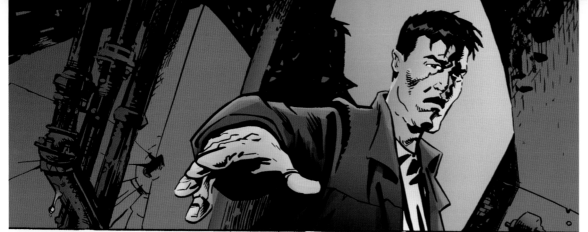

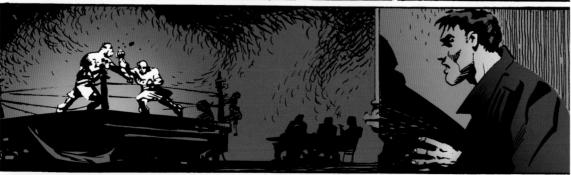

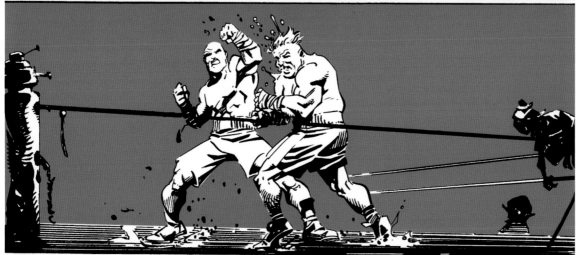

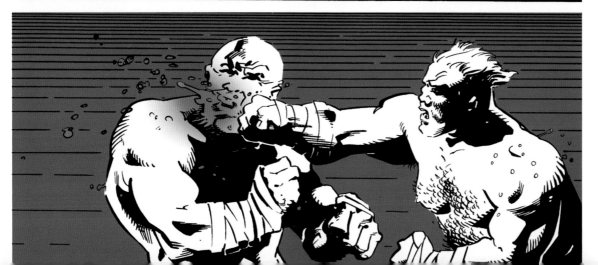

◄ **Two Hole Punch**
John McCrea
Pen and ink, colored
in Adobe Photoshop
www.johnmccrea.com
john.mccrea@gmail.com

Two Hole Punch *is a movie
concept currently languishing in
Hollywood limbo, but the writer
asked McCrea to storyboard
it — as finished comic panels —
with an eye to producing a comic
as well. McCrea comments, "I
was going for a film noir effect
combined with urban decay. I
drew the pages in Biro, using
a Pentel corrector instead of a
rubber. This gives interesting,
and sometimes surprising
results. Once it was inked I
handed it to Lee Bradley for
colors to be applied in Photoshop.
I asked him to keep the palette
simple and bloody, and when he
colored the boxers in white on
the third panel I knew we had
the stark effect I was after."*

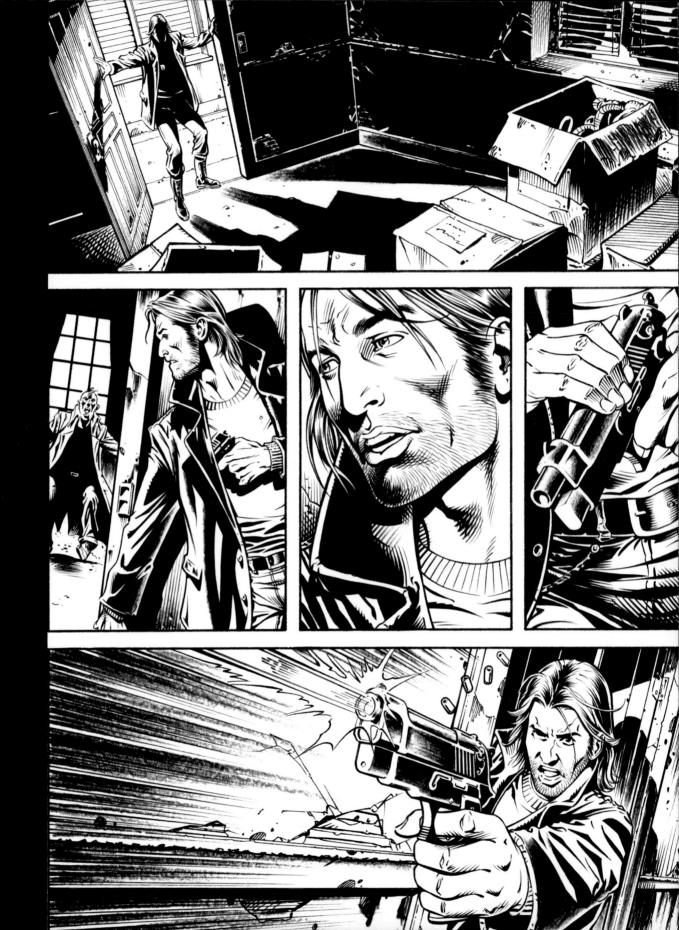

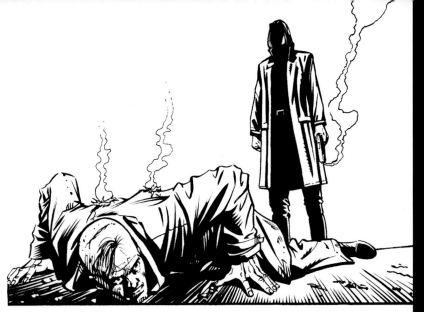
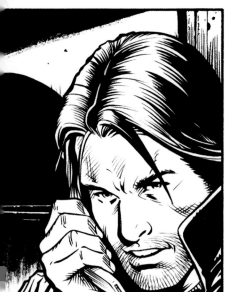
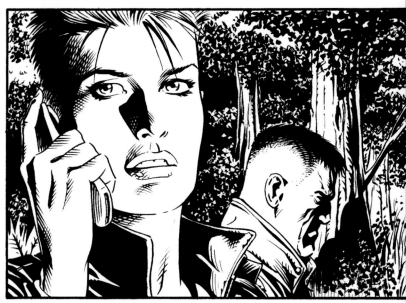
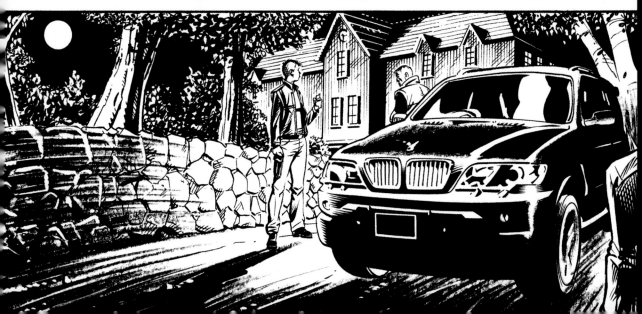

Back to Basics
Dylan Teague
Unpublished
www.dylansdrawingboard.blogspot.com
dylan_teague@hotmail.com

"I don't get to do as many interior pages as I'd like nowadays, as I tend to do more illustration and cover work. This is a shame as interiors are my favorite thing to work on. I did these two to keep my eye in on the storytelling side of things. As they weren't commissioned I experimented with textures, dry brushing, and an overall looser approach than I usually go for."

◄ Criminal
Sean Phillips
Marvel Comics
Acrylic
www.seanphillips.co.uk
sean@seanphillips.co.uk

Detail from Phillips' panoramic wraparound cover to the **Criminal** *story* **Coward**. *"Because the book is published through Marvel's Icon imprint we have to turn in a complete book, ready to print. Previously I was playing with other peoples' toys and you have to give them back sometime, but here I get to draw people standing around and talking in recognizable real-world environments, rain-slicked shadowy streets and tortured, frowning anti-heroes. With total creative freedom I get to draw the book, paint the cover, design the title logo and text pages — even letter the story. So it's nobody else's fault if the book fails!"*

► Varg Veum
Mike Collins
Pen and ink, toned
in Adobe Photoshop
www.freakhousegraphics.co.uk
mike_collins@ntlworld.com

Wales-based Collins proves that comics are a global village. When not drawing superheroes for US publishers, **Doctor Who** *in the UK, or illustrating Welsh-language school books, he finds the time to draw a series of graphic novels starring private eye* **Varg Veum** *for a Norwegian publisher.*

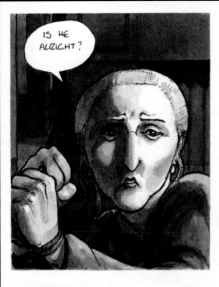
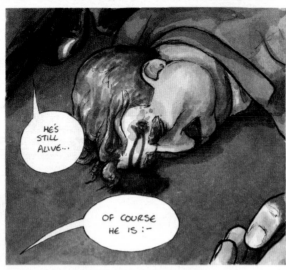
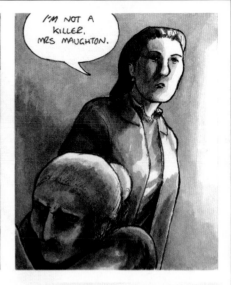
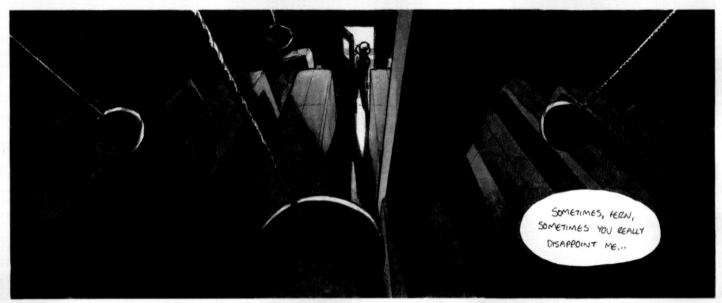

▲ **Britten and Brülightly**
Hannah Berry
Pen, pencil and acrylic ink
www.hannahberry.co.uk / the.right.mistake@gmail.com

*Now that comics have grown into an all-areas medium, new creators
with fresh approaches constantly appear, as is the case with Hannah
Berry. These stunning images are from her first graphic novel, which is
due out from Jonathan Cape Publishers in 2008. While there has been*

FINE. TELL ME, WHEN ARE THEY GOING TO EMPLOY ENOUGH DAMN 'FLICS' TO DO THEIR OWN WORK?

I DO NOT KNOW.

WHAT DO YOU KNOW?

OUR CASE THIS MORNING.

WHICH IS?

MURDER.

Rue MORGUE
1er Quartier St. Roch

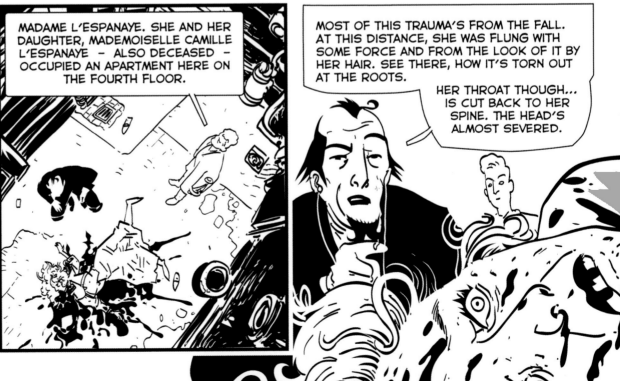

MADAME L'ESPANAYE. SHE AND HER DAUGHTER, MADEMOISELLE CAMILLE L'ESPANAYE – ALSO DECEASED – OCCUPIED AN APARTMENT HERE ON THE FOURTH FLOOR.

MOST OF THIS TRAUMA'S FROM THE FALL. AT THIS DISTANCE, SHE WAS FLUNG WITH SOME FORCE AND FROM THE LOOK OF IT BY HER HAIR. SEE THERE, HOW IT'S TORN OUT AT THE ROOTS.

HER THROAT THOUGH... IS CUT BACK TO HER SPINE. THE HEAD'S ALMOST SEVERED.

▶ **The Murders in the Rue Morgue**
D'Israeli
SelfMadeHero/Eye Classics
www.disraeli-demon.com
matt@d-israeli.demon.co.uk

For the Edgar Allan Poe anthology **Nevermore**, *the artist known as D'Israeli draws a "study of the criminal mind" as he adapts the 1841 short story that introduced mystery fiction's first fictional detective. Outside of his early work on* **2000 AD**, *D'Israeli (aka Matt Brooker) is best known for his comics collaborations with Neil Gaiman and Warren Ellis.*

▶ **November**
Robert Deas
Sketchbook Pro 2
and Adobe Photoshop
www.rdcomicsonline.com
rdcomics@rdcomicsonline.com

An effective page from
November — the writer/artist's
online science fiction espionage
story set in near-future Russia,
where the world is on the brink
of a second Cold War. Deas chose
a stark, yet appropriate art style
for the story, and while he feels
more comfortable knowing his
line work is usually enhanced
with color, he would relish the
challenge of working in black-
and-white again.

▶▶ **Waterloo Sunset**
Trevor Goring
Black prismacolor on vellum,
colored in Adobe Photoshop
www.electricspaghetticomics.com
kaskgor@verizon.net

In demand as an LA-based
storyboard artist, Goring still
loves to indulge his passion for
drawing comics, admitting he
gets much of his inspiration
from old black-and-white films.
"What I tried to do with
Waterloo Sunset was use my
experience of storyboarding
films to bring cinematic
composition and storytelling
to the comic book form."

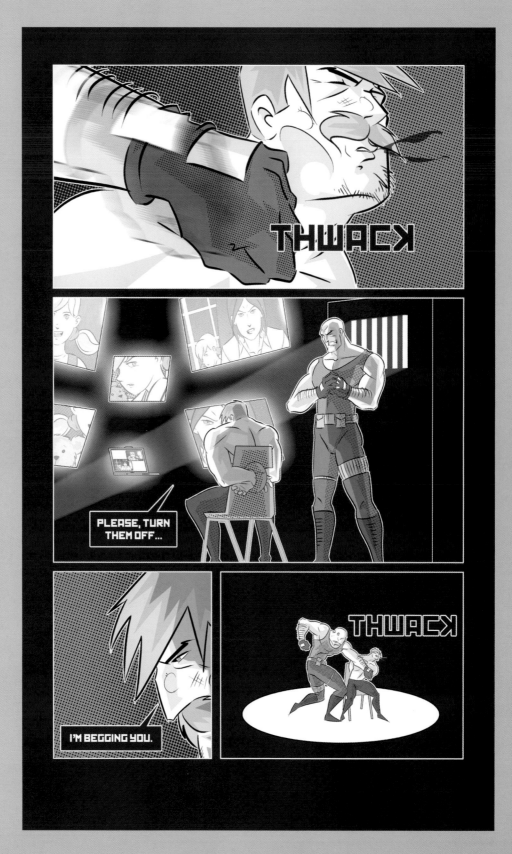

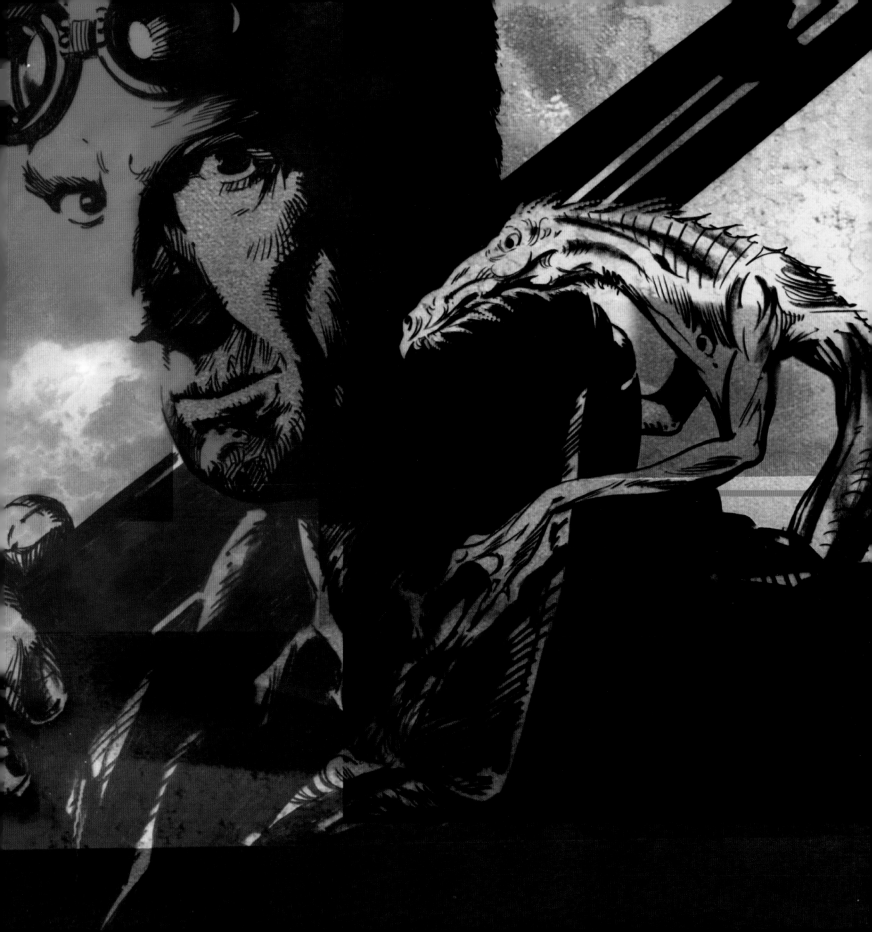

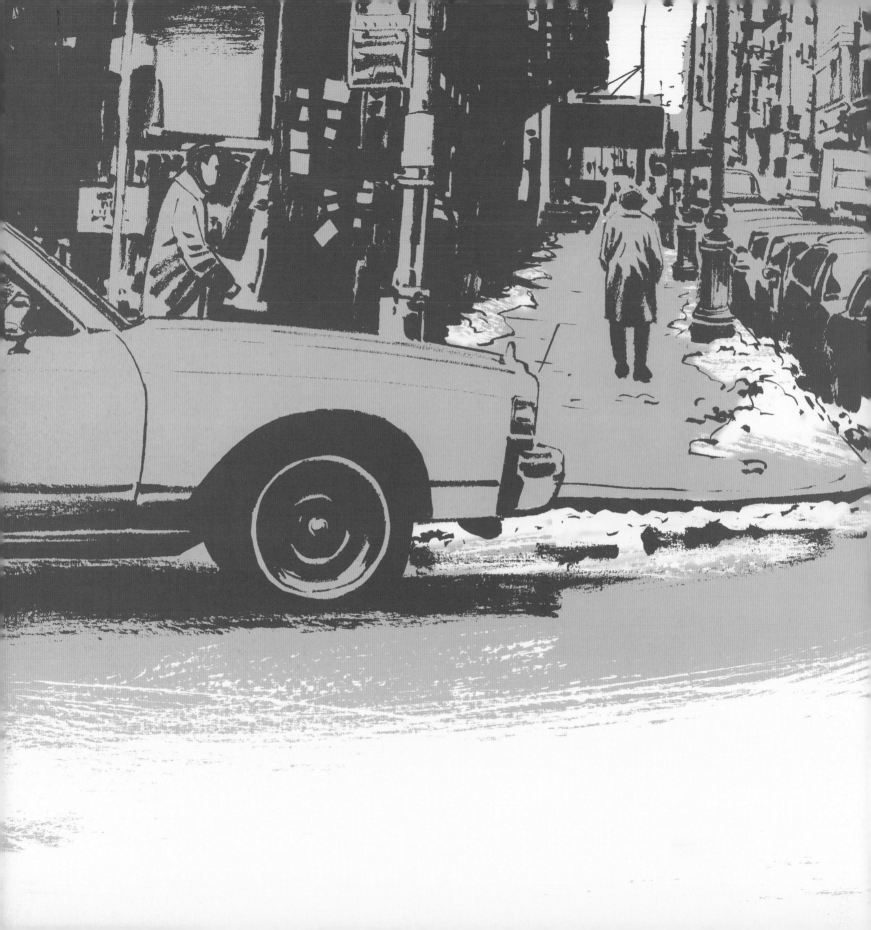

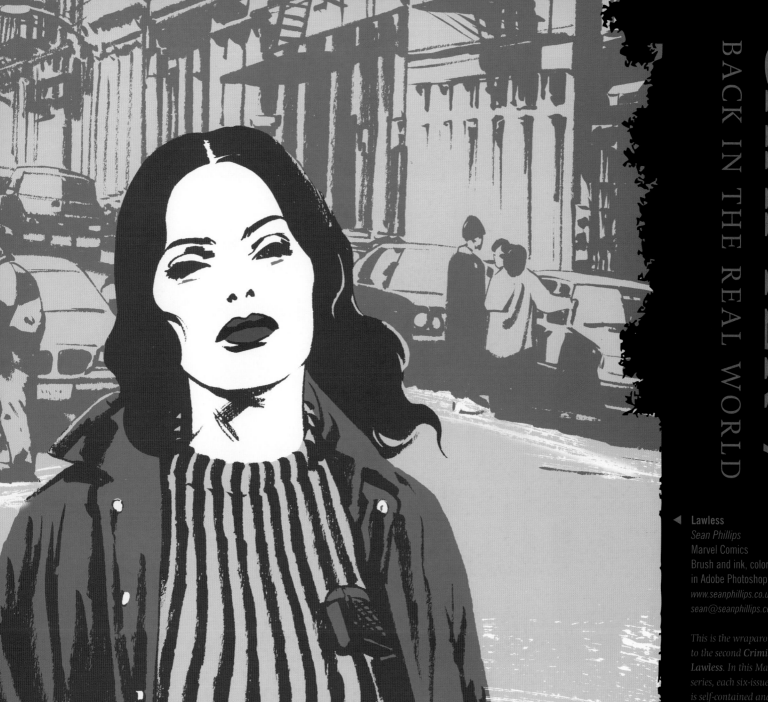

◄ **Lawless**
Sean Phillips
Marvel Comics
Brush and ink, colored
in Adobe Photoshop
www.seanphillips.co.uk
sean@seanphillips.co.uk

This is the wraparound cover art to the second Criminal storyline Lawless. In this Marvel/Icon series, each six-issue story arc is self-contained and focuses on different characters, but all frequenting the same bar and sharing a common history of two generations of crime. To visually underline this, Phillips is using a different art style for each story's cover. "The first story arc had hand-painted covers, but for the covers of Lawless I was aiming for a flatter, screen-printed effect. The covers for the next storyline will be different again."

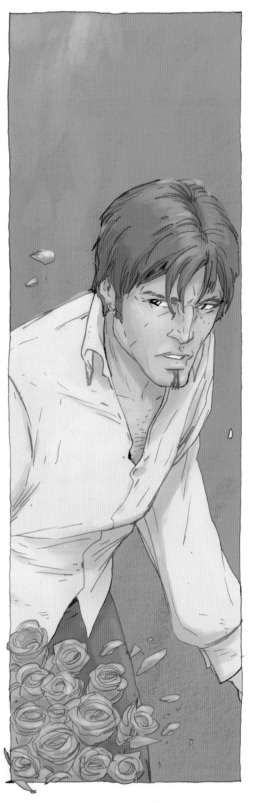

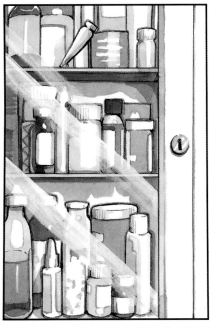

◀ **Sojourn**
Paul Duffield
Pencil, colored in
Adobe Photoshop
www.spoonbard.com
spoonbard@gmail.com

*Written and drawn by Duffield
for his under-construction,
self-published comic, this is the
opening spread from **Sojourn**,
which he calls "a short story
using only images, and as few
panel borders as possible."
He adds, "it's a piece about
a man attempting to escape
his life, but unintentionally
dragging all his baggage and
rubbish behind him." Following
the crucial establishing shots on
the first page, Duffield utilizes
an effect unique to the graphic
narrative medium; that of an
overlapping sequence of close
ups and longshots that convey
the passage of time, while
minimizing the claustrophobic,
boxed-in look of comics.*

▼ **Girl's Comic**
Cosmo White
Blue pencil on Bristol board, felt tips, fine liners, Adobe Photoshop
cosmo.w@gmx.co.uk

Working to a brief of characters who had to be cool—but not overtly sexual—these two pages were submissions for a comics project aimed at teenage girls. To give the strips a unique feel, and remove them from the traditional (but somewhat gaudy) full color "boys comic" look, White chose to limit his palette to gray plus a single muted color.

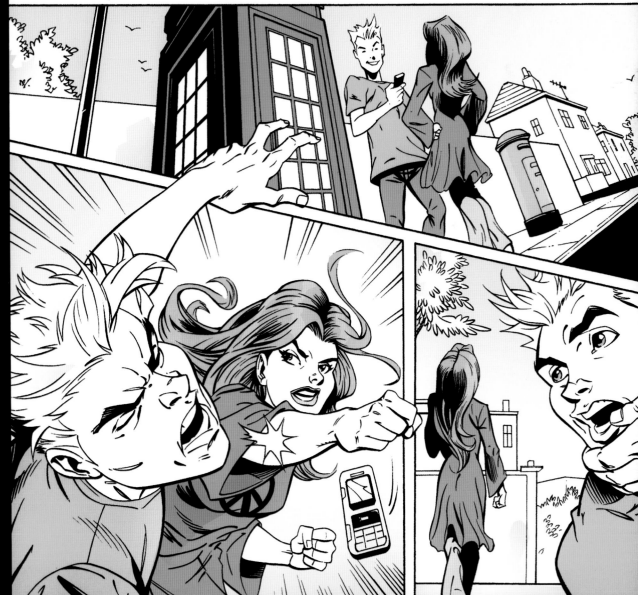

Orange
John Royle
Pen and ink, colored
in Adobe Photoshop
www.johnroyleart.com
johnroyle007@hotmail.com

Contrasting with (but echoing) the facing visuals, this is another two-color page with a female star. Aimed at an all-age market, this is part of a strip commissioned for Orange's house magazine, hence the choice of second color. Recalling the cost-effective approach of the past, Royle comments, "I enjoyed coloring this in an old-school, 1960s UK comic style."

Honey Bees
Gary Millidge Spencer
Pen and ink, ink wash on
watercolor board, paint,
and digital manipulation
www.millidge.com
gary@millidge.com

*A typical Millidge composition for
the self-published Strangehaven,
that fulfills a crucial, but often
overlooked aspect of cover art.
With its intriguing visuals—in
his case the weirdly disparate
images of a hanging man, three
key protagonists and a beehive—it
piques the reader's curiosity by
setting up scenes that demand you
crack the covers to discover what
is going on! The writer/artist's
dedication to his work has resulted
in numerous awards worldwide
and his Strangehaven comic being
published in eight countries
and five languages.*

The Piper Man
Kate Brown
Pencil, Adobe Photoshop
www.danse-macabre.nu
extra.minty@gmail.com

*Brown opts to use silhouettes to distance the support characters, while adding a shadow only to the main protagonist of this story. A contemporary retelling of the legend of the **Pied Piper of Hamelin**, Brown's concept image conveys subdued menace in both the stance and facial features of the barefoot Rat Catcher, contrasting with the more natural poses of his surrounding victims.*

There was a friend, when I was younger.

When she slept over,

we lay next to each other and played a game.

I traced letters on her back, and she had to guess which word I was spelling...

Then we'd swap.

If we played for too long, my fingers felt numb...

and her back felt sore, she said.

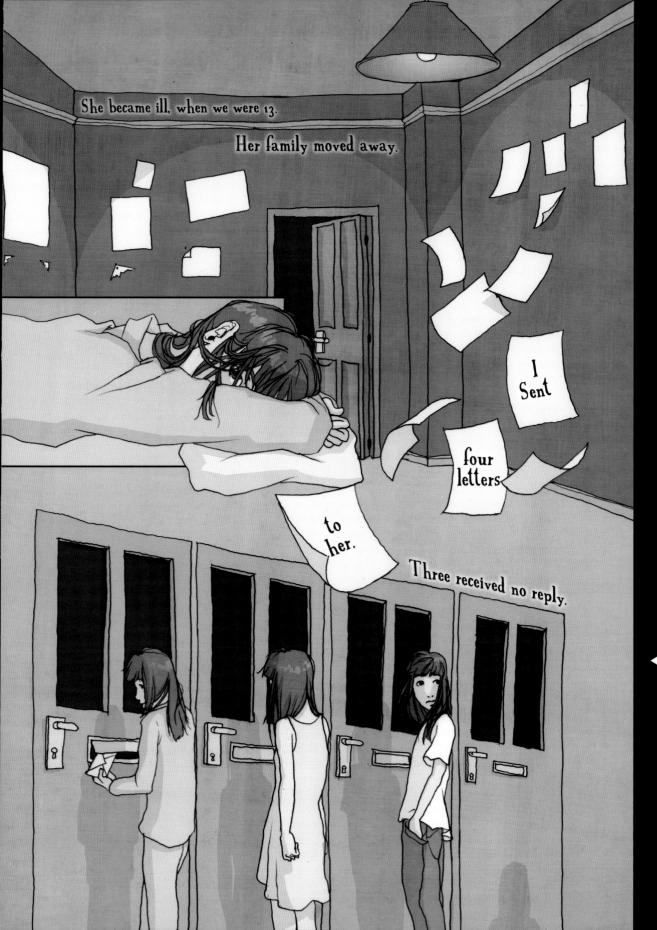

She became ill, when we were 13.

Her family moved away.

I Sent

four letters

to her.

Three received no reply.

◀ **Diamonds**
Paul Duffield
Pencil, Adobe Photoshop
www.spoonbard.com
spoonbard@gmail.com

The opening spread from
Diamonds is a finely balanced
during-and-afterwards reflection
from a collection of short stories
Duffield is working on with Kate
Brown. The unifying theme of
the project is a focus on real-life
stories with a surreal twist, and,
as Duffield says, "slightly more
than first meets the eye."

▶ **Edgar Allan Poe's
The Tell-Tale Heart**
Alice Duke
Eye Classics/SelfMadeHero
Pen and ink
www.paper-pushers.com/alice
alice.naomi.duke@gmail.com

*Alice Duke is one of the new
wave of comics artists, with a
flair and ability beyond her
age. Only 20 years old, Duke's
first published work shows a
great understanding of the key
ingredients of narrative flow
and composition, especially given
the task of illustrating a classic
story "seen" through the eyes of
a blind girl. She rises admirably
to the challenge here, especially
with her depiction of an abstract
street scene with ghostlike figures
swirling around.*

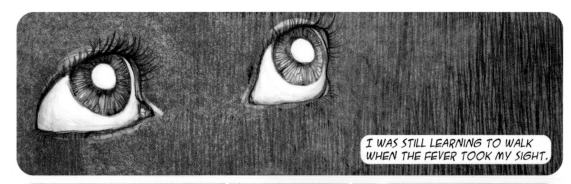

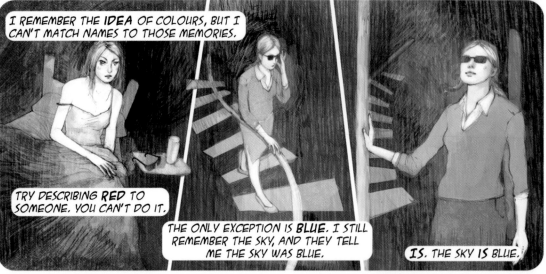

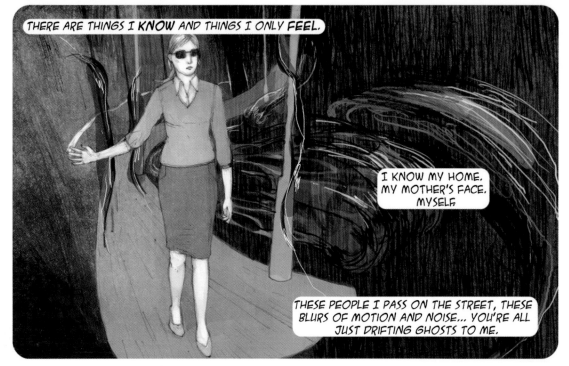

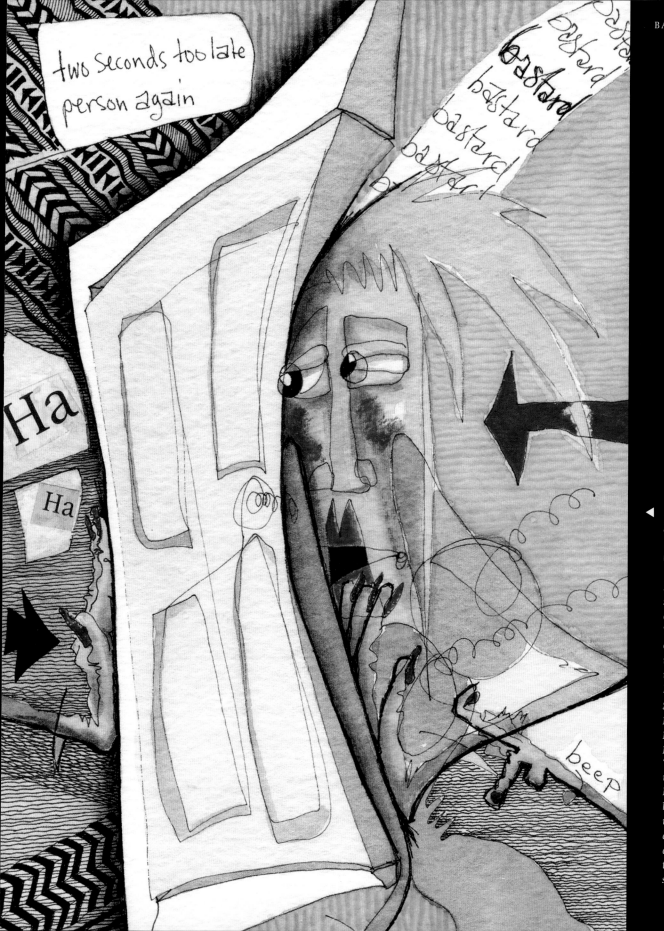

◀ **Deadlines**
Katherine McDermid
Mixed media on canvas
www.katherinemcdermid.com

*McDermid is an artist who
started life producing strip
cartoons for Yorkshire's Goole
Times newspaper. With a love
of 2B pencils, Rotring pens, and
indian ink, she took a mid-life
university course, resulting in a
BA Hons in Fine Art. Favoring
gallery space above the printed
page for her comics-inspired
pieces, she admits her love of the
panel composition, still having
"an urge to play within a blank
rectangle, thinking without."
Produced specifically for this
book, this piece typifies such an
urge (note the corner caption),
and depicts the dilemma faced by
an artist attempting to embrace
the expediency of computer
software at the eleventh hour.*

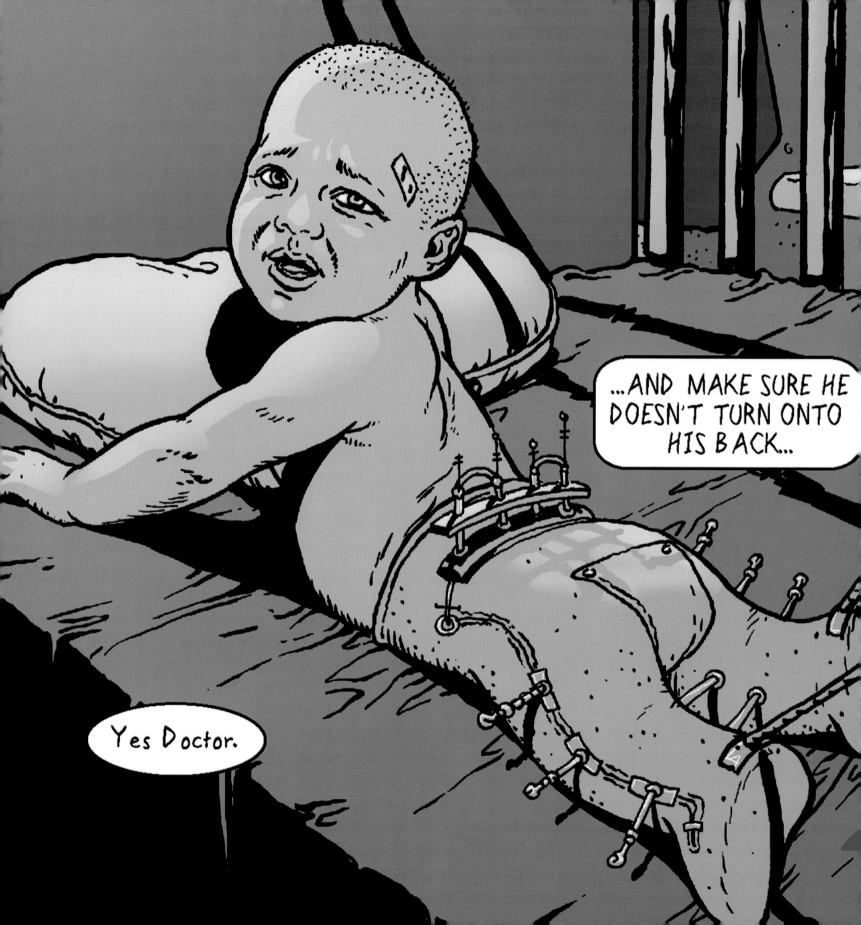

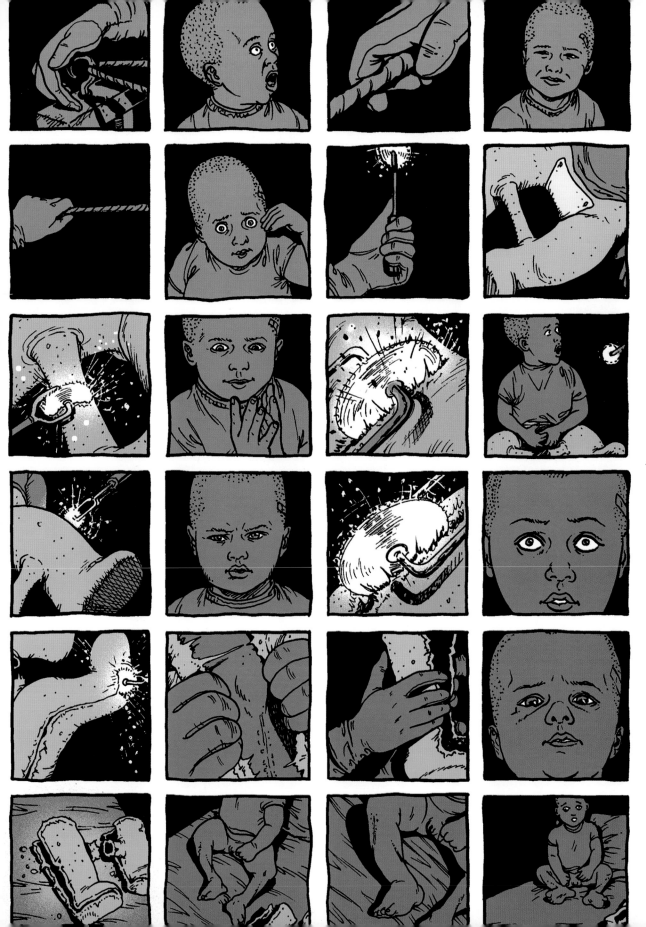

◀ **Scar Tissue**
Al Davison
Pen and ink, Adobe Photoshop
www.astralgypsy.com

Like this chilling piece from his new graphic novel, much of Davison's work is semi-autobiographical. Born with severe spina bifida, he was operated on at one hour old and placed in a hospital's isolation unit. "I wasn't expected to live, but I was there for two years. No windows, no pictures on the walls." He went on to survive 21 operations by the time he was eight years old, and says that it was art that kept him sane during that time. Refusing to acknowledge perceived limitations and prejudices, the wheelchair-bound artist says "I am fascinated by the human form, and how its perception is transformed in dreams. This also ties in to my interest in representations of disability in figurative art and the media."

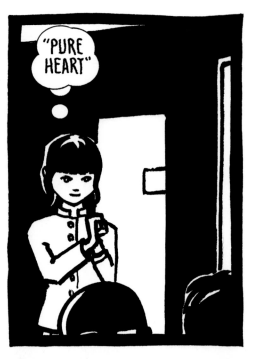

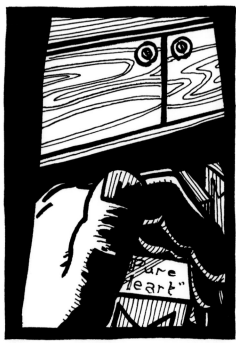

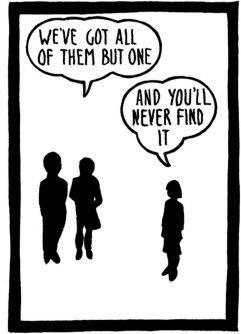

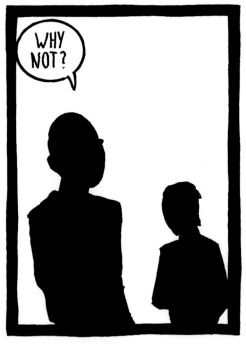

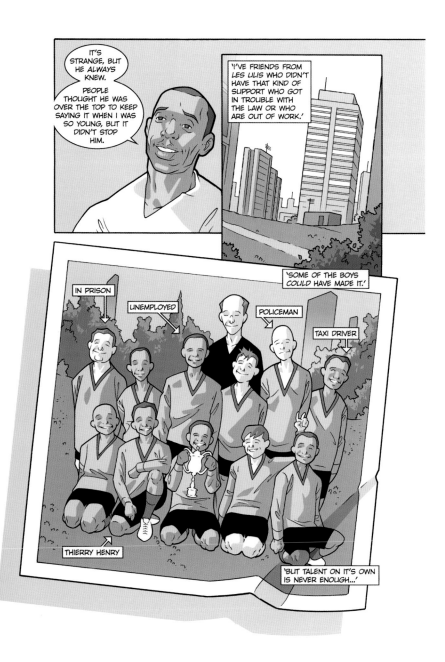

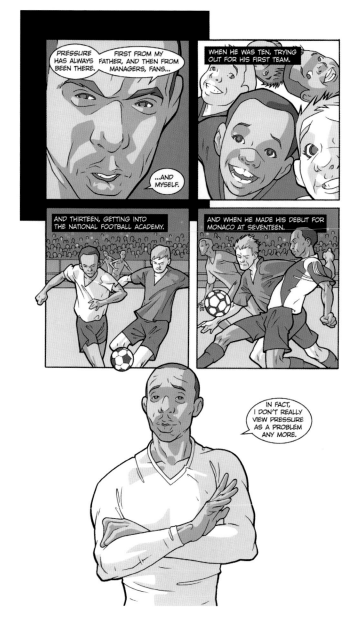

◀ **Pure Holiday**
Chris Reynolds
Ink on paper
www.metropoppyfield.com / metropoppyfield@yahoo.com

Pure Holiday marks a return for Reynolds to the simple black and
white style he used in his self-published **Mauretania** series (voted one
of the Best Comics of 2006 by The Comics Journal). Reynolds feels this
gives "a slightly nostalgic look" to the story, where Marilyn and Eric
search for music in what seems to be a strange, older world.

▲ **Thierry Henry**
Cosmo White
Blue pencil on Bristol board, felt tips, fine liners, Adobe Photoshop
www.cosmowhite.com / cosmo.w@gmx.co.uk

*A rising star, White has a distinct advantage over his peer group by
being an artist with a wide range of styles. Here he shows his ability at
biographical strips, with sample pages for a speculative comic based
on the life of the French footballer, Thierry Henry, who transferred in
2007 from London's Arsenal to FC Barcelona in Spain for over $30m.*

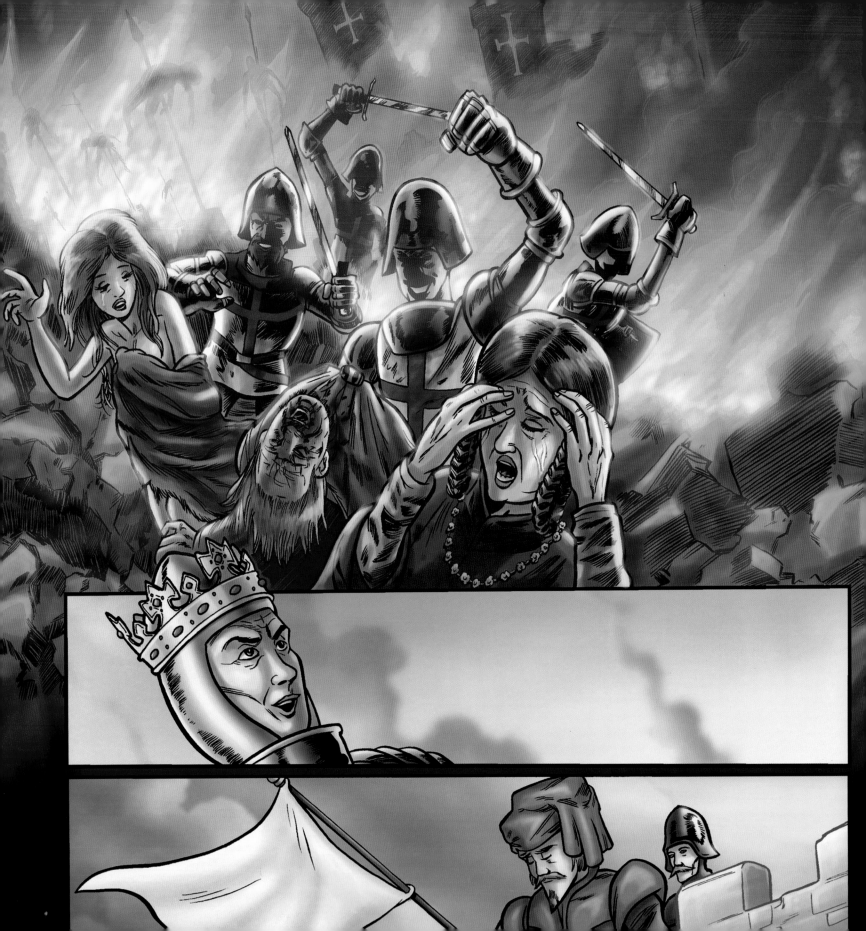

Henry V
Neill Cameron
Classical Comics
Pencil, inked with brush
and Rotring pen, colored
in Adobe Photoshop
www.neillcameron.com

For this adaptation of William Shakespeare's **Henry V**, Cameron's layouts and pencil art—inked by Bambos Georgiou—were left open to allow the colorist sufficient opportunity to add texture and depth. However, being an adaptation of a well-known play, there was also the prerequisite need for a great deal of emotion and drama to be contained within the linework. On inking Cameron's pencil art (left), Georgiou says, "I tightened the line up—adding weight where needed—but didn't embellish the pencils or drop any detail. I simply ink what's there, making it crisp, clean, and hopefully stylish." Colorist Jason Cardy adds "The colors were chosen to enhance an image depicting an extreme of human depravation." However, for the facing page, colorist Kat Nicholson says, "This needed to have an almost ethereal feeling—an atmosphere that was heavenly, but still firmly grounded. The creeping mist helps to achieve this, but Henry's vision had to stand out, so I used golden lighting to make it look other-worldly."

▶ **Red Prophet:**
The Tales of Alvin Maker
Rodney Buchemi
Marvel Comics
Pen and ink
www.glasshousegraphics.com
rbuchemi@gmail.com

Despite the overt and extreme violence of this page, with settlers mercilessly wiping out a peaceful tribe of native Americans, Brazil's Rodney Buchemi employs stoic — almost classical — line work, contrasting the "noble savage" of the still and remorseful opening panel with what is about to happen. He then emphasizes the savagery of what follows by indenting the second panel, the bullets having almost pushed it across the page, coupled with a mass of what are generally considered speed lines–used here to visually depict the roar of the guns. The pivoting movement of the central figure in the last three panels is almost cinematic, with its use of close-up victims leading to the page's denouement.

◀ **Great Expectations**
John Stokes
Pencil and ink on Bristol board
www.classicalcomics.com

*A UK artist with over 40 years
experience, Stokes comments
that "a graphic novel of
Dickens' Great Expectations
is a terrific opportunity, but
also a daunting challenge.
I wanted the style to retain
some of the qualities of the
original illustrators of the
novels, Phiz and Cruickshank;
their mixture of realistic detail
and caricature, their careful
observation of background,
and their lifting the location
of a scene almost to the level of
another character. Melding the
vigor and drive of the modern
graphic novel to this pastiche
of the great masters of pen and
ink illustration has not been
an easy task."*

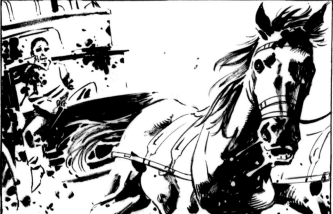

◀ **Dead or Alive**
John McCrea
Pen and ink
www.johnmccrea.com
john.mccrea@gmail.com

If you're going to create a western strip featuring zombies, what better title than **Dead or Alive**? A work in progress, McCrea says it is remorseless and bleak. "I wanted a gritty, washed-out style, so I pencilled it very roughly — sometimes little more than stick figures — and used a cheap, synthetic, worn-out brush, with very little water to achieve the dusty style. I tried keeping the holding lines to a minimum as it isn't going to be colored. The trick with this style is not to get too lost in the technique or the art can easily lose its clarity."

▶ **Jane Eyre**
John M Burns
Classical Comics
Pen and ink, watercolors

One of Europe's leading comics artists, Burns is the end-product of art agency heydays, and a staunch traditionalist. From his apprenticeship at the shoulders of the top artists of the 1950s, he unwaveringly carries his craft into the 21st century, shunning all modern technology. A perfect choice for illustrating the Charlotte Bronte classical romance, Burns began with thumbnails (small layouts and frame compositions) so he could design and tell the story in the drawing and — equally importantly — allow space for balloon placement and solid black areas to ground the work. Burns says this page provided "a chance to introduce a little dramatic action, using the falling horse to carry the page."

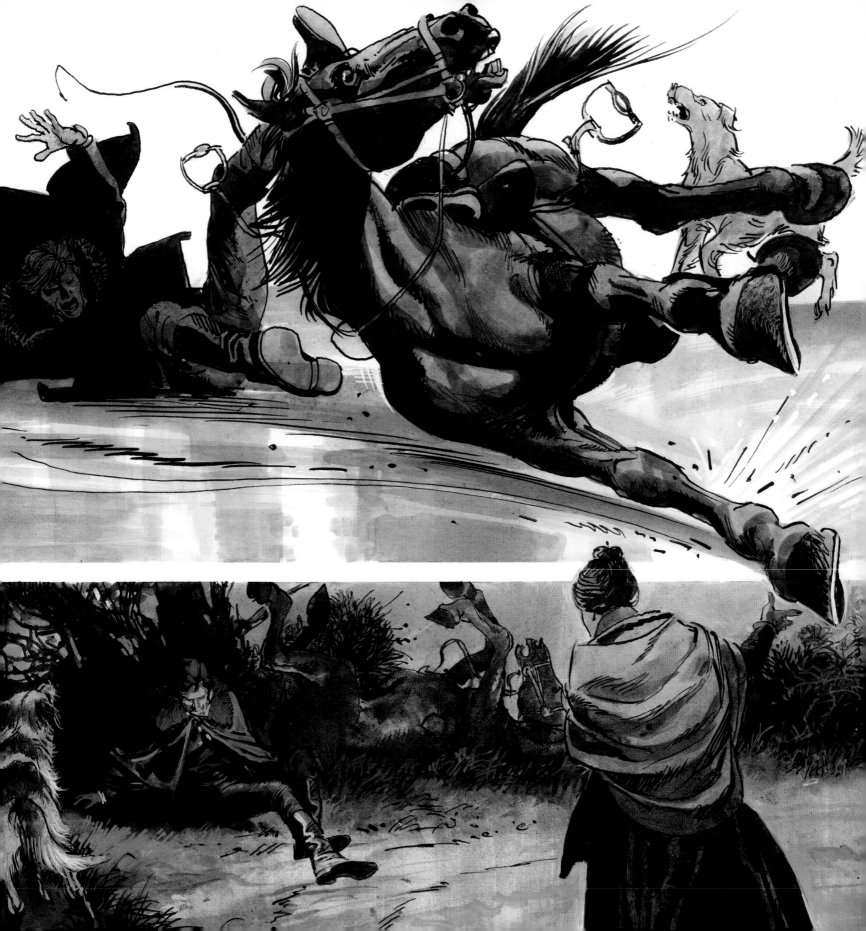

ATTACKING NOW.

Dogfight
Gary Spencer Millidge
Pen, ink and wash on board
www.millidge.com
gary@millidge.com

This page from Millidge's
Strangehaven comic has
graytone shading that harks
back to the era of black-and-
white war movies. The artist
takes the three panels through
non-linear continuity, almost as
if storyboarding the action for a
cinematographer. Reminiscent
of Roy Lichtenstein's pop art
canvases of the 60s, Millidge
also incorporates classic sound
effects into the composition.

30 Days Of Night
Ben Templesmith
IDW Publishing
Pen and ink, acrylic, watercolor,
Adobe Photoshop
www.templesmith.com
contact@templesmitharts.com

This is a cover to **30 Days of**
Night, a comic Templesmith
co-created with writer Steve
Niles. Its success prompted a
bidding war for film rights with
the winners—Sony—basing the
movie's look very heavily on his
art. Templesmith says, "generally
all the covers for the series
are strong close-up character
studies—this one being Hoeppner,
a member of the SS from a World
War II story set on the Eastern
Front." Limiting his palette to
cool blues, with a rash of blood
red highlighting, Templesmith
effectively underlines the mood
of the actual artwork in his
often-emulated signature style.

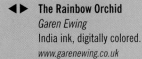

The Rainbow Orchid
Garen Ewing
India ink, digitally colored.
www.garenewing.co.uk

The Rainbow Orchid is an
adventure comic, written and
drawn by Ewing, that celebrates
the tradition of classic European
"bande dessinée" — in particular
the *"ligne claire"* (clean line)
approach of Hergé (**Tintin**),
Edgar P. Jacobs (**Blake and
Mortimer**) and Yves Chaland
(**Freddy Lombard**). Set in the
1920s, the story is firmly rooted
in the adventure fiction of
writers such as Rider Haggard,
Jules Verne and Sir Arthur
Conan Doyle. With only the first
part printed to date, Ewing has
posted the continuation online
(including a French translation).
When completed, **The Rainbow
Orchid** will be published as
a single album.

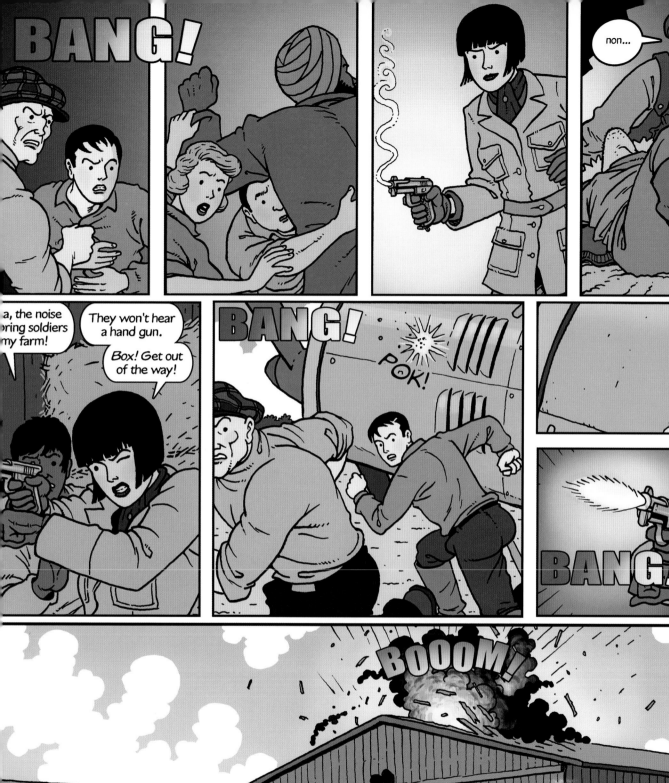

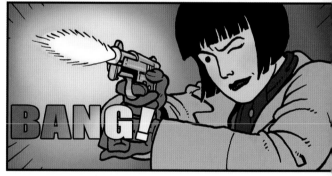

◀▶ **Razorjack**
John Higgins
Pen and ink, Adobe Photoshop
www.turmoilcolour.com
turmoil@globalnet.co.uk

*While probably best known
for his association with the
groundbreaking graphic novel
The Watchmen, comics-
allrounder Higgins prefers to
work outside the restrictive
corporate structure, but
recognizes the pitfalls.
"To create, write, draw,
color, letter and self-publish
a comic book character is an
exhilarating, but daunting
task. To create something from
nothing but an idea, with the
intention of being honest to
your own personal creative
endeavor — and then to achieve
a profit-making publication —
can seem like an impossible
task." Here are two examples
of Higgins' wonderfully-
realized attempts to achieve
the impossible.*

All work in this book is
the copyright property of
the named artist, unless
stated otherwise.

BEN ANG
www.xplixit.blogspot.com
freelance.ben@gmail.com
Bloody Ballerina *p70*
Maxwell Cockswagger *p73*
© 2008, Tenacious Games Inc.
Lincoln's Heart *p133*

DANIEL ATANASOC
satanasov@gmail.com
Dragonlast *p82*

ADRIANO BATISTA
www.bubbagump.blogger.com.br
adrianobatistasketchbook@
ieg.com.br
Jungle Girl *p89*
© 2008, Dynamite Entertainment

HANNAH BERRY
www.hannahberry.co.uk
the.right.mistake@gmail.com
Britten & Brulightly *p156*

SIMON BISLEY
sbizbiz@aol.co.uk
Thicker than Blood *p107*
© 2008, Reed Comics

CRIS BOLSON
www.glasshousegraphics.com
crisbolson@gmail.com
Contagion *p114*
© 2008, Trepidation Comics

DAN BOULTWOOD
baronvonbloodshrimp@
gmail.com
The Crimson Todger *p26*
The Gloom *p29*
Hope Falls *p8, p142*
© 2008, Markosia Enterprises

NORM BREYFOGLE
www.normbreyfogle.com
nbreyfogle@chartermi.net
The Danger's Dozen *p18, 49, 76*
© 2008, First Salvo Comics

KATE BROWN
www.dance-macabre.nu
extra.minty@gmail.com
The Monster in the Well *p108-109*
The Piper Man *p169*

RODNEY BUCHEMI
www.glasshousegraphics.com
rbuchemi@gmail.com
Red Prophet *p180*
© 2008, Marvel Comics

JOHN M BURNS
Jane Eyre *p183*
© 2008, Classical Comics

NEILL CAMERON
www.neillcameron.com
neillcameron@googlemail.com
Thumpculture *p75*
Henry V *p178*
© 2008, Classical Comics

PAUL CEMMICK
www.paulcemmick.com
mail@paulcemmick.com
Making a New Friend *p48*
© 2008, Future Publishing

FRANK CHO
www.libertymeadows.com
Jungle Girl *p71*
© 2008, Dynamite Entertainment

MIKE COLLINS
mike_collins@ntlworld.com
Varg Veum *p155*
© 2008, Gunnar Staalesen

CARL CRITCHLOW
www.carlcritchlow.com
c.crit@virgin.net
Rumble in the Jungle *p68*

HOWARD CRUSE
www.howardcruse.com
howardcruse@verizon.net
Destroy All Santas *p132*
© 2008, Birmingham Weekly

HUW-J DAVIS
www.hayena.net
huwj@japan.com
Garth *p22*
© 2008, Mirrorpix

AL DAVISON
www.astralgypsy.com
astralgypsy@btconnect.com
Mrs Moon *p62*
Leicester Square *p69*
DeadShift *p94*
Scar Tissue *p174*

ROBERT DEAS
www.rdcomicsonline.com
rdcomics@rdcomicsonline.com
Unity Rising *p74*
November *p136, 146, 158*

MIKE DEODATA JR
www.glasshousegraphics.com
mdeodato@terra.com.br
Wolverine *p16*
© 2008, Marvel Comics
Thunderbolts *p24*
© 2008, Marvel Comics

D'ISRAELI
www.disraeli-demon.com
matt@d-israeli.demon.co.uk
Murders in the Rue Morgue *p157*
© 2008, Eye Classics/SelfMadeHero

DIX
www.grimreality.co.uk
dix@grimreality.co.uk
Diary of a Genus *p134*
Roll Up, Roll Up *p134*
Greedy Boy *p135*

PAUL DUFFIELD
www.spoonbard.com
spoonbard@gmail.com
Falling *p67*
Sojourn *p164*
Diamonds *p170*
Orange Room *p192*

ALICE DUKE
www.paper-pushers.com/alice
alice.naomi.duke@gmail.com
The Tell-Tale Heart *p172*
© 2008, Eye Classics/SelfMadeHero

JEAN-JAQUES DZIALOWSKI
www.jeandzia250@hotmail.com
Groomlake *p84*
© 2008, Editions Bamboo

NEIL EDWARDS
www.thebristolboard.blogspot.com
neiledwards342000@yahoo.co.uk
Starship Troopers *p38-39, 46*
© 2008, Markosia Enterprises
21 Demons *p99*
© 2008, Altered Expression

HUNT EMERSON
www.largecow.com
hunt@largecow.demon.co.uk
Oink! *p124*
Citymouth *p126-127*

GAREN EWING
www.garenewing.co.uk
The Rainbow Orchid *p186*

DUNCAN FEGREDO
www.fatotto.nildram.co.uk
fegredo@nildram.co.uk
Game Grrls *p54*
© 2008, Future Publishing

JAMES FLETCHER
flexographics2001@yahoo.co.uk
Darkkos Manse *p92*
Annabell Lee *p100*

SIMON FRASER
www.simonfraser.net
si@simonfraser.net
Lilly MacKenzie *p55*

RON GARNEY
yenrag@aol.com
The War at Home *p12*
© 2008, Marvel Comics
Spider-Man *p17*
© 2008, Marvel Comics

MICHAEL GOLDEN
evaink@aol.com
The Silver Surfer Strikes *p25*
© 2008, Marvel Comics
The Woman in Red *p147*

TREVOR GORING
www.electricspaghetticomics.com
kaskgor@verizon.net
The Building *p145*
Waterloo Sunset *p159*

ROBERTA GREGORY
www.robertagregory.com
Roberta@drizzle.com
Bitchy Bitch *p125*

MATT HALEY
matt@matthaley.com
Liberty Rocket *p40*
Liberty Rocket™ 2008, Rift Software
© 2008, Andrew Cosby and Matt Haley
GI Spy *p41*

SAM HART
www.samhartgraphics.com
samhart@samhartgraphics.com
Robin Hood: Outlaw's Pride *p81*
© 2008, Walker Books

JOHN HAWARD
www.jonhawardart.com
Macbeth *p2*

JOHN HIGGINS
www.turmoilcolour.com
turmoil@globalnet.co.uk
Razorjack *p188-189*

DAVID HITCHCOCK
www.blackboar.co.uk
black_boar1@yahoo.com
Zombies *p110-111*

JAMES HODGKINS
www.olivepresscomics.net
james.hodgkins@gmail.com
Lass Vegas *p30*

LAURA HOWELL
www.laurahowell.co.uk
nyanko@blueyonder.co.uk
The Bizarre Adventure of
Gilbert and Sullivan *p130*

RIAN HUGHES
www.devicefonts.co.uk
rianhughes@aol.com
Red Hot and Ready *cover*
Dan Dare *p45*
© 2008, The Dan Dare Corporation
Goldfish *p149*

ILYA
ilyaillkillya@yahoo.co.uk
Strangehaven *p80*
Ballast *p150*

SYDNEY JORDAN
kolvorok.intergalatic@virgin.com
Hal Starr *p56-57*

MYCHAILO KAZYBRID
mychailo@btinternet.com
Do-Do Man *p129*

JACK LAWRENCE
www.jackademus.com
jack@jackademus.com
The Demon Outlaw *p27*
Thug *p28*

TONY LUKE
www.rengamedia.com
renga@mac.com
Dominator *p11, p50*

PETER LUMBY
www.tozzer.com
pete@tozzer.com
Tozzer and the Invisible Lap
Dancers *p122*

JONATHAN AND JOSHUA LUNA
www.lunabrothers.com
jonathan@lunabrothers.com
The Sword *p4*
Girls *p103*

JOHN MCCREA
www.johnmccrea.com
john.mccrea@gmail.com
The Facts in the Case of
Mr Valdemar *p106*
© 2008, Eye Classics/SelfMadeHero
Two Hole Punch *p151*
© 2008, Doselle Young & John McCrea
Dead or Alive *p182*

KATHERINE MCDERMID
www.katherinemcdermid.com
katherinemcdermid@hotmail.com
Deadlines *p173*

ANGUS MCKIE
www.angusmckie.co.uk
apbh75@dsl.pipex.com
The Thing with Feathers *p58*
The Blue Lily *p140*

GARY SPENCER MILLIDGE
www.millidge.com
gary@millidge.com
The Medicine Cabinet *p163*
Honey Bees *p168*
Dogfight *p184*

INAKI MIRANDA
www.inakieva.com
The Lexian Chronicles *p88*
© 2008, Markosia Enterprises

MICHIRU MORIKAWA
michirum2000@yahoo.co.jp
At a Corner of Toytown *p66*
Isolation and Curiosity *p90*

BENJAMIN NAYLOR
benjaminnaylor@
yahoo.co.uk
Alcohol + Me *p123*

DAN O'CONNOR
Kong: King of Skull Island *p85*
© 2008, Markosia Enterprises

CARLO PAGULAYAN
www.glasshousegraphics.com
c.pagulayan@gmail.com
The Incredible Hulk *p15*
© 2008, Marvel Comics
What If..? *p20*
© 2008, Marvel Comics

TIM PERKINS
www.wizards-keep.com
tim@wizards-keep.com
World's End *p63*

IAN PETERSON
www.idpeterson-art.com
peterson100@btinternet.com
Big Ben *p32*
© 2008, Quality Communications

HUGO PETRUS
RAISE THE DEAD *P112, 113*
© 2008, Dynamite Entertainment

SEAN PHILLIPS
www.seanphillips.co.uk
sean.p.phillips@btinternet.com
Criminal: Lawless *p138, 160*
Criminal: Coward *p154*
© 2008, Ed Brubaker & Sean Phillips

MIKE PLOOG
mike.ploog@btconnect.com
Lone Wolf & Cub *p77*
© 2008, Dark Horse Comics
After Weirdworld *p87*
Thicker than Blood *p107*
© 2008, Reed Comics

STEVE PUGH
www.stevepugh.com
steve@stevepugh.com
Sharkman *p59, p117*
The Pit and the Pendulum *p104*
© 2008, Eye Classics/SelfMadeHero

KEN REID
fudgetheelf@aol.co.uk
Fudge and the Dragon *p64*
© 2008, Tony Reid & John Ridgway

CHRIS REYNOLDS
www.metropoppyfield.com
metropoppyfield@yahoo.com
Pure Holiday *p176*

CLIFF RICHARDS
www.glasshousegraphics.com
cliffric2@yahoo.com.br
Echoes of Dawn *p84*
© 2008, Trepidation Comics

JOHN RIDGWAY
john@ridgwaydesign.fsnet.co.uk
Alternate Earth *p36*

ALEX ROSS
www.alexrossart.com
Superpowers *p21*
© 2008, Dynamite Entertainment

JOHN ROYLE
www.johnroyleart.com
johnroyle007@hotmail.com
Super Aussiebum *p14*
© copyright 2008, Aussiebum
Orange *p167*
© 2008, Orange UK

STEPHEN SEGOVIA
www.glasshousegraphics.com
mamaru_chiba_19@yahoo.com
Vampirella *p83*
© 2008, Harris Publications

DECLAN SHALVEY
www.classicalcomics.com
dshalv@gmail.com
Frankenstein *p98*
© 2008, Classical Comics

LIAM SHARP
www.mamtor.com
mamtor@mac.com
S.T.E.M. Cell *p19*

SIKU
www.theartofsiku.com
mutantbox@aol.com
Judge Dredd *p42, p52*
© 2008, Rebellion A/S
Jesus and the Disciples *p60*
© 2008, Hodder and Stoughton
David & Goliath *p78*
© 2008, Hodder and Stoughton

CHRIS STEININGER
www.christophersteininger.com
csteininger@gmail.com
Beowulf *p116*
© 2008, Markosia Enterprises

JOHN STOKES
www.classicalcomics.com
Great Expectations *p181*

LEW STRINGER
www.lewcomix.tripod.com
lew.stringer@
btopenworld.com
Brickman *p128*

BRYAN TALBOT
www.bryan-talbot.com
bryan.talbot@btinternet.com
Jabberwocky *p86*
The Cauld Lad of Hylton *p115*

ANTHONY TAN
www.glasshousegraphics.com
aug224@yahoo.com
Sherwood *p120*
© 2008, TokyoPop

DYLAN TEAGUE
www.dylansdrawingboard.
blogspot.com
dylan_teague@hotmail.com
Donor *p102*
© 2008, Men's Heath/Rodale
Back to Basics *p152-153*

BEN TEMPLESMITH
www.templesmith.com
ben@templesmitharts.com
Conluvio *p6*
Wormwood *p95, p185*
30 Days of Night *p118, p135*
© 2008, Steve Niles & Ben Templesmith

ART THIBERT
www.hackshackstudios.com
aethibert@comcast.net
Black & White *p54*

RICK VAN KOERT
www.4f-creations.com
rikof@xs4all.nl
Nunblade *p44*

PATRICK WARREN
mrmetallium@gmail.com
Richard III *p34-35*
© 2008, SelfMadeHero

JOHN WATSON
watson904@btinternet.com
Magneto *p33*
© 2008, Marvel Comics

ANDI WATSON
www.andiwatson.biz
andicomics@yahoo.co.uk
Glister *p65*

COSMO WHITE
www.cosmowhite.com
cosmo.w@gmx.co.uk
Jet Black *p23*
Vamps *p5, p96*
Girl's Comic *p166*
Thierry Henry *p177*

ANDREW WILDMAN
www.wild-ideas.co.uk
andrew.wildman@wildfur.net
Meta-Physix *p47*
Driftwood *p162*

Acknowledgments

Having worked in the comics industry for what seems like forever, I am fortunate to have a fantastic database of artist contacts, without whom this book would not have been possible. But it would only have been half as good without the following's input.

For keeping me up to date on cutting trends I would like to single out ILYA and John McCrea for their above and beyond.

For enhancing my awareness of Brazil and the Philippines' burgeoning range of talent, thanks go to Glasshouse Graphics' David Campiti and Studio Saka's Michelle Calanog.

Comics International's Mike Conroy has been essential for artists who had the audacity to move since I last spoke to them, and for showing me some of the fine talent they are (thankfully) publishing, special thanks to Dynamite's Nick Barrucci and Markosia's Harry Markos.

For expanding the market with their new titles and letting us boast about such, hats off to SelfMadeHero's Emma Hayley and Classical Comics' Clive Bryant.

And, for coming up with the initial idea for this book, thumbs up go to Ilex Press' Tim Pilcher—my only regret is that we didn't have enough pages to show all of the superb 500+ submissions that trail boss Chris Gatcum and I have had to choose from.

So, now that you have seen the wonders of 21st century comic art and can contact the artists, let's go create some fantastic new titles to show what a cool industry this is!

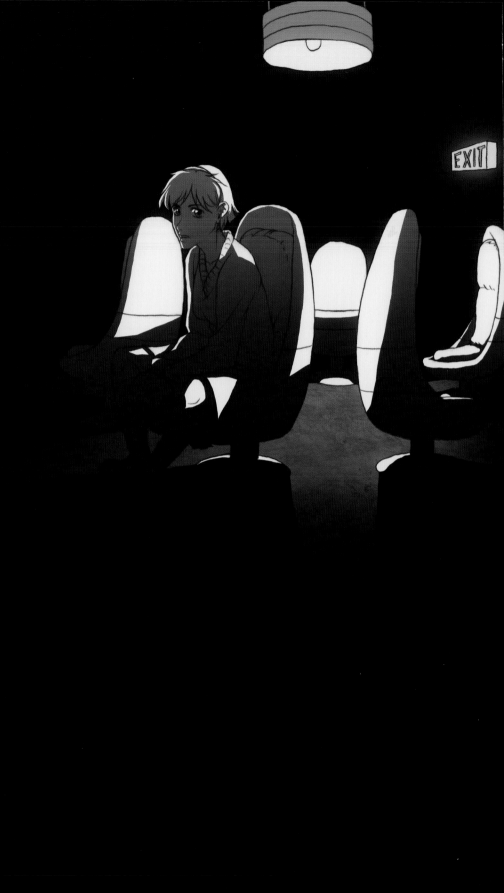

▶ **Orange Room**
Paul Duffield
Pencil, Adobe Photoshop
www.spoonbard.com
spoonbard@gmail.com